The World's Top Photographers

Portraits

Published and distributed by:
RotoVision SA
Route Suisse 9
CH-1295 Mies
Switzerland

A RotoVision Book
RotoVision SA
Sales & Editorial Office
Sheridan House
114 Western Road
Brighton & Hove
BN3 1DD
UK

Tel: +44 (0)1273 72 72 68
Fax: +44 (0)1273 72 72 69
Email: sales@rotovision.com
Web: www.rotovision.com

10 9 8 7 6 5 4 3 2 1

ISBN (10 digit): 2-940378-09-6
ISBN (13 digit): 978-2-940378-09-8

Design by Fineline Studios

Michael Birt portrait by Richard Pereira.

Reprographics in Singapore by ProVision Pte. Ltd
Tel: +65 6334 7720
Fax: +65 6334 7721

Printed in Singapore by Star Standard Industries (Pte) Ltd

The World's Top Photographers
and the stories behind their greatest images

Portraits

Fergus Greer

Contents

Introduction

Welcome to *The World's Top Photographers: Portraits*—a collection of images from an international selection of photographers, all of whom are acknowledged as contemporary "greats" in their field. Along with the pictures are the stories behind each photographer's rise to the top and something of the philosophy that lies behind their work. It is striking to see how much passion and hard work lies behind the image-making… and even more to maintain a reputation.

Portraiture is the most high-profile photographic subject of them all. Portraits record and represent moments in history, and often become iconic images of their era. One could say that, in a number of ways, portrait photographers are the rock stars of the photography business.

This is the "sexy" genre of photography .Everything you ever heard about it is true. Check out what they say for themselves: read what John Stoddart has to say about car photographers (this is the man who showed you a "different" image of Liz Hurley), and how Tony Duran purchased his mansion in Bel Air, California, from a single shot of Jennifer Lopez.

It is noteworthy how each photographer has a different approach to their images, and the images of themselves! They are as individual as the sitters they photograph. Some contributors to this book refused to be represented by a self-portrait at all, and some were very precious about including technical captions, preferring instead to let the pictures speak for themselves.

Anyone who has tried to shoot pictures has taken a portrait of someone—their children, a neighbor, a friend. So, what's the difference between this and making lots of money out of photographing famous people? Well, it is very difficult to break into this business. Portrait photographers really are a breed apart.

Taking the time and energy (and schmoozing) to get access to the big-name subjects—sometimes even royalty—and making a top-class showcase for one's portfolio is no mean feat. This is huge business, and is highly competitive and demanding. To compete is a daunting prospect for anyone breaking in from the outside. Perhaps a beneficial effect of this environment is that photographers have to find, and work in, innovative ways to ensure their images stand out. Like Martin Parr says, it requires "rigor."

There are all kinds of challenges for those who take up portrait photography full-time: the long working hours, frustrations with the publicist who only rarely cooperates, and having to routinely rise at ungodly hours to jump on a plane that is bound for some distant location.

For those talented, committed, and fortunate photographers who adhere to this regime, and break into the market, portrait photography promises more fame, money, and excitement than your average still life or landscape. There is a thrill of the chase, and the matchless feeling of achievement when a fleeting perfect moment is captured on film. However challenging a portrait can be, for the world's greatest portrait photographers, the adrenalin rush is too good to give up, and their passion for their subjects, their craft, and the buzz of sometimes being a part of the world of celebrity, are too great.

Fergus Greer

Michael Birt

Born in Liverpool, Michael Birt studied photography at the Arts Institute, Bournemouth, UK, from 1972 to 1975. After graduating, he focused principally on fashion photography. "I didn't originally set out to be a portrait photographer, but my first commission was to take a portrait of a fashion designer and I have since been unable to escape the call of the portrait."

Birt's enthusiasm is evident in his work. "Every day I meet some of the world's most interesting people and, whether they come to me, or I go to them, I am given an insight into their lives. However brief this glimpse may be, it allows me to see the qualities that make us all individual."

Talking about the nature of his occupation, he says: "Photography is a difficult medium to work in. Either one captures the moment at the perfect time, or not. And if not, it is lost forever. There are so many factors that contribute to a picture being successful, and I'm only happy when I achieve it."

Birt has interesting ideas with regard to his personal strengths and weaknesses. "I think my greatest strength is knowing my weaknesses, and my greatest weakness is knowing my strengths. Some photographers know where their strong point lies and repeatedly rely on it to do well, but it's good to explore your weaker areas of photography too, or you'll never develop your work."

Birt has worked for a variety of publications in London and in the United States, including *The Sunday Times Magazine*, *Glamour*, *The Sunday Review*, *The Times*, *Newsweek*, *People*, *Luxe*, and *Talk*. He considers his most prestigious moment as being contracted to Tina Brown's *Talk* from its inception. "My most exhilarating period in photography was working for *Talk*. I was shooting prominent and influential people continually for several years. I created the concept of 'Talking Pictures,' a six-page layout with quotes of conversation I had with the personality during the shoot, set into the pictures."

Some of Birt's most reputable qualities stem from his ability to think with depth and listen conscientiously. "I think most photographers are good thinkers. They also seem to be very easy people to talk with. Part of the process is that we have to be able to adapt the conversation to keep the sitter interested. Often the people I photograph are under great pressure and their time is very limited, so I have to be able to build a bond immediately."

Along with Irving Penn, David Bailey, August Sander, and Richard Avedon, Helmut Newton is one of the artists whom Birt respects. "His work is so momentous and energetic. It's invigorating to know that he worked for such a great length of time. I think longevity in work is a difficult aspect for a photographer to achieve. It's one thing to be good for five or ten years, but to excel for 50 or 60 is something completely different." Bill Brandt, whom

Chow Yun-Fat
Actor, 1999, Los Angeles, California.
"It's exciting to find such calmness, kindness, and talent in a sitter. We struck an accord very quickly and produced many really good images in a short space of time."

Alexander Payne
Director, January 2000, Topanga Canyon, California.
"The Band-Aid was covering a real cut, and not a photographic prop, but nicely adds to the portrait—maybe looking up, anticipating another bump on the head."

Harrison Ford
Actor, May 1999, New York.
"Ford's obvious physical strength, intelligence, and intensity, were summoned for a private moment in the studio."

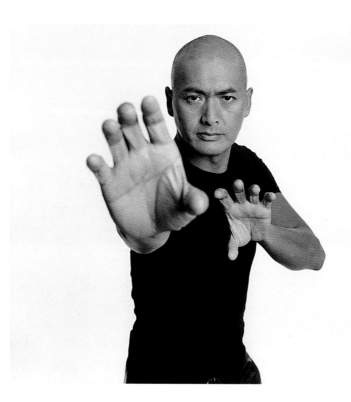

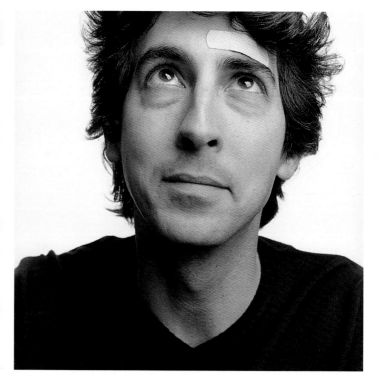

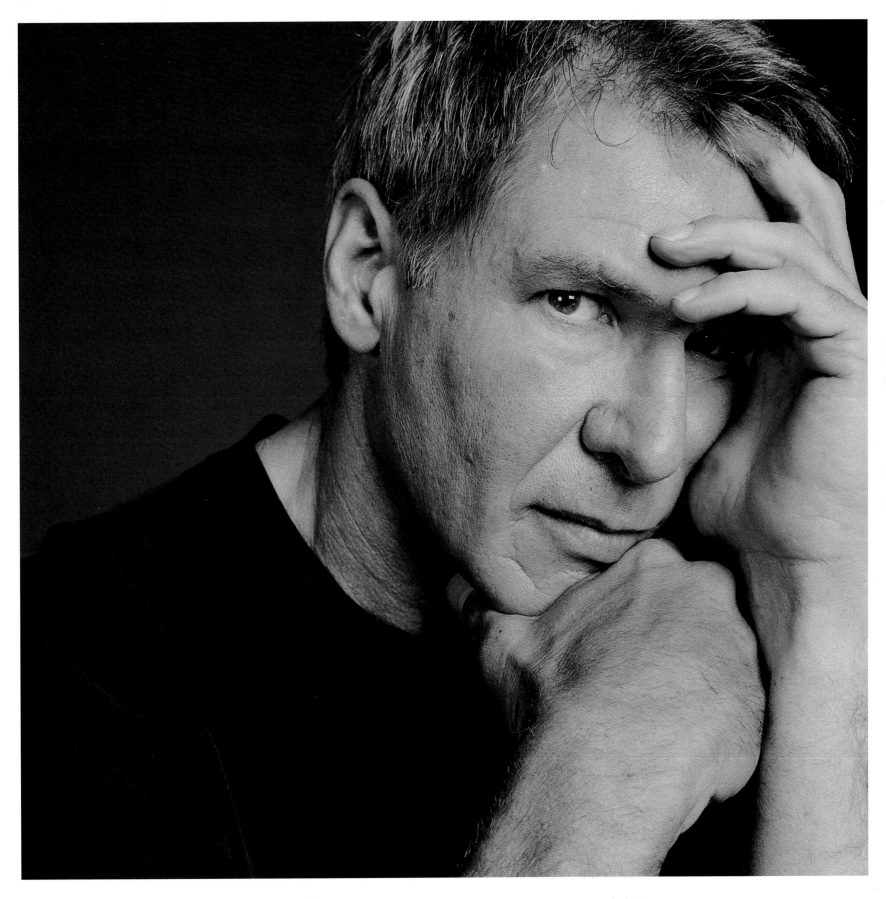

Michael Birt

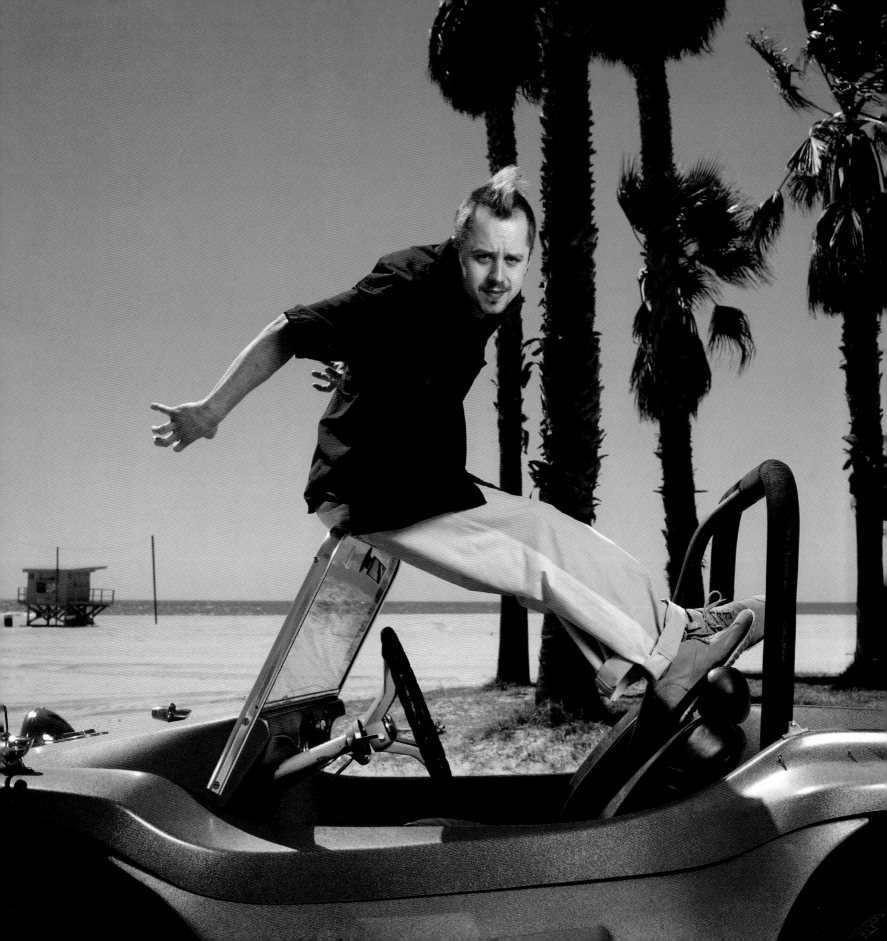

Giovanni Ribisi
Actor, March 2000,
Venice Beach, California.
"The picture was perfectly set,
but just before we shot, a
sandstorm swept by. We had to
wait and re-light. The original
daylight was better than the one
we photographed with."

Birt considers to be one of the fathers of portraiture, has been another major influence. "Brandt developed a new way of approaching nudes, almost Picassoesque."

Birt took his first photograph aged 11 with a Kodak Instamatic, which his brother John brought back from New York in 1964. "I took a picture of John pretending to be on the telephone at home. I still have the picture somewhere!"

Of all the people Birt would like to photograph, he is most fascinated by the idea of capturing Osama bin Laden's image on film. "It would be interesting, to say the least, for people in the future to have a portrait of him and, through it, be able to visually place him in history and discern his character for themselves by looking into his eyes."

The quality that Birt most likes to bring out of his subjects shows his thoughtfulness and compassion. "Capturing someone's generosity of spirit definitely helps to make a better photograph. It's important that they offer a part of themselves to the viewer."

These are the words of a modest man with a wonderful perspective and charming manner. It is perhaps then natural for him to struggle when asked how he might define his own talent. "It's really for other people to pass judgment, though I would hope that they, above all, see honesty and integrity in my photographs."

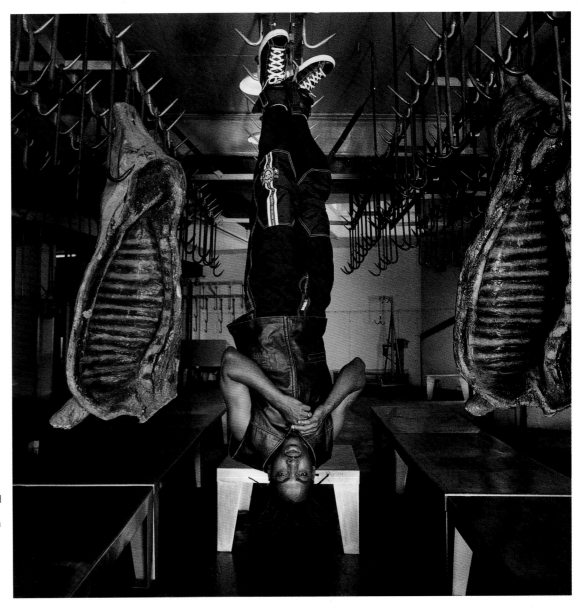

Coolio
Rapper, August 1997, Smithfield
Meat Market, London.
"I hung Coolio up but, although
I had rehearsed it with one of
the riggers, he kept spinning
because there was nothing to
hold him down. This picture
was the first frame I took, the
only motionless one."

Michael Birt

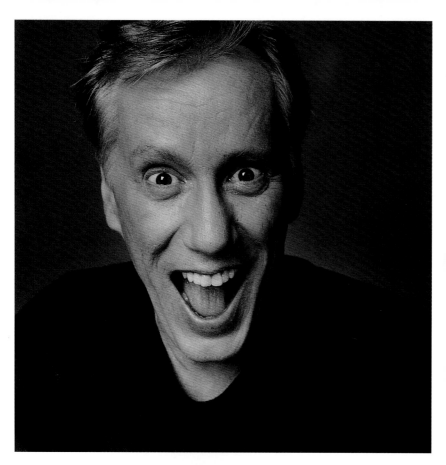

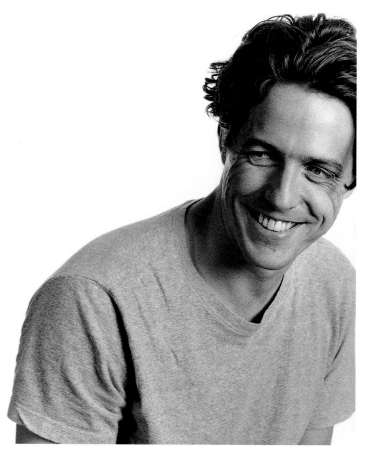

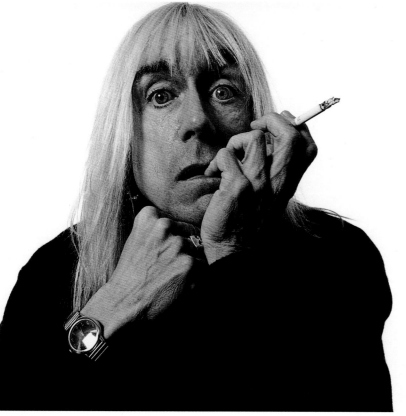

James Wood
Actor, October 1999,
Los Angeles, California.
"James Wood is a wonderfully
generous man who participates
fully in the portrait process.
He is great fun."

Hugh Grant
Actor, June 1999,
Fulham, London.
"An easy person to photograph
as he knows precisely how to
perform in front of a camera."

Iggy Pop
Musician, January 1996,
Notting Hill, London.
"Shot in a hotel room. Not
much work—I set-up a white
background and popped him in
front of it. He did the rest."

Piper Perabo
Actor, March 2000, Coney
Island, New York State.
"This was shot on a freezing
day. A few days before I had
photographed four other actors
on hot beaches in California.
I tried to match the atmosphere
on Coney Island and, in spite of
the cold, Piper dressed for the
effect. Lit with daylight and
portable studio flash."

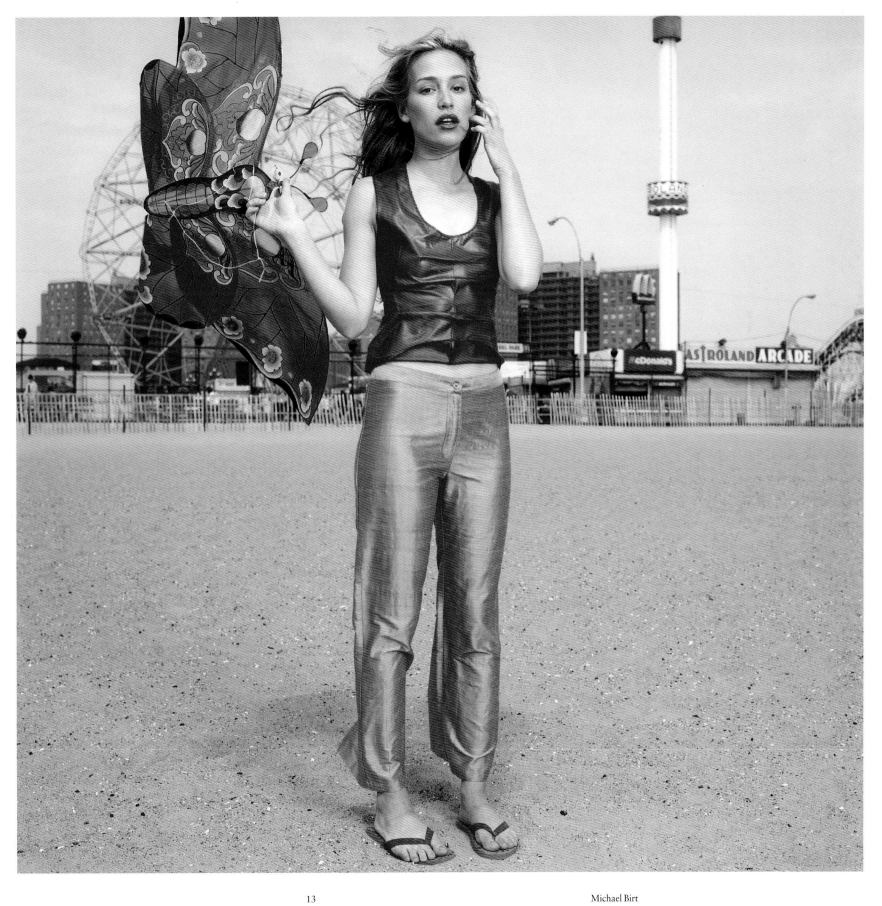

13 Michael Birt

Chris
Buck

When Chris Buck started taking pictures he seemed to have a natural aptitude for it. "I don't say this as a kind of boasting, just that when I picked up a camera and started shooting I was pretty good at it—I had a basic talent for recognizing what made an interesting picture." Throughout his childhood Chris's father worked for Kodak, which he now believes had an important influence. "I'm not mechanically or technically minded, but I think that I found photography unintimidating as it was so familiar in our household."

Chris was born in Toronto in 1964; he grew up playing hockey, board games, and lots of hide-and-seek with the neighborhood kids. He studied photography at Ryerson Polytechnical Institute and quickly got his professional start with the local music publications *Nerve* and *Graffiti*. After moving to New York in the early 1990s, he soon started working with artists' representative Julian Richards and has worked with him ever since. With Julian's guidance, Chris has garnered assignments from the likes of IBM, Citibank, and Hewlett Packard, as well as editorial regulars *Esquire* and *Vanity Fair*, among others.

Traditionally, Chris has been known for shooting celebrities and now, he explains, "I have a kind of second career based on shooting odd still-lifes and 'real' people. It's a new thing and an exciting direction for me, and it colors my celebrity work, too. It has given me a double trajectory with my career. I do celebrity portraits for certain clients and my 'idea-based' pictures for others, and advertising feeds off of both of them." In 2002 he took up a second residence in Los Angeles and it's led to more of both kinds of assignments.

Chris is most satisfied when he's getting a picture that he loves and the client agrees with his take. "When the client uses my favorite shot from a session and they use it well, that's just perfect. Of course, I have to live with 'not perfect' most of the time."

He knows what he wants out of a portrait and he sees that as important. "Certainly any photographer who is successful has a pretty good sense, not necessarily while they are thinking about the job or even at every moment while they are shooting it, but at some point they have clarity about what they want.

"Unfortunately, it seems that a lot of photographers fall back on what they think magazines want rather than doing what they would like to see. A lot of my pictures that are now people's favorites are ones that were rejected by their original clients. I remember an art director looking at my contact sheets, and then at me, with abject horror, with a kind of 'what are you thinking? We can never run this' expression."

John Cusack, actor *(facing opposite).*
"I don't know what state John Cusack was in when I photographed him, but he was somewhere else in some way—maybe it was too early in the morning for him. We brought along this blow-up doll of a man that people use for safety in their cars, or to prevent burglaries. In the photograph the Safe-T-Man is wearing clothes that the stylist brought for John. He never looked so good, in an Armani suit, so uptown. As we got to shooting, John suddenly grabbed the doll by the collar and began trashing him, literally pounding him. Then he turned him upside down and started banging his face against the floor. John then picked him up and drop-kicked him towards me, knocking over the camera. It was the only time he came alive in the whole shoot."

Billy Joel, musician *(right).*
"I saw this sign on display while picking out a couch at a prop house for another job about six months earlier. I scrawled 'applause sign' on my ideas list. I was told I would be shooting Billy Joel for half an hour in a hotel. On a whim, I rented the sign on the way to the shoot (not bothering to consult the magazine on the $275 fee). It all happened in a hotel suite, the reporter interviewing him in the living room, while we set up in the bedroom. We pulled the drapes mostly shut, plugged in the sign and shot a few Polaroids to find the right light balance."

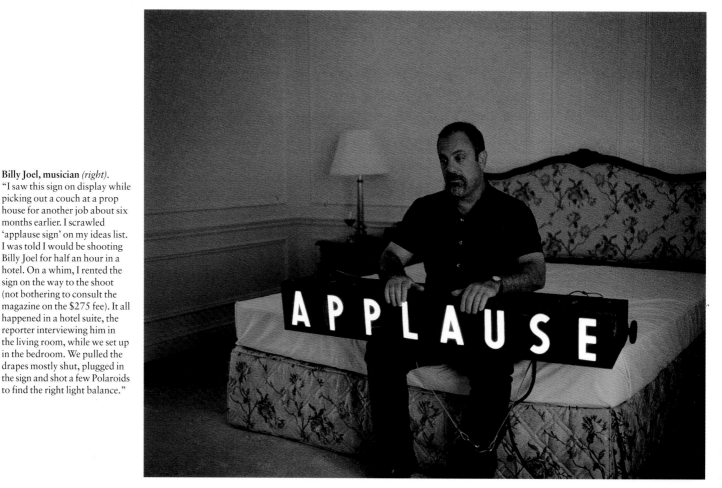

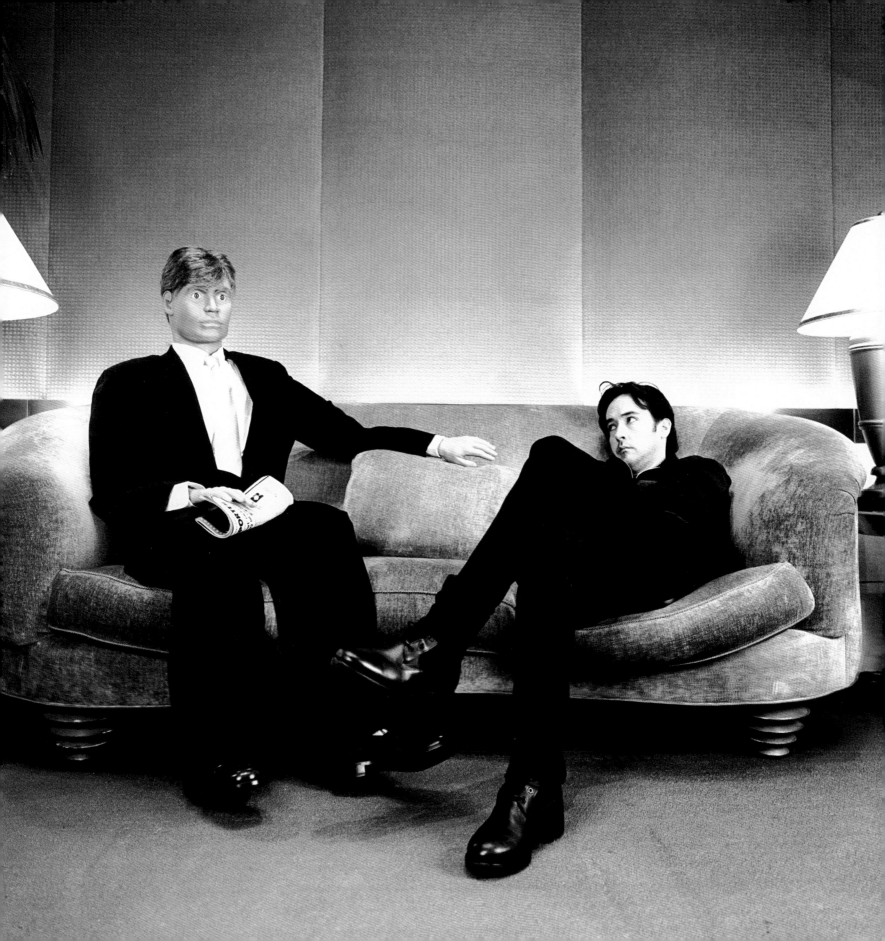

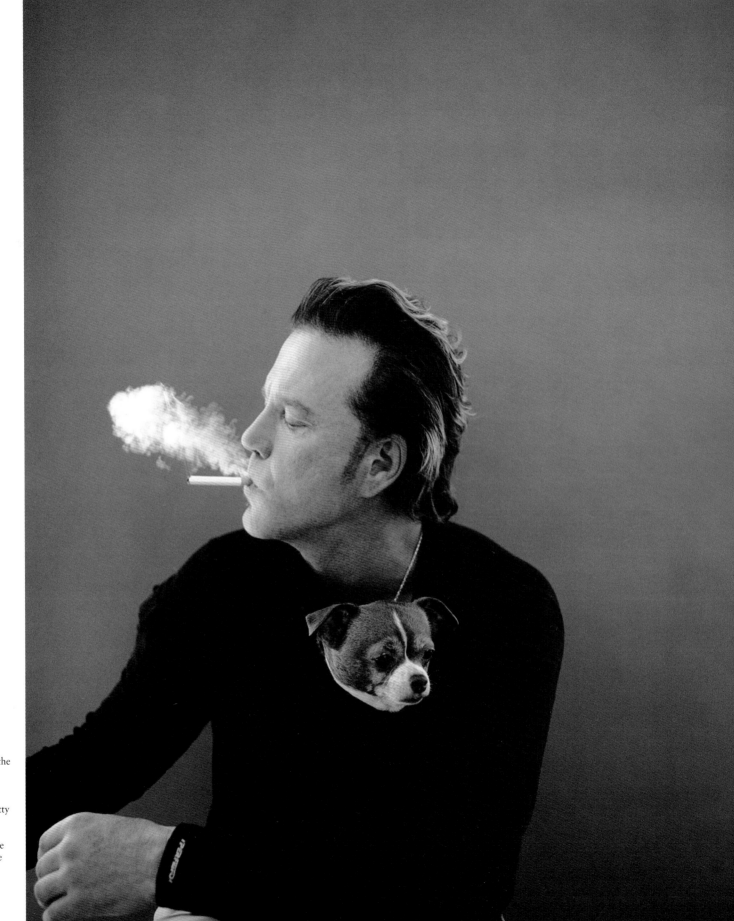

Mickey Rourke, actor
"This picture is really about the dog. My fiancée jokes that I have turned into a dog photographer. I don't really like dogs and yet I have a pretty good knack of making them look good, and have a good empathy with them. A picture of a cat doesn't have the same emotional depth as a dog."

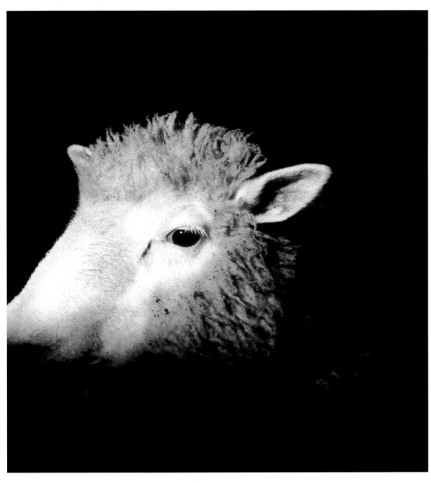

Dolly, the cloned sheep

"Amongst the hay in the pen we set up a blue backdrop, then had the handler bring Dolly over. He'd be straddling her and we'd get into place. He would let her go but she would just wander off. We tried different things to keep the handler around, yet out of frame, but Dolly would just walk away. Before I knew it my time was up and she was off to another media engagement. I thought, my God, I've been sent all the way to Scotland (for a possible cover even), and I haven't done anything that's usable yet. I was totally freaking out. So I put my portable flash on my camera and just shot with that. I'd started doing this with portraits a lot around that time—you get physically close to your subject to get the flash right, and it just kind of brings out something with people. It delivers an intensity. I'm not intending to bring out something in particular with the sheep, but hey, I'll just do anything at this point."

Chris Farley, actor and comedian

"A couple of months after Chris Farley died I found myself flipping through the contact sheets of my session with him. I found a set-up which, at the time I shot it, I read as being too serious. Being who he was, the pictures were unnecessarily dark and moody. This was me putting my style onto someone in a way that felt totally inappropriate. Looking back through them, I found a couple of frames that were graphically strong and, I think because he had died in a tragic way, the pictures showed a Chris Farley who was dramatic and kind of sad in a way that was no longer pretentious but actually telling."

Friends and clients tell him that they can often recognize his style when they open a magazine. They talk about his dry sense of humor and the awkward physicality of the subjects. The way that he places people in the frame, often off-kilter in some way, suggests a "Chris Buck" composition. "I bring my aesthetic to any kind of picture that I might be doing, I can't help it. The pictures start off serious and dark and by the end of the shoot there is a little joke in there too."

Chris believes that his one weakness is probably similar to other photographers. "Fear. Fear of failing, fear of trying something new, fear of the unknown. I think a lot of people, in creative fields or not, have to deal with this."

Alternatively, he considers being "low-tech" part of his style. "I rarely use fancy lighting and camera tricks. I tend to gravitate to simple executions and solutions, even with sophisticated ideas. It feels more honest, and is thus more effective as an image."

One of his earliest influences was Irving Penn. "I like his portraits: simple and strong, but the best of them are also odd. The oddness seems to be inherent in the people and the photograph, and not a gimmick." Another key influence was

music photographer Anton Corbijn. For Chris, Corbijn's music portraiture has a consistent mystery about it: "strange and simple, lit with natural light but mythically beautiful—a refreshing antidote to the usual 'young and energetic' music photography." There are people Chris has missed the opportunity to photograph, which causes him some regret. "Unfortunately, the people I most want to photograph keep dying! I wanted to photograph Richard Nixon, and then Frank Sinatra. I think the established legends—the ones from before my time—are always the most magical to me. I'd love to have a sitting with Eric Rohmer, the French film director, but he's famously reclusive. I plan on writing him a nice letter and will get around to it when I stop procrastinating."

Although Chris says that he was always interested in media of one sort or another, it seems to be the practicalities of being a photographer that have led him to this particular calling. "The definitive thing that is great about being a photographer is that I can take responsibility for the work. If the pictures are good I can take the credit and if they are bad, I take responsibility for that too. And hopefully I can learn and make it better next time."

E. J. Camp

Upon graduating from Rochester Institute of Technology, New York, E. J. Camp moved to New York City to work as an assistant to fashion photographers Albert Watson and Bruce Weber. During that time, Laurie Kratochvil, the photo editor at *Rolling Stone* magazine, gave Camp an assignment to shoot Christie Brinkley for the cover. Her next assignment for the magazine was with Annie Lennox. "From that day forward, I knew I would always be a portrait photographer," she recalls.

Camp travels extensively between New York and Los Angeles, shooting well-known faces from the entertainment industry, and also keeps busy with a vast roster of commercial clients. She is sought after by top agencies and has produced amazing work for the ABC television network, American Express, Danon Yogurt, General Electric, E! Entertainment Television, IBM, among many others. Her music and cinema clients include VH-1, Paramount Pictures, and Sony Pictures. Her movie poster work ranges from *Top Gun* (her first) to *Austin Powers: The Spy Who Shagged Me*. Publications such as *Rolling Stone*, *Premier*, *Esquire*, *Forbes*, and *In Style* also consider her one of their top shooters.

Because of her patience with people on set, and her ability to make her subjects feel comfortable, she is well-liked and respected by top celebrities and their representatives. "I am able to stay unruffled by any insecurity they may have about being photographed (which we all do), and get them to let down their guard. Ultimately, I try to make the subject laugh to help them relax. I think I am a good read on what makes people comfortable." She prides herself on her ability to come back from any assignment with a great shot, "no matter what obstacles or circumstances are thrown at me."

George Clooney, actor
"George Clooney won the hearts of everyone on the shoot. He was fun to work with, nice to everyone, and so photogenic. It was more like hanging out with a friend for a day then doing a shoot. This is what you call the perfect assignment."

Jodie Foster, actor

"For this assignment I wanted to do a visual tie-in with Jodie's then current movie, *Panic Room*, so I had a red box built for Jodie to crouch inside of. Jodie is actually quite tiny, but she was just a little too broad across the shoulders for the dress. We taped the back of the dress, and she seemed comfortable enough. As comfortable as can be expected hunched up in a small box in a tight evening gown."

E J Camp

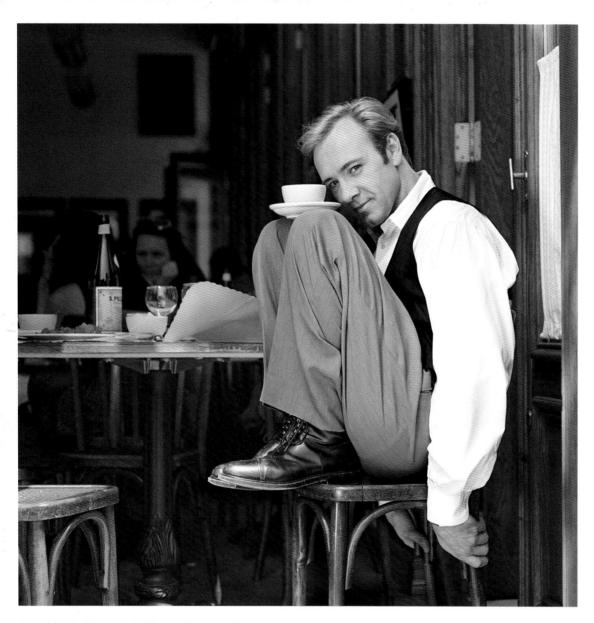

Kevin Spacey, actor. *(left)*
"Kevin was very intimate with the camera. Whatever you asked him to do, he would take it a little further in order to make the shot more playful. How strange it could have appeared to have a subject balance a coffee cup on his knee, but Kevin makes it look like the most natural place to put it."

Camp is inspired by the work of George Hoyningen-Huene, and considers him a real pioneer in the field. "He took commercial work out of the studio as early as 1929," she says. "He broke new ground for what is now commonplace for most professional photographers.

For Camp, happiness is as simple as holding a camera. "Whether shooting Tom Hanks, Shaquille O'Neal, or Carly Fiorina, for a few hours in a day I get to meet and work with people who are at the top of their profession. And I get to tell them what to do!" No matter who the subject is, there are certain moments that add to Camp's sheer enjoyment of holding a camera and shooting. "The willingness to trust where I am taking the direction of the photograph," is the quality that she admires most in a subject.

Agencies and industry representatives, as well as private clients, commission her for the work that she is consistently and easily able to produce—a unique and extraordinary "E. J. Camp"

image. "[Her images are] ones that do not compromise the integrity of the subject, depict them as approachable, and still have a bit of a twist," she says. "My photos are not locked into a restricted style. I try to challenge myself on every shoot." She demonstrates her skill behind the camera with each assignment she completes.

When asked who she would like most to photograph, Camp's comical and playful nature is revealed, "Amelia Earhart, if I can find her." Further, when asked what she might have been had she not become a photographer, she says, quite frankly, "A bum."

In a field where the competition is fierce, coupled with a rigorous work standard and schedule, Camp continues to remain on top. "Staying successful in a very competitive and changing business continues to be my greatest achievement," she states. Her longevity and popularity distinguish her career, as well as her profound and prolific contribution to the world of photography and art.

Samuel L. Jackson, actor. *(right)*
"Sam was extremely relaxed during the shoot. It started to get intense when the sun started to set behind a building across the street. Sam joked that I don't laugh much, which generally is not true. He made me realize I was letting the shoot get the best of me. I smiled and moved on to a shot less challenging, and ultimately better."

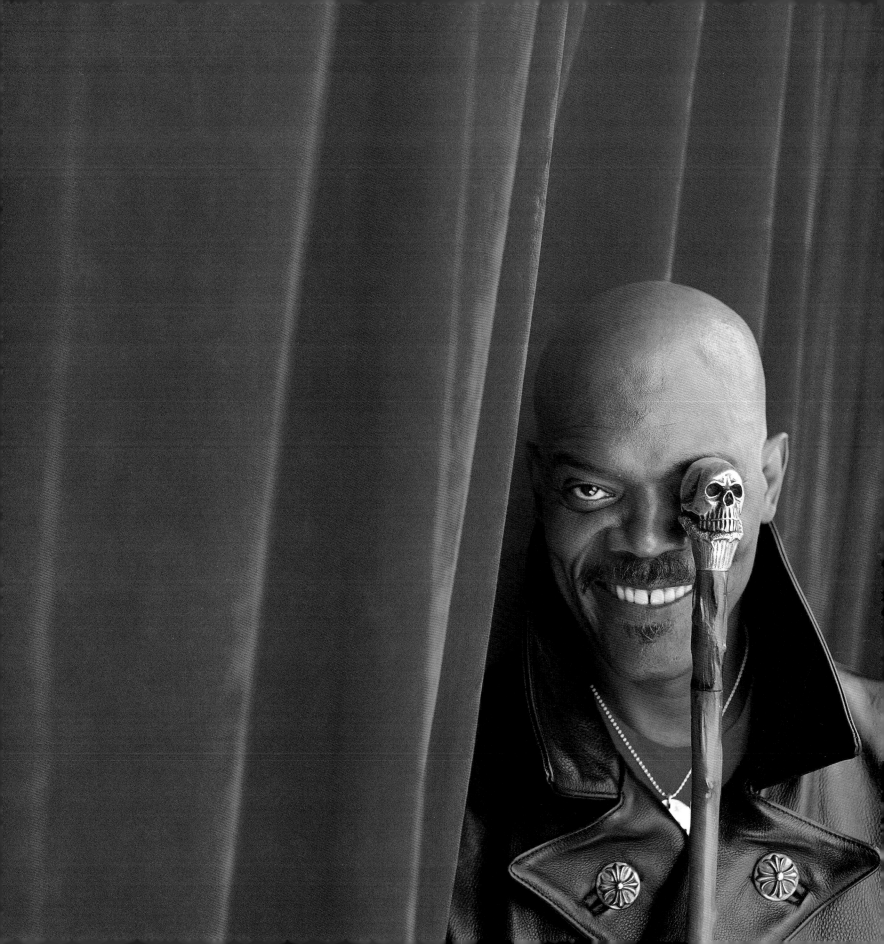

John Clang

Born in 1973, John Clang is the youngest contributor to this edition. He has produced remarkable work and garnered powerful recognition in a very short time. Fueled by his passion for taking pictures and learning, Clang works constantly at refining his skills and accumulating new ones.

Raised in Singapore, he had a brief stint at art college, then quit school. He realized that school wasn't going to guide him to the places he wanted to be. "Why stick with it?" he asked himself. Instead he opted for assisting a photographer whose work he had seen in the news. "I called him and said, 'I'll work for you for free.'" The photographer took him up on his offer and gave Clang invaluable training. He claims he learned more by assisting than he would have in a formal educational setting and has become an advocate for the benefits of assisting.

"Assist, assist, and assist! It's the best start for a young photographer," Clang insists enthusiastically. Further, he credits his success at such a young age by doing whatever it takes to have his work seen by the people he wants to see it. "That's the most important thing."

Clang recalls the first photograph he ever shot was of a young girl (who later would become his wife) when he was fourteen. By the age of 21, Clang was exhibiting his photographs in many galleries in Singapore while also working as an installation artist. Two agency directors attended one of his shows, liked his style and hired him to shoot an ad campaign for Singapore Airlines. This would be the job that would start his career in commercial photography.

Upon completing his work for Singapore airlines, he moved to New York, and was hired for Nordstromshoes.com to shoot a layout in the United States. Clang then began shooting for such corporate clients as Nordstrom, IBM, Adidas, Reebok, Hermes, British Airways, and editorial work for *Interview*, *The New York Times Magazine*, and Rank, among others. He considers relocating to New York with his wife one of his greatest achievements to date.

Clang adores living in New York. "New York is heaven for photographers because as a photographer here you have more pride and are more respected; you are chosen to do a job based on

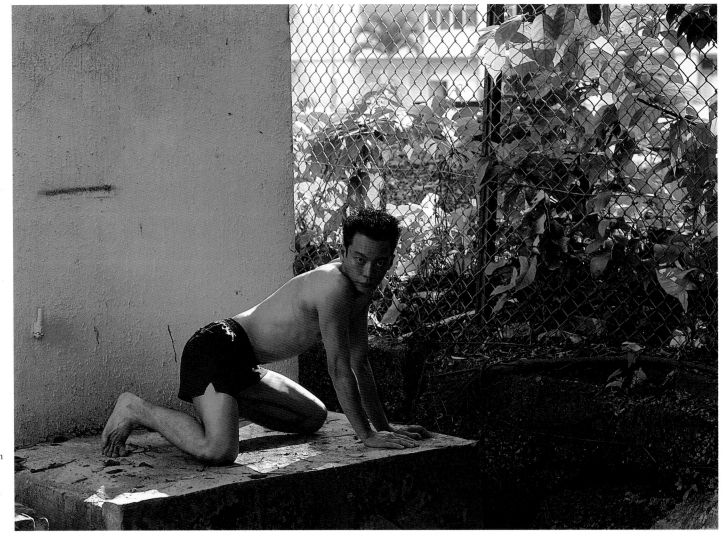

"This is a portrait of Beon. I've been doing various series on him over the years. In this shot he was becoming me, as I constantly projected myself and my thoughts into these images. He is portrayed here as a Singapore 'stray cat.'"

"Part of the 'Ground Zero' series. This picture was taken two months after 9-11, somewhere around Ground Zero. I was trying to capture what I was going through emotionally. By deleting the background and putting the people out of context, it helped me to focus on the human relationships rather than the dramatic event that took place."

John Clang

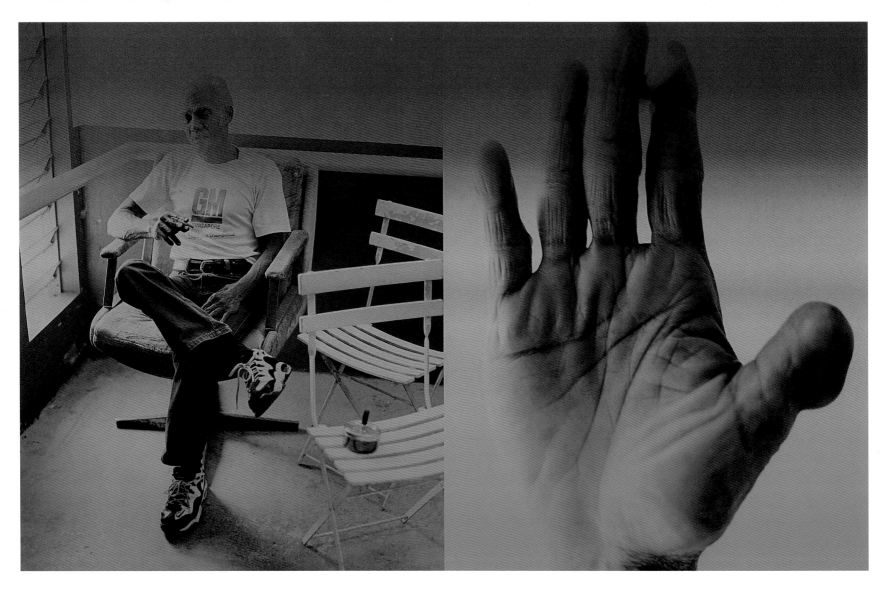

"This is from a very early series. I'm a strong believer in fate. I did a series of portraits of some people around me that I was curious about. Their palms told me a bit of their life story."

your visual sense, based on your style." This is a bold contrast to his days in Singapore where he was required to maintain a studio with full-time assistants. "I had to work and keep taking jobs even if I wasn't crazy about them so I would have money to live on."

New York also provides Clang the inspiration that is critical to an artist. Movies especially drive this creative force. He is a simple man and a simple artist, which may well be the best word to describe his work, as well as his most powerful inspiration. "To me, the daily life that we live and breathe is pure inspiration. If you want inspiration just put a sign in a stuffy room. Don't breathe for one and a half minutes. Walk to the window, open it and breathe. That breath is life." His photographs represent that breath of fresh air.

Clang speaks with freshness as well. "I have never termed myself as a 'portrait' photographer. Photography was a fascinating medium for me to express myself when I was a teen. It gave me a lot of freedom and joy to explore and understand my sitter, especially those whom I love. When looking at my portraits, I tend to see self-projection. I think most of the time I am just doing 'self-portraits' even though the sitter varies," Clang says. "I am not sure why I like what I do, I am still looking for that

answer. Seriously, I don't know if I like what I do, but I sure am very passionate about it. It has become a part of me. It feels very natural, just like breathing," remarks Clang when asked why he likes taking pictures. "When I feel comfortable with my images, I am at my happiest."

He never really thought much about being known as a fashion photographer or a commercial photographer and is looking forward to returning to the world of photography as art and presenting his work in galleries around the world. Most recently his first solo exhibition was unveiled at the Diane von Furstenberg store in New York. It included ten images and a video installation.

Further, Clang worked as Director of Photography for a magazine called *Werk*, which features the work of fashion and art photographers, working closely with his mentor and owner of the publication, Theseus Chan. He loved his work there, reviewing the submissions for his publication. "I looked for photographers who were confident with their own signature, their own style." As much as he would have liked to continue his position, his schedule no longer allowed time to work with the magazine. Perhaps it is his sensibility and perspective in life that

has brought him so far in such a short amount of time. This, and his charming, charismatic nature, work together to produce his simple images. He says of his work: "My images engage you in the most restrained and subtle manner. Very quiet, but with a voice."

When he works with his subjects he is most touched when they demonstrate beautiful body language. "It speaks louder than words," he states. He is a master at capturing that unspoken language on film for all to study and enjoy.

He admires the work of Cuban-born artist Felix Gonzalez-Torres, who was an installation artist probably best known for his billboard project around the city of New York in 1992. Clang would love the opportunity to photograph Singapore's ex-Prime Minister Lee Kwan Yew if it were possible.

Finally, it is no surprise that a man who has taken such tremendous gambles at such a young age in his life—such as moving with his young wife to New York City in pursuit of his place among the greats—reveals that had he not been so passionate about his photography he may well have become a professional poker player.

"This is from an ongoing series that captures my feeling for our parents. My lady, Elin, and I really miss them. I'm very afraid that I may forget them."

Sophie Dahl, model
"She is one woman that I truly adore. A very talented writer and a great model. I'm fortunate to know her. This was used as a cover for *Werk* magazine."

John Clang

William Claxton

Claxton recalls that the first picture he ever took was one of himself in a mirror, when he was seven years old. As a child, he spent his time collecting and listening to Duke Ellington, Lena Horn, Count Basie, and Tommy Dorsey, and as a young man he studied psychology at the University of California, Los Angeles. It was here that he began photographing jazz musicians as a hobby.

At the time he was using a 4x5 Speed Graphic camera, which was obsolete even then. "When I worked, holding that big, clunky camera up, with flash bulbs and dangling extension cords, friends would laugh at me and remark that I looked like a crime photographer."

Claxton had begun to craft his own unique style when he met Dick Bock, and they partnered in establishing the Pacific Jazz label. He shot all the covers for the albums, and in a short time, other labels commissioned him to shoot their covers, too. He has long been considered an insider in the world of art and entertainment, and loves what he does with jazz musicians, "because, as a rule, they don't care about pretense," Claxton comments.

In the early 1960s he met Peggy Moffit, a top model who not only wore high fashion but inspired it. Meeting her became a critical turning point in his art, as well as his life. They have now been happily married for more than 40 years, exchanging thoughts and ideas as best friends as well as husband and wife.

Soon his work was published in major magazines and exhibited around the world. He developed a way of portraying musicians as people, not just performers. "I study them carefully before photographing them, much like I would a dancer, an actor, or even an ordinary person performing an ordinary task. I note how their faces and bodies reflect or catch the light, and when and at what angles they look their best. I do all this, of course, while listening to their playing. In a sense, I listen with my eyes."

For the most part, Claxton is loved by all kinds of people for his grace, humor, and style. He, in turn, admires these qualities in others. "I get to meet people from all over the world, and I have the challenge of making them look good… finding their best qualities… no matter who they are—an evil tyrant or an innocent child."

John Cassavetes, director
"This was shot in Burbank, California, in 1962. On an assignment for *LIFE* magazine, I met John at the Warner Bros Studios executive offices one afternoon after he had been working on his first feature film, *A Child is Waiting*, starring Judy Garland and Burt Lancaster. He said that he was exhausted and just flopped down on the grass. I thought to myself, 'Great!' (I never would have thought to have him do that). I got down on my belly and put the camera at his eye level and shot him. I shot the image with 35mm Nikon F and Tri-X film."

Chet Baker, musician
"I took this shot in Hollywood in 1954. Chet was seated at the piano in a recording studio 'noodling' a few notes of some tune he was trying to recall. I saw his striking reflection in the piano top and placed my Rolleiflex on the piano. It was a one-time shot because he moved away almost immediately. I shot this very carefully at 1/30th of a second at f3.5 wide open."

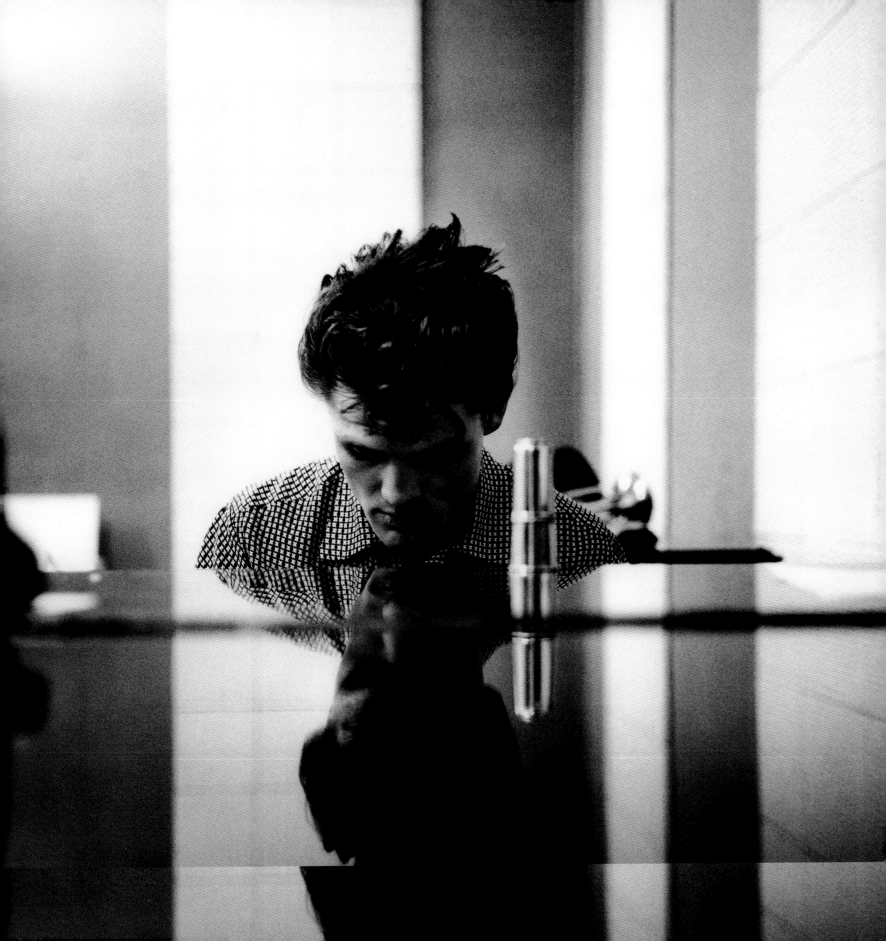

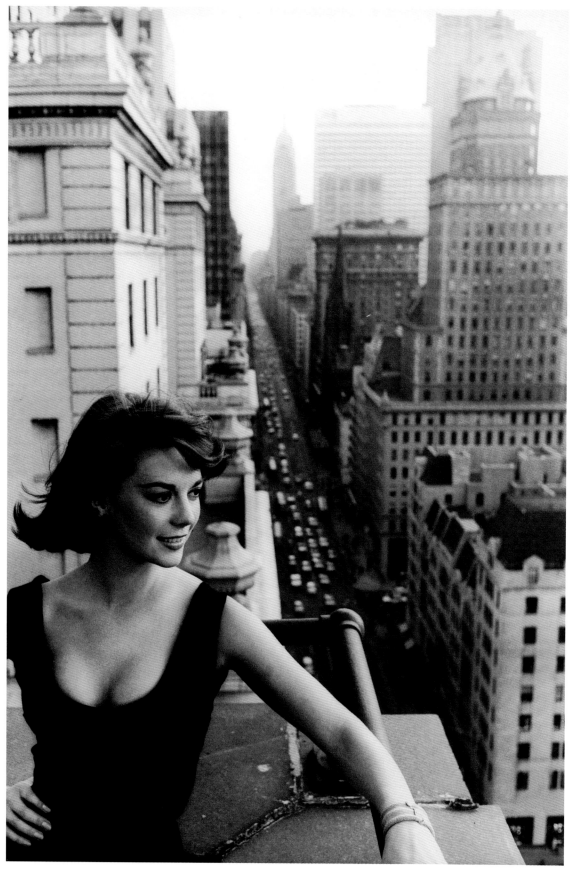

And find those qualities, he does. His portraits are a demonstration of the beauty he sees in people. "I hate ugly pictures of anybody. I am dedicated to beauty. I know there is beauty in all kinds of human beings. So, the act of finding and capturing that beauty is relatively easy for me." He states simply, "I am happiest when I can create a beautiful and poignant image of a subject." He is a master of capturing sex appeal as well, not only of the artist but of the musical instrument itself.

He has photographed the famous—writers, actors, directors, composers, artists, musicians, and fashion designers—as well as family and friends. Interestingly enough, his friends are often his subjects, and his subjects often become his friends. "Above all, my work is about friendship."

In these days of agents, lawyers, and stylists, Claxton clearly prefers the time when he was able to have an artist alone, to get to know them personally, enabling him to create more intimacy. He considers this his strength, "My ability to put a subject at ease and gain his complete trust." If given an opportunity, Claxton would love to photograph world leaders. "I'd like to get to know them well enough to capture their true personality on film."

His weak point is dealing with the finances surrounding his art. "I sometimes forget to bill a client when I'm so concerned with capturing the right photograph. That is why we have reps," he admits. Once, jazz musician Dan St. Marseille asked if Claxton would photograph him for his first CD. "I met with him and heard him play," he says. "He was so sincere and such a good musician that I agreed to shoot his pictures for just the cost of my materials." Later, the effort paid off. Dan composed a tune for Claxton, called "Claxography," in homage to the man he had grown to like.

When he's not shooting, Claxton loves to be in his darkroom. "Here I have a chance to discover and create all over again. Occasionally the shot I thought was so great is not all that fabulous. Perhaps another frame is more interesting when blown up, and an entirely new and exciting image begins to appear through the developer on the print paper. That's a visual surprise that can be rewarding."

Claxton has enjoyed a long and fruitful career. And if photography had not grabbed him at a young age, he is sure that he would have become "a happy musician." In his book, *Young Chet: The Young Chet Baker*, Claxton says it best: "Photography is jazz for the eye. All I ask you to do is listen with your eyes."

Natalie Wood, actor
"Shot in New York City, 1961. On an assignment for Paramount Pictures, I was asked to shoot some portraits of Natalie to be used for publicity for the film she was shooting with Steve McQueen called *Love With the Proper Stranger*. We shot a few set-ups in her hotel suite, but nothing really magical was happening. I suggested that we step out onto the balcony and try something. Wow, there was practically all of Fifth Avenue at our feet. Natalie in New York! It was so cold that we had less than two minutes to shoot before getting her back into the warm room. But that was all we needed—two minutes. It was shot with a Leica M3 with Plus X film."

Marlene Dietrich, performer.
Las Vegas, 1955.
"On an assignment for Columbia Records, I was asked to shoot glamorous shots of the legendary beauty. When I arrived at her dressing room, I was confronted with this small almost wizened, old (I thought) lady with a wisp of hair on the top of her head. With her heavy German accent, she instructed me to put my camera away and sit down next to her make-up table. She then went to work on her face, chatting with me and finding out all she could about me and how I work. After a long while, she snapped her fingers and her maid brought her wig over and they placed it carefully on her head and made a few adjustments. She looked quite gorgeous. Then she turned, smiled and said, 'You may now take out your camera.'"

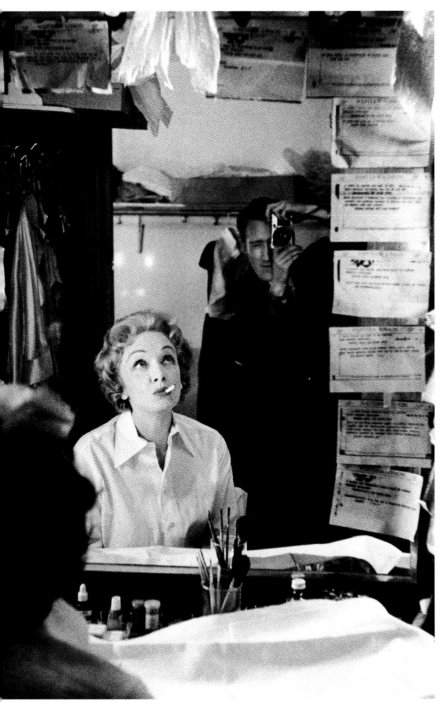

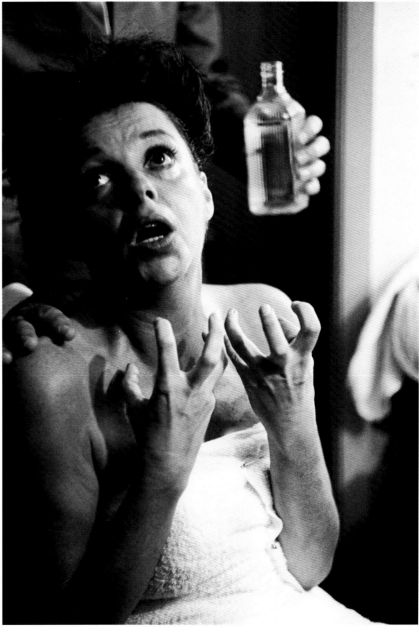

Judy Garland, performer.
"This was taken in Las Vegas in 1961. I was assigned by my agent to shoot a picture story of Judy for some tacky movie magazine. I jumped at the chance just to be with Judy Garland. There she was in her dressing room surrounded by agents, PR people, a make-up person, a masseuse, and a lot of hanger-ons. She was taking some kind of pills and washing them down with Liebfraumilch. She was a bundle of nerves, and the people around were trying to calm her down. At one point she grabbed a bottle of rubbing alcohol and started to drink from it when her make-up lady stopped her with, "No, no, Judy… not that!" After she was fully made-up and dressed, she magically stepped out onto the stage and began belting her first number, and she was, of course, wonderful and a big hit. I kept these personal and revealing images for myself. I didn't want a cheap movie fan magazine to print such a revealing a shot."

William Claxton

Craig Cutler

Within just a few years of opening his New York photography studio in 1987, Cutler became one of the most sought-after commercial photographers in the industry. He has created innovative campaigns for such high-profile clients as Rolex, Tiffany & Co., Bombay Gin, Hilton Hotels, Mercedes Benz, and received an array of prestigious awards.

Although widely recognized for his commercial success, Cutler is a prolific travel photographer and has compiled a large collection of work from assignments in Italy, France, England, and South America. He pursues travel to work on his own landscapes and portraiture.

Cutler studied for a degree in industrial design, then one day suddenly realized that he didn't want to sit at a desk for the rest of his life. "Any job [other than portrait photography] would probably kill me!" He likes that travel is part of his work. Cutler especially enjoys his career in photography because, "I have a very short attention span!" he says, laughing.

Until recently, Cutler avoided portrait photography as much as possible. "I travel a lot, and in my travels I would sit and wait for people not to be there. I had this thing in my head that I had to have these stark, empty places. After that crazy little phase, I started to wish that all those places I had been to, I had taken portraits.

"I just started to realize that I like taking people's portraits in different places and environments that I travel in, so I went 180 degrees in the opposite direction. Now when I travel, I have a hard time taking those pictures that I used to like to take. I just like taking portraits now. I can't explain it, but that's how it happened."

His quick wit and sense of humor makes him easy to like and able to gain the trust of the people he wants to shoot in his extensive travels quickly. "The portraits that I have been really focusing on are the ones where I find youth. I am fascinated with youth, the kids, the teenagers, and college kids. I like shooting the kids I have just met because it's so much fun. They have so much life ahead of them and it's in their eyes. Finding—no, stumbling upon—a person, and then talking to them a bit, and then finding a great location to shoot, that's what I try to capture right now."

When Cutler finds the perfect location with the perfect light, that's perfection. "I know it sounds like a cliché, but when you get those three elements: finding a very interesting person, and the light's very flattering, and then I work very hard on the background, even though my pictures don't come off like I do.

"When there is nothing in the background and then something peeks in, it all works together. When I find someone, I look frantically for a place to put them, and they think I am completely crazy, but it works. It's the location that has to come off looking almost secondary, subliminal to the portrait. A lot of people take pictures on location of people, but they just put them in a spot and, to me, it feels very snapshot-like. It almost works against them. They try to get that spontaneity without having taken it a step deeper."

Amanda *(facing opposite)*
"I was lucky enough to find Amanda walking down the street next to this old Buick in Austin, Texas. I thought they worked well together."

Byron and Courtney *(far right)*
"This very young couple just got married and live behind the hotel we were staying at in Quartzite, Arizona. The temperature in this small town goes above 110°F in the summer."

Samantha Delaport *(right)*
"Samantha lives along the coast from Le Havre, France, in a small family resort town. The mood of the town is quiet, tranquil and peaceful, which emanates from Samantha."

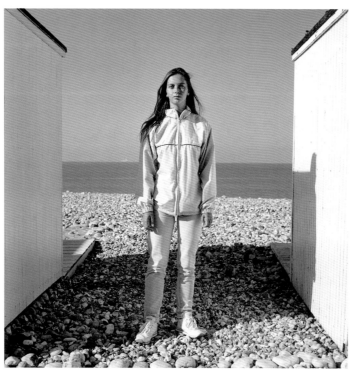

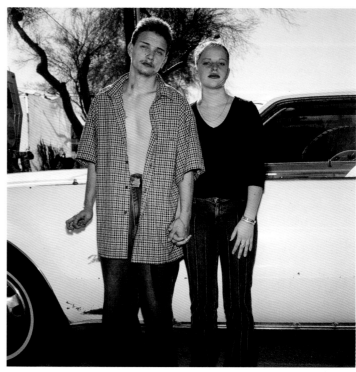

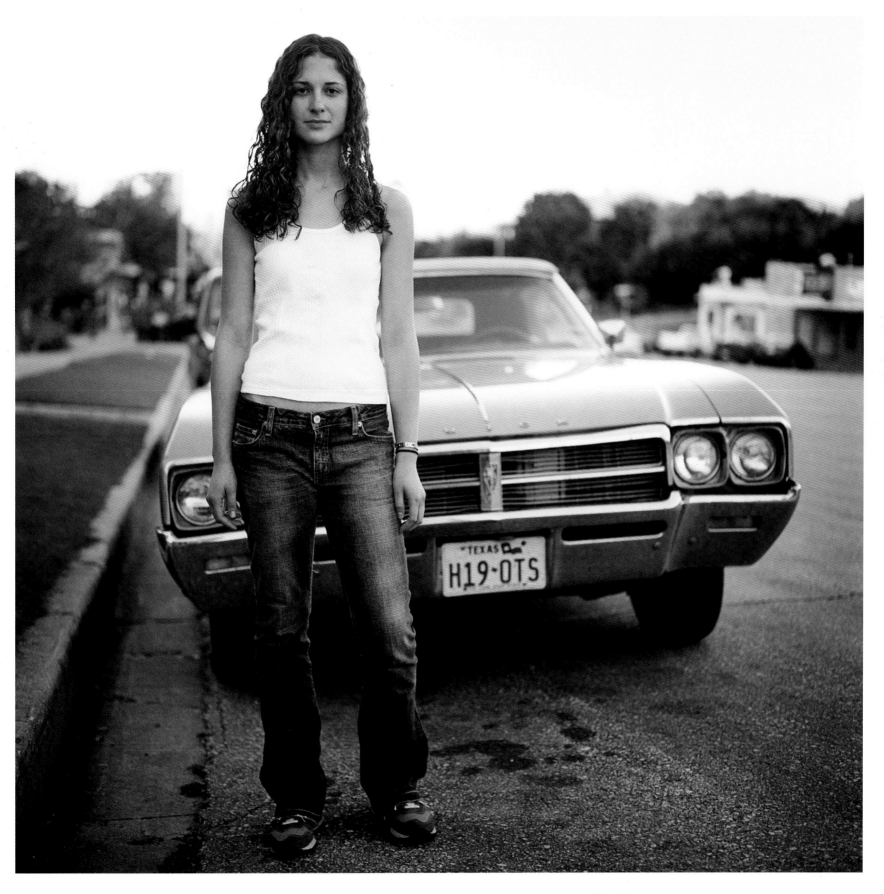

Craig Cutler

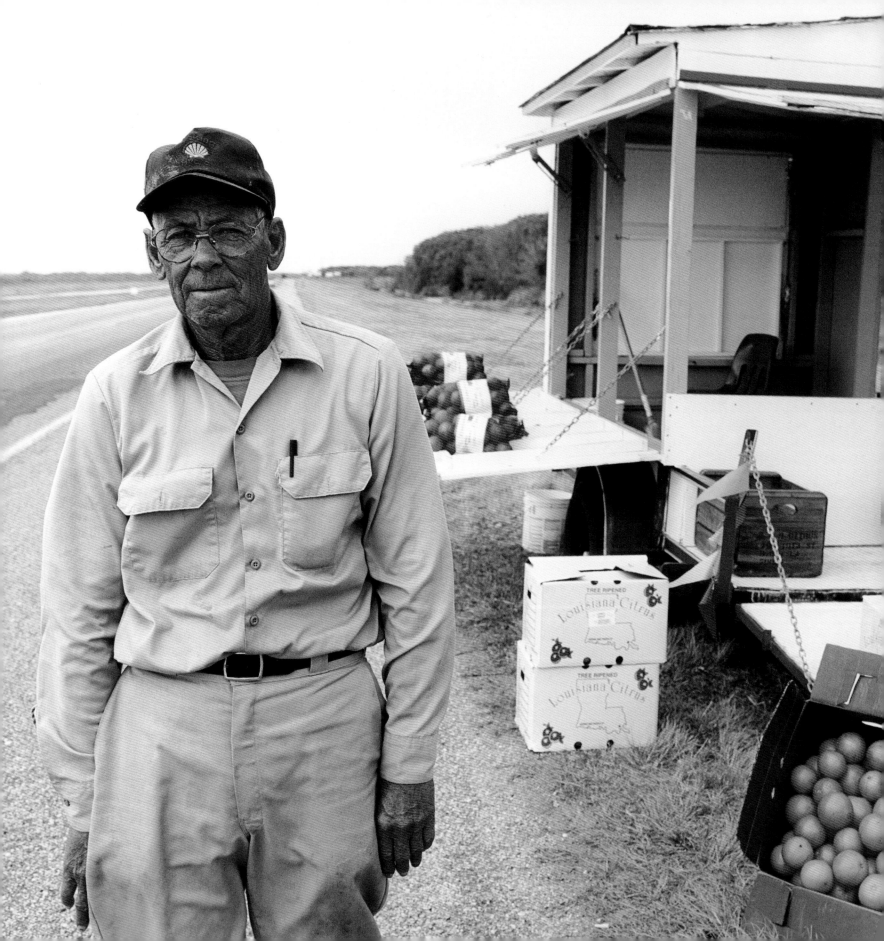

Hammer
"He goes by the name of
Hammer. He has lived and
worked in the orange grove
in Port Sulfur, Louisiana, all
his life."

When he travels, he goes on walking tours around entire cities and towns, and stumbles upon the people who become his portrait subjects. Holding no preconceived ideas of what he will find or what he is going to take pictures of, he finds the people perfect for his art. "I think that is what comes off in my pictures," he declares. There have been moments when he has seen someone he wants to take a picture of but doesn't act on it and has let them pass by, only to decide two minutes later that he wished he had stopped them.

Never one to stay static in one form of photographic expression, he confides, "I always get excited about the last picture I take and the next one is the one that I really like to get!"

To achieve the classic, signature look of his portraits, he explains, "I try to strip down the emotional expressions of a person, because I want to break them down to nothing and then I try to shoot almost no attitude in them. I just want you to look at the picture and observe, try to figure out who this person is, without feeling tension or happiness or sadness, or whatever it is. Breakdown the 'inner' of themselves."

"One of my all-time favorite photographers is Jacques Henri Lartigue because of the way he captures innocence." The other talented photographer that has had considerable influence on Cutler's career is Rineke Dijkstra. "I just came back from a show with six of Dijkstra's beautiful portraits. She shot these people on the beach, on the waterfront, which I found very striking. Perhaps the most amazing shots though, were these six portraits of a refugee girl that she had taken every two years in her apartment. She captures the innocence admirably." What Cutler most relates to in Dijkstra's work is that there are no gimmicks; you see the existing light and the portrait is all about the person. "Even though there might be something in the background, she has a beautiful way of framing something."

Given how Cutler so avoided portraiture in the beginning of his career, the story behind his first photograph is ironic. "I shot with this twin-lens Kodak camera. I took a picture of some people on a field trip to the Amish County and you weren't supposed to take pictures of the people, because they frowned upon that," he admits in a boyish manner. Surprisingly, perhaps, he finds great relief in the therapeutic nature of gardening and reveals, "If I hadn't become a photographer, I would have become a gardener. The best therapy in the world. I garden a lot, even though I'm not very good at it. I do love it. Chopping things, digging."

Eugenie Denoia
"Eugenie is of Moroccan
decent. I shot this in the
Luxembourg Gardens, Paris,
France. I love the way her hair
blends in with the fall foliage of
the gardens. I also think her eyes
are incredibly expressive."

Craig
"Craig is a young casino worker
in Las Vegas who I ran into
along the strip on a break."

Jenna
"Jenna plays in a band, but
thinks she wants to go back to
school to study art. For now
she is a hostess at the local
steakhouse in Las Vegas."

Craig Cutler

Terence Donovan

Terence Donovan was born in London's East End in 1936. Having quit school at the age of 11, he aimed to follow in the footsteps of his uncle, who was a lithographer, and so went on to study blockmaking at the London School of Engraving and Lithography. He then went to work in the photo department of a Fleet Street blockmaker. It was there that he discovered photography and fell in love with it. By the time he was 15 years old, he would force himself to go up to people and take their pictures. "I'd do anything that frightened me!" His advice to young photographers was always not to sneak a picture with a long lens—rather, to get a 35mm lens and walk right up to them, then get the shot.

As with many great photographers, Donovan learned most of what he knew by assisting the legends of his time, such as Michael Williams, John Adrian, and John French. During his national service he worked as a military photographer, and when his service was complete, he opened his own photography studio.

"Often imitated but never reproduced," is how one might describe Donovan's work. In the 1960s he became one of the infamous and avant-garde trio of photographers—dubbed by Cecil Beaton as "The Terrible Three"—to break into the scene. The other two were David Bailey and Brian Duffy. Donovan was known for capturing the image the public had of London at the time—having fun, having sex, having money. People believed that every photo shoot wound up with sex, and that the photographers must be the coolest and most charismatic people on the planet.

He was one of the first photographers shooting fashion to break new ground by taking the models out of the studio and onto the streets to capture the contrast between fashion and industry. He was able to see in so many different ways that expanding his locations was a natural step for him—a step that is imitated to this day.

His pictures for *Town* fashion magazine are what made Donovan's name in the industry. He also did regular work for *Queen, Vogue, Ellen,* and *Marie Claire*. Donovan became best known for his celebrity portraits, which included Jimi Hendrix, Margaret Thatcher, Princess Diana, and the Duchess of York.

In Donovan's 40-year career, he produced nearly one million photographs and more than 3,000 commercials and rock videos. Of the latter, perhaps the most memorable is the video for Robert Palmer's "Addicted To Love," where Donovan assembled tall, beautiful women, playing guitar, as a backdrop. He says, "I did something rather odd—I thought of it! It seemed to be a rather old-fashioned thing to do."

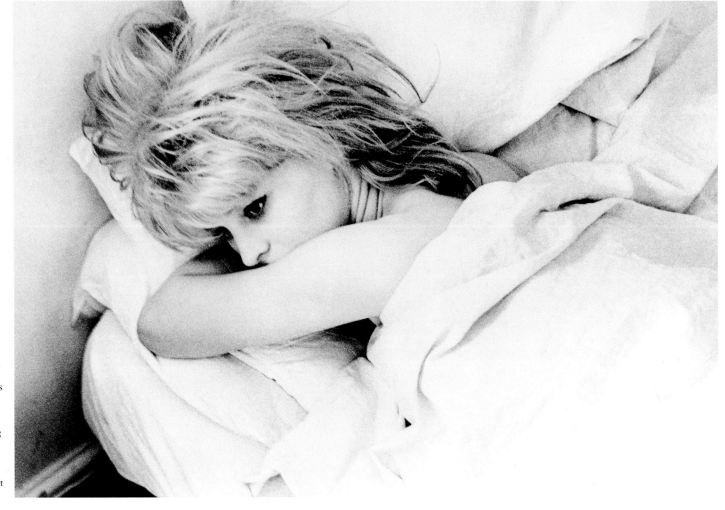

Julie Christie, actor
Julie Christie was born to British parents in India in 1941. She made her film debut in *Crooks Anonymous* in 1963, and just three years later won a Best Actress Oscar for her role in the era-defining film *Darling*. She followed this with acclaimed performances in films such as *Dr Zhivago*, *Far From The Madding Crowd*, and *Shampoo*. Christie received her third Oscar nomination in 1998 for *Afterglow*. She continues to work but has now swapped the glamor of Hollywood for the Welsh countryside. This portrait was shot in 1962.

His shoots were always relaxed and easygoing, and, with his stories and jokes, he was able to put everyone involved at great ease. He always made sure that the people enjoyed themselves as much as he did. Donovan often took time out of his busy schedule to meet with amateur photographers in the London area by going to local camera clubs. He once had an opportunity to speak with students at Manchester Polytechnic, where he delivered this very useful piece of advice: "You don't have to work for an employer. You have to find something you want to do, and get someone to pay you for it."

For many years, Donovan concentrated on his commercials and videos, which brought him great success and a great deal of money. Although distinguished as a portrait photographer, those who knew him laughed with him when he held up a wad of money and declared, "These are all the portraits I am interested in."

It wasn't until the 1990s that he decided to return to the world of shooting stills, and discovered that the art editors of magazines were far too young. "They've never heard of me," he would say, "or the Beatles!" So he started shooting stills again for others. Although through the years he always insisted to others that he was a craftsman and not an artist, he began to try to become an artist, for himself, during this time. His widow, Diana, remembers that he did sell a painting once. None of his paintings were for sale, but a friend saw it and wanted it, and so a deal was arranged. Diana recalls that she had never seen Donovan more thrilled to earn money than he was in that moment.

Tragically, Donovan died in 1996, leaving behind a world that still mourns the loss of his great talent. Shortly after his death, Diana and archivist Robin Muir (ex-picture editor at *Vogue*) worked non-stop on a retrospective of his work that is now seen all over the world, as well as a book of his images. Although in his lifetime Donovan rarely exhibited, Diana and Muir, the curator for the exhibition, felt it was important that his work be seen by anyone who wants to see it, and that the world experiences what a truly great photographer Donovan was.

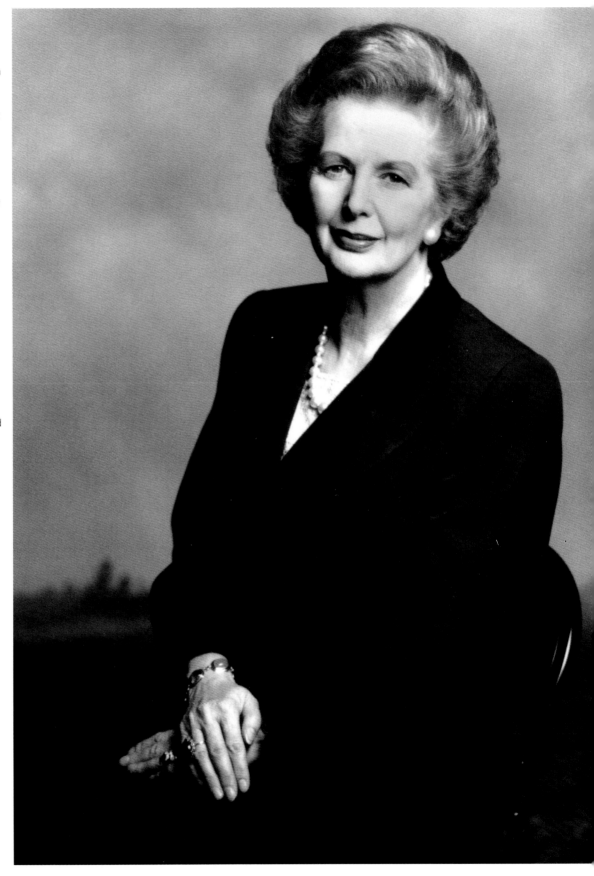

Margaret Thatcher, politician
Britain's formidable Prime Minister and leader of the Conservative party.

Terence Donovan

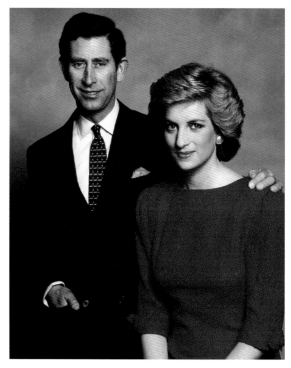

Prince Charles and Princess Diana
Charles and Diana in 1988. The couple married in July 1981 but divorced in 1996, shortly after their 15th wedding anniversary. Diana was tragically killed in a car crash in Paris in August, 1997.

Claudia Schiffer
Since she was discovered in the 1980s, the German supermodel has appeared on hundreds of magazine covers, and is one of the most successful models in the world.

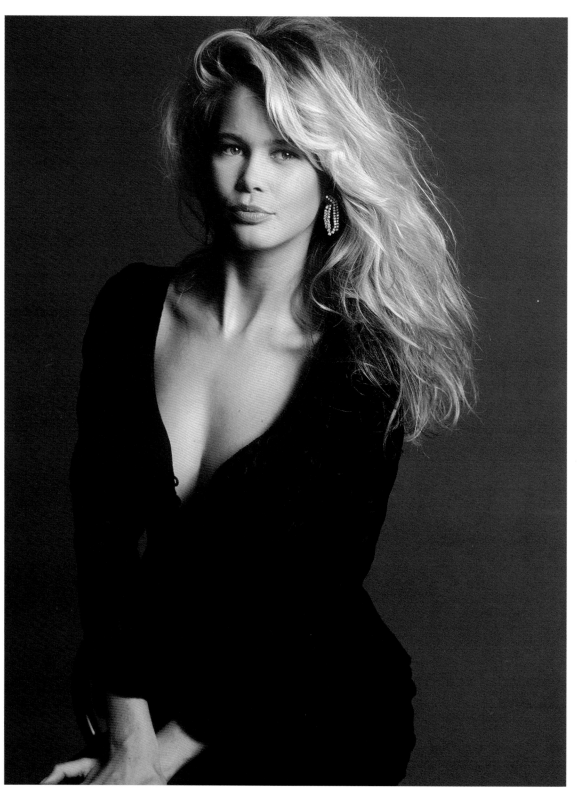

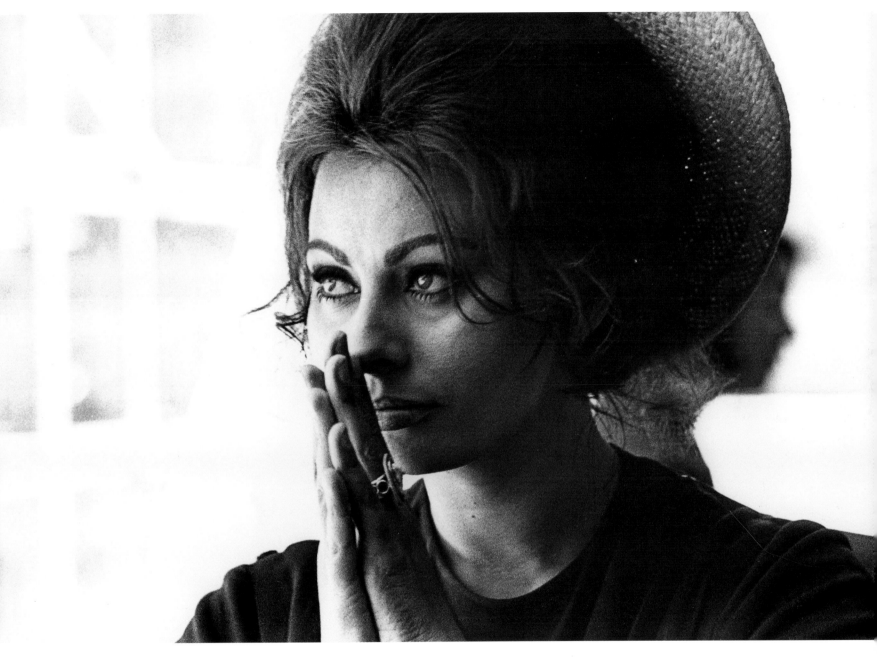

Sophia Loren
Sophia Loren was one of the true beauties of the twentieth century. Donovan was enamored with her, and she posed for him twice, in 1963 and 1965.

Terence Donovan

Tony Duran

While Tony Duran was studying business advertising at the University of Minnesota, he took a requisite course in photography during his last year as part of his major. He laughs at the irony when he describes it, now that he is the well-known photographer he is today. "I was the only person not to get an A," he recalls. "I think the teacher hated me because I asked too many questions." At the time, he had a friend in the class who didn't have time to do the assignments, so Duran would do them for him. "I would get As on all of those assignments under his name, but no As for me. Now the teacher is giving speeches about *me* at the school!"

Duran's first break in portrait photography came while he was still studying. A fellow student sitting next to him in an art class saw some of Duran's contact sheets and told him about a friend of his who was trying to break into modeling. Would Duran consider shooting him? Duran replied, "Sure, why not?" He enlisted the assistance of his sister to set up a studio at his fraternity house, then, using only the lamps around the house to light his subject, he took portraits that eventually won the model a contract with a major New York agency. To this day, Duran continues to use whatever resources are available at the time to shoot his portraits. "I like to make it go fast so I don't lose the energy of the person."

After college, a trusted friend suggested that they go and live in New York. "I had a couple of hundred bucks and said, 'Great, let's do it.' I got on a plane and moved to New York without a clue. As soon as I got there I got run over by a bus, and had to go home. I was in bed for about six months, then packed up and moved to Milan because my friend told me to go there." After that, Duran followed his friend to Greece, then Australia, supporting himself through photography. "I have no idea why I would've done that. I didn't know anything about photography, so I have no idea how I actually did it."

But he did do it, and since then he has never worked at anything other than photography. "I watched other people— they would say they wanted to be an artist or a painter, so they were waiters at night, or worked in stores. They ended up working their asses off just paying the rent with the stupid, measly money they got. They were too tired to do what they actually wanted to do. I promised myself I wouldn't let that happen to me." Working in Australia led him back to the States. "My agent in Australia was doing fashion, and she would say to me, 'You realize that you are at your best when you are just taking portraits.' I had to admit, I had thought that for many years." So Duran packed up and moved back to New York. Once ensconced in the "in your face every night, sensory overload," as Duran refers to New York, he couldn't take any more and moved to Los Angeles, where he has created a quiet haven. "I really do think that if I had stayed in New York I wouldn't have gotten half as far as I have."

Since Duran bought his first camera, he has shot with a Pentax 67, and that's all. "I've never changed films either. I wouldn't know how to load another camera or work with it!" he reveals. "I am going to start to play around with digital. It makes sense for me—I overshoot everything anyway. But there is something about the process of film that I love. My beef about digital is that you see certain images out there, and things are so digital and retouched that you lose the person in the process—lose the rawness and the touchability because it is just too perfect. It sounds stupid, but getting the contact sheets are the fun part. When I get a delivery from the lab, it's like a gift, and looking through them is fun."

Duran's photographs have a rough element to them, which he says is due to his ability to pull confidence and a connection out of a subject. "The skin tones are always apparent, and people usually have a good sheen on their skin. It's not all retouched or powdered, and that kind of stuff." Duran is able to bring out the raw sexiness of his subjects. "Not like an *FHM*-magazine kind of sexy—just timeless sexiness. I want to look at my pictures years from now

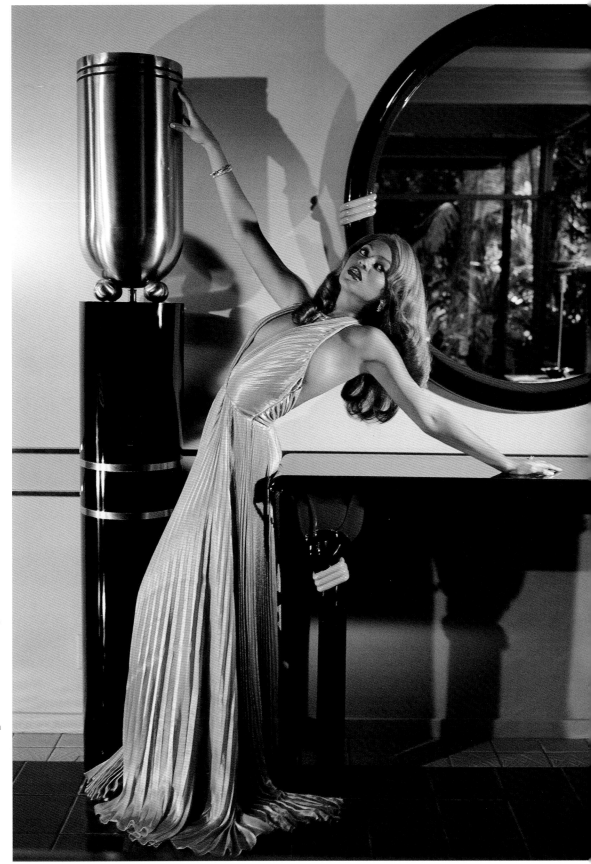

Beyoncé, musician
"We were shooting at Barbra Streisand's house, and there were so many locations that I wanted to shoot, but we had no time. In fact, we had only 45 minutes for the whole shoot. We finally found this little place, and by the time I was ready to take the picture there were so many people backed up behind me that I could hardly move: her people, their people, and their people's people. There was a room full of 30 people, all being really loud and no-one paying any attention. I shot with the shortest lens possible and just whipped off that shot in minutes. She couldn't even hear me because so many people were talking loudly and not caring. It looks like one of those really set-up, lit pictures, but it was actually a spur of the moment, two-second shot."

Tony Duran

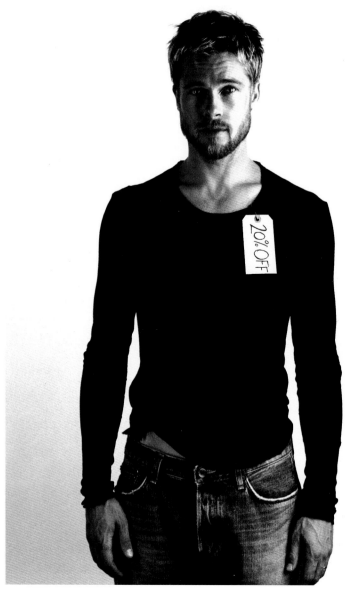

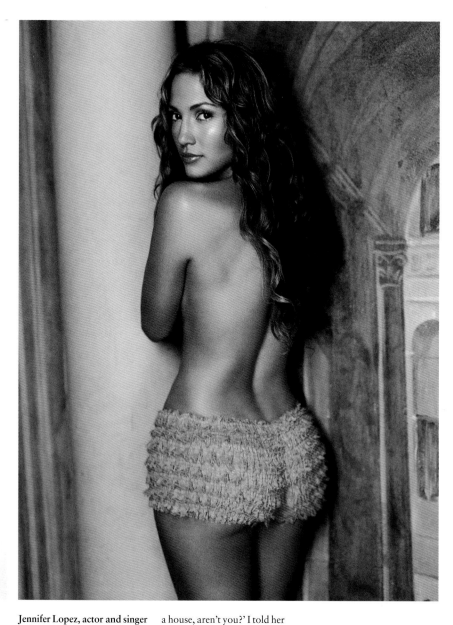

Brad Pitt, actor
"The tag says, '20% off.' It was supposed to be a post-September 11th cover for *Flaunt* magazine, and we were trying to think of a way to not make light of the situation, but make a bit of a fashion statement, too, as it's a fashion magazine. The cover was going to say, 'Times Are Tough,' and the next cover was going to be, 'We All Have Our Price.' At the time everyone was talking about him making $20 million dollars a picture, and putting the tag on him was a simple way to make a statement. It was my first shoot with him and he is such a nice guy—very low pressure, very easy."

Jennifer Lopez, actor and singer
"This was a shot in between shots. There are only two or three shots of her butt from behind like this in the world, and two of them I have. Considering that everybody talks about her butt all the time, it was kind of interesting. We were going through the house to switch outfits and she said to me, 'You're interested in buying a house, aren't you?' I told her yes and she said, 'Well, why don't we buy you a house!' Then she popped her top off and gave me two or three minutes to take this picture. It was such a huge selling picture for me over the course of the last two or three years that it really did help out with buying a house! It was shot in natural light with a little bounce with some silver."

Tom Cruise, actor

"He is sitting on the *Gilmore Girls* television show bench in the middle of a movie studio lot at midnight! The set happened to have snow on it, and it was the only set I could actually see at midnight because there were no lights. I couldn't really look around and see what other kinds of locations there were, so I went to the one that had bright light. I had 15 minutes to shoot him 'as is,' and he just came driving up in a golf cart and told me that he was Tom. I slapped my jacket on him and said, 'Sit on that bench, let's go!'"

and still say they are sexy, that they stand the test of time." Duran developed an interesting perspective on the work he does after the death of his most respected mentor, Helmut Newton. "I was having breakfast at Chateau Marmont on Sunset Boulevard, and I was talking about Newton—how he had lived in Australia for a long time, and no-one would work with him, but he just stuck to what he did and sold sex really well. And then all of a sudden his car crashed into a wall 20 feet from where we were sitting!" He returned home and started to concentrate on finding projects that interested him. "I really want to be one of those people that, 20 years from now, somebody looks at their pictures."

Among other photographers he admires is Herb Ritts. "He could bounce from advertising to fashion to celebrity stuff, and still keep the same image working for all genres." Michael Jansen has also inspired him.

Duran is wildly inventive in devising locations and interesting settings, and he is careful to always consider the personality of the subject. He is currently putting together a shoot for Tom Cruise, and having an obstacle course built, and every inch of it will be lit. "That will make it so no-one can come near him while we are shooting, and we will just go for 75 minutes straight. I'll bark orders, or coach him, because he responds well to that. I won't stop shooting for 75 minutes, and I will shoot hundreds of rolls of film."

Of the ups and downs, and in and outs of Duran's life and career, he honestly believes that his greatest accomplishment is, "Just making it through this. One second you're a loser, the next second everybody adores you and puts you on a pedestal, then the next second they pull it all out from under you."

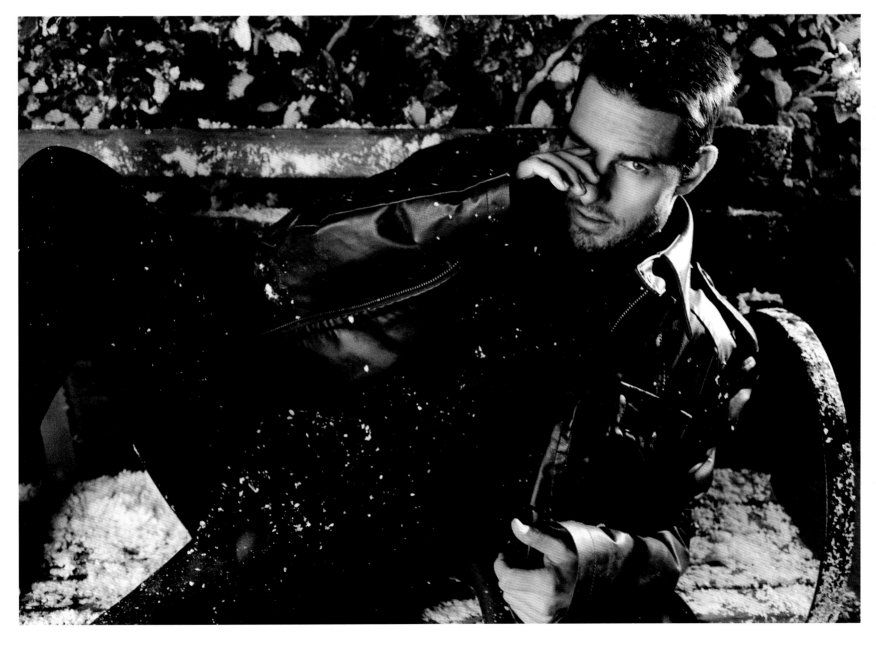

Tony Duran

Andrew
Eccles

Funnily enough, Andrew Eccles was somewhat afraid to take pictures of people when he was younger. "Back in art college I gravitated more toward still life and landscape photography," he says. The first shot that mattered for him came during that time. "I was hired to be the photographer on a small film starring Vincent Price in Toronto. The director told me to shoot with his Hasselblad. I had only handled one once, and at three in the morning someone yelled, 'Still photographer!' Terrified, I stood on a little stool and tried to take a picture of Mr Price. No matter how much I pushed the button, the camera would not fire. Mr Price finally leant into the lens, reached for the camera and pulled out the dark side. He couldn't have been kinder about the whole thing." Two weeks later the picture ended up on the cover of *Cinema Canada* magazine, and so Andrew's career as a portrait photographer had begun.

It wasn't until Eccles began assisting Annie Leibovitz in New York that he had the profound realization that portraiture was what he wanted to do. He assisted Leibovitz for three years, then spent another two assisting Stephen Meisel and Robert Mapplethorpe.

He considers his assisting work his "real" education, the place where he learned how to work with people and celebrities, and to deal with the extraordinary challenges of portraiture.

"I wouldn't be where I am today without the experience I gained by assisting Annie Leibovitz. I find it staggering how decade after decade she continues to take the most influential portraits in the world."

When Eccles was younger he was influenced by Irving Penn and Arnold Newman. "These days I love Dan Winters' stuff. I think Nigel Parry takes better black and white portraits than anyone, and I'm forever impressed how consistently brilliant Mark Selinger is."

Eccles established himself in New York as a professional photographer in 1987. His images have been seen on the covers of hundreds of magazines, including *Time, Life, Rolling Stone, The New York Times Magazine, Newsweek, ESPN,* and *Texas Monthly.* He also does advertising and publicity shoots for MGM, 20th Century Fox, Miramax, New Line Cinema, ABC, Sony Music, Atlantic Records, and Warner Bros.

One of the first big shoots he ever did, with famous Japanese art director Eiko Ishioka, revealed to Eccles something about himself that would be forever valuable. "We had models on Plexiglas stages in a pool, a backdrop hanging off the deep end, and more electricity around a body of water containing people than you would ever want to have. After hours of preparation I finally took the first Polaroid. Eiko looked at it and said, 'Andrew picture so safety!' I never forgot that and it still haunts me almost 20 years later. I think my pictures are too safe. I am getting a little more dangerous these days, but I need to work on going further with my concepts, my lighting, and especially what I demand of my subjects."

On having been named by *American Photo* magazine as one of the 100 most important people in the photography business in 1998, Eccles muses, "Having *American Photo* acknowledge me ultimately meant nothing, but felt great!" He says of his career, "I get paid to do what I would most certainly be doing in my spare time for free, and I've been fortunate enough to meet more people in two decades than many could imagine meeting in two lifetimes."

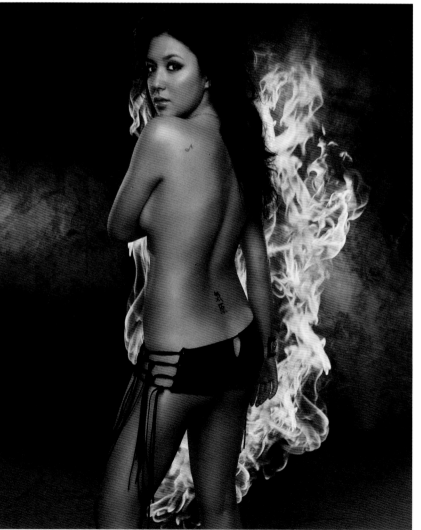

Michelle Branch, musician
"I'm excited about this portrait, and it's not for the reasons you may think! I feel that the lighting on this was really successful. I knew that fire was going to be added to the shot in post-production, so I needed to make it feel as though she was being lit from behind by the flames. I've tested a lot of different kinds of gels to put over lights and have come up with a combination that really feels like firelight. The other reason I like this shot is that Michelle's hit song 'Are You Happy Now?' is somehow illustrated by her attitude in this picture. All the other pop stars have relied upon their sexuality first and their talent second to get to the top. Michelle is a great singer/songwriter first and has now chosen to play with being sexy. I feel like she's earned her way into a position of power now and she'll take her clothes off if she damn well wants to!"

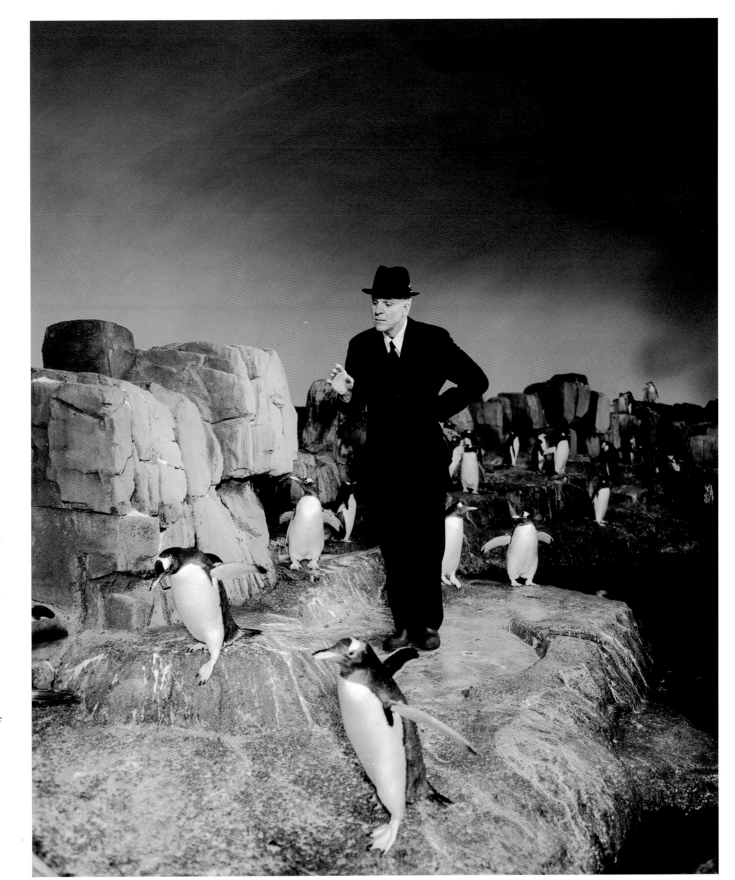

Steve Martin, actor.
"This photograph was one of a series of four shots I did of Steve for *Esquire* in 1994. The story was titled 'Lonely Guy' and concentrated on how Steve was dealing with life after getting divorced. I talked to Steve at least three times on the phone leading up to the shoot, being sure that he approved my concepts before the shoot day. My original thought was to have Steve standing in Central Park feeding pigeons with one penguin standing amongst them. When I inquired about getting a penguin from the zoo to our location they said, "You can't take a penguin out of the exhibit, but you can bring Steve in." They gave us 15 minutes. We had to wear rubber boots up to our knees because they peck. It smelled unbelievably bad and was freezing cold. I had no time for Polaroids so I bounced a strobe off the ceiling, said a Hail Mary and hoped for the best. I shot it with the now discontinued VHC negative film and cross processed it to chrome. It's one of my favorite shots."

Andrew Eccles

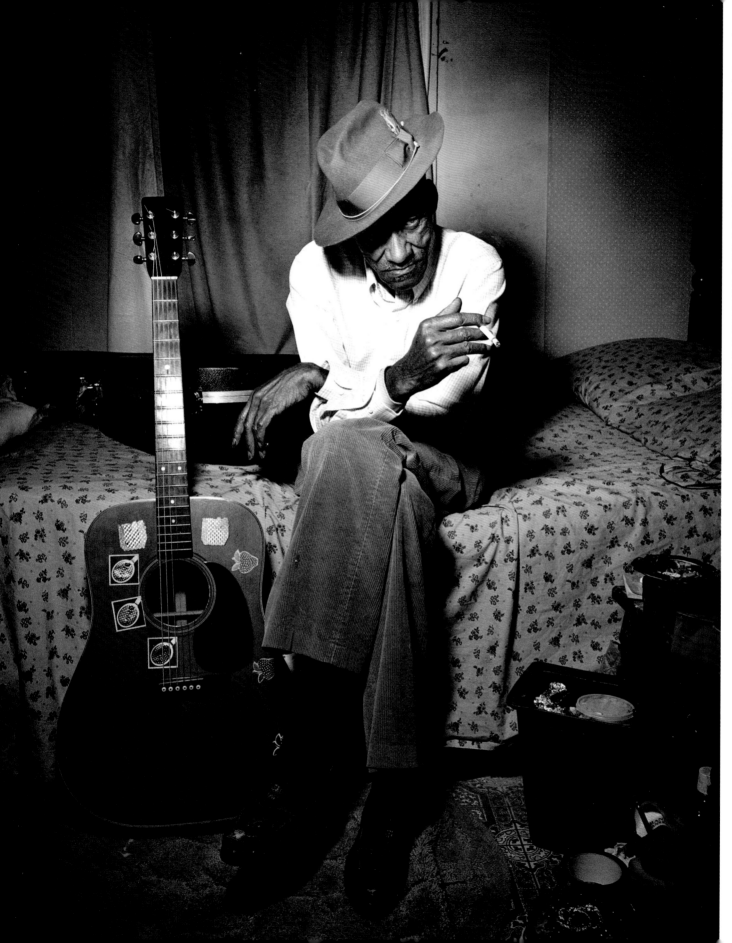

James "Son" Thomas, artist and musician.
"I was in Leland, Mississippi, as part of an assignment for *Art and Antiques* magazine featuring 'Outsider Artists.' 'Son,' a brilliant self-taught artist and somewhat well-known blues musician, was being equally exploited by both the art world and music industry. He and the others in the story were having their life's work bought up for nothing and resold at astronomical profit. They were famous among gallery goers in New York and didn't even know it. I tried to explain to Son as best I could that his work was being sold for a lot of money up north and to not let dealers offer him too little. He just told me that all he knew was that his gas bill was $50 a month and if they offer him $50, he's not going to say no. Despite his humble surroundings and destitute circumstances, he might be as elegant and sophisticated a man as I've ever photographed. It was lit with one strobe and a handmade cardboard snoot."

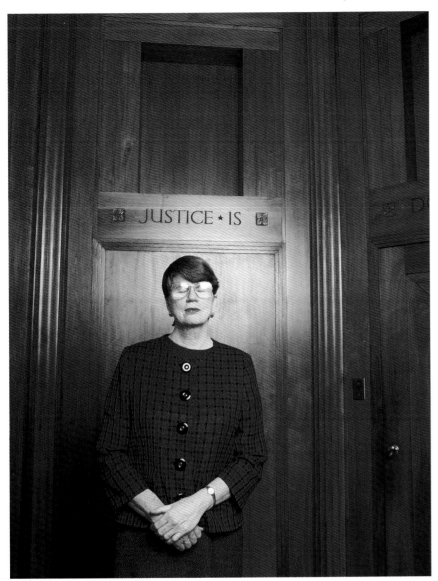

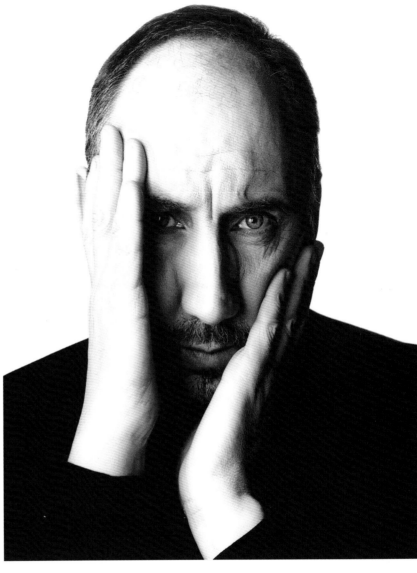

Janet Reno,
US Attorney General
"Some portraits turn out to be great ones and it's not always intentional. That was the case with this portrait of Janet Reno. I was shooting her for *The New York Sunday Times Magazine* and was given about half an hour at the Attorney General's office. It was a terribly uninspired space, but I found this little room, more like an entry hall, that was circular, wooden and had six closed doors. Above the doors was a quote, which I can't remember now, carved into the paneling. The words 'justice is' stood out to me, so when Ms. Reno arrived I asked her to stand beneath those words. When I got the film back I was horrified. She had blinked and her eyes were closed in every single frame! It only took a minute for me to realize the beauty of my misfortune."

Pete Townsend, musician
"After getting over the initial fear of working with one of music's greatest legends, I got to the task of photographing Pete the way he had asked me to. He had recorded a new rock opera titled *Psychoderelict* and wanted to venture into the area of insecurity he was feeling about getting and looking older. We took extremely honest pictures that day and although Pete called me to tell me how good he thought they were, he confided in me that he wasn't brave enough to run them on the CD cover. He ended up blurring an image in the computer, rendering himself virtually unrecognizable in the final shot. The photograph may be more poignant now, after all that has happened to Pete since it was taken."

Andrew Eccles

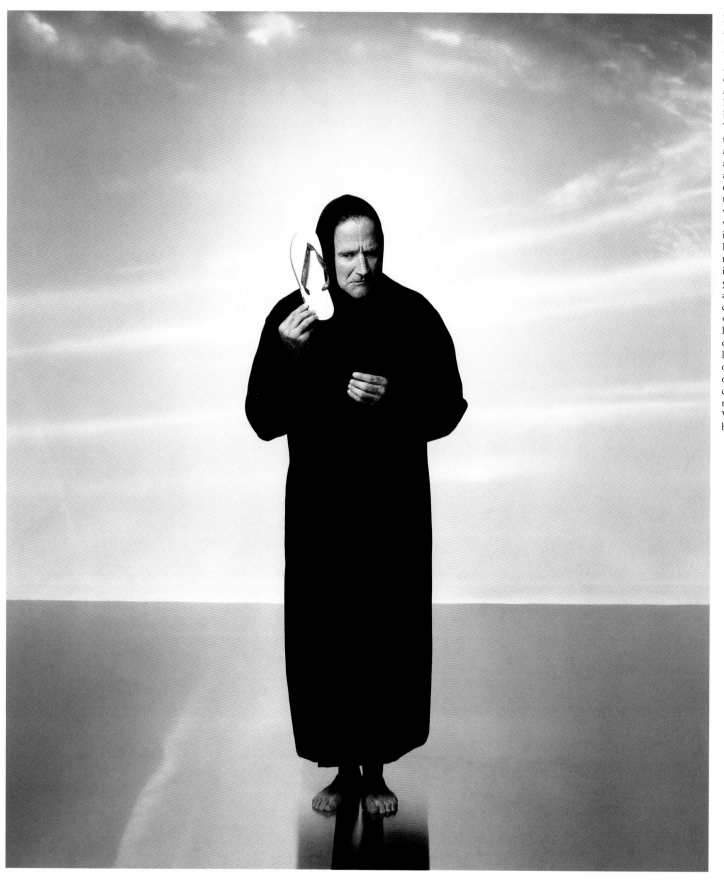

Robin Williams, actor and comedian.
"A year prior to the millennium, *The New York Sunday Times Magazine* hosted a worldwide design competition to create a time capsule that would be buried in the year 2000 and not be reopened until the year 3000. To help illustrate the concept they selected Robin Williams as their cover subject. We filled a photo studio with props, all actual contents of the time capsule, and gave them to Robin to play with. Some of the items were mundane articles that were from our everyday lives, including this flip-flop or thong. I almost wish someone had taped the session. Robin was to illustrate the idea of a man in the year 3000 opening the capsule and reacting to some of its contents. There were times when I could barely focus from laughing. As outrageous as most of the shots were, I ended up liking the quiet comedy of this one the most. That day felt like one of those MasterCard commercials—camera $2,000, roll of film $25, watching Robin Williams perform for two hours… priceless!"

Eccles continues to be fascinated by the work and the vast array of subjects he is privileged to interact with. "I've worked with athletes that I idolized when growing up, musicians that influenced me in high school, actors and actresses who have made me laugh and cry. I've been to the White House twice to photograph two presidents. I get to shoot supermodels! I've been to Hawaii, Alaska, China, and Africa on assignment. There is a lot to like about what I do."

One of the reasons he is continually sought after is his ability to ease his subjects through the awkward and often uncomfortable experience of being photographed. "It's scary out there in front of the camera, and your subject should never feel alone." This talent, combined with his finesse and skill at lighting, makes his subjects look comfortable, approachable, and beautiful, which keeps the work coming.

He loves portraiture. "It's probably as intimate a relationship as you can have without touching someone, and it can still be quite terrifying at times in that 'first date' kind of way. But there are moments, the rare epiphany when everything comes together for a fraction of a second; when the subject, the light, the composition are all better than you could have imagined. It can happen accidentally, but it's almost more rewarding when the attempt was intentional," Eccles reveals. "It's that feeling when you've taken a picture so beautiful, powerful, clever or funny, that someone is genuinely moved to feel something that they weren't feeling until they saw the picture. Or simply when you can frame a picture, hang it on a wall, stand back, and say, 'yup, that's a good one.'"

When Pete Townsend was asked by Eccles why he selected him to shoot his album cover, Townsend told him, "The record company kept shoving different books at me and I kept coming back to yours, it was the only one that was honest." Eccles, though honored, isn't sure how accurate Townsend's observation is but does say, "I don't use photography as a way of disguising the truth the way some do. I think my better pictures are fairly memorable. I tend to keep my compositions free of visual clutter so that the viewer is better able to concentrate on the subject. They are usually well lit and sharp."

There are many actors who Eccles would like to shoot, but what he most likes is personal work. "In the past I've done portraits in the deep South, covered the oil spill in Valdez and photographed poor 'outsider artists' being exploited by wealthy gallery owners. When I'm not shooting the rich and famous, I am attracted to making photographs of those who are struggling in the naïve hope that the pictures could bring about some kind of positive change for them."

Kim Cattrall, actor
"Kim was inspired by some photographs of Brigitte Bardot she had seen and wondered if we might be able to photograph her in a similar way. I felt that her connection to Bardot was an insightful one, especially considering her portrayal of the equally liberated Samantha in *Sex and the City*. Technically, I think we captured something that feels as if it could have been shot three or four decades ago, but what I particularly like is the connected expression in Kim's eyes. Some of the sexiest photographs I have ever taken have nothing to do with how much skin is showing—it has much more to do with the look in someone's eyes."

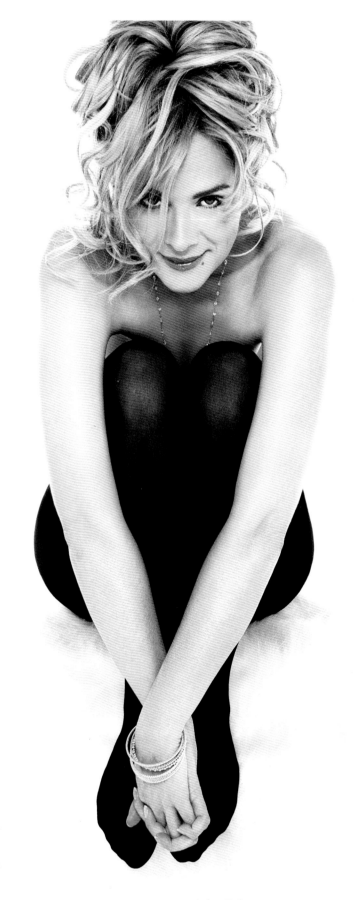

Andrew Eccles

Larry Fink

Larry Fink has been a photographer for over 40 years, and fondly remembers the very first picture he took. "I was 13 and it was daffodils on my mommy and daddy's front lawn. I developed them with a friend and fellow hobbyist from across the street. My mother thought that it was on par with Durer, the fifteenth-century artist and etcher, in its description. I remember that picture was really lousy and hardly on a par with Durer, but my mother loved me and wanted me to do the best, so she couldn't help but fantasize!"

He has become what his mother saw for him, a brilliant photographer whose career has spanned across the decades in all media and around the world. Currently he is a tenured Professor of Photography at Bard College, New York, has more than 60 prints in the permanent collection of the Museum of Modern Art in New York, received two Guggenheim fellowships, two National Endowment for the Arts endowments, and a career retrospective touring the museums of Europe.

In addition to these major accomplishments, Fink is under contract to Condé Nast and works for *Vanity Fair*, *The New Yorker*, *GQ*, and *The New York Times Magazine*. His advertising portfolio includes such international clients as Cunard, Chivas Regal, Smirnoff, Godiva, Nike, and MasterCard.

He loves great questions, asking them as well as being asked. "What is a portrait?" he muses. "Somebody comes to the studio or a photographer comes to someone's home to make a portrait, to portray. What does portray mean? Does it mean context or does it mean the internalization of a soul in its external factors. What is a portrait? There is only a question about the question. I am not a portrait photographer, I am a photographer who seeks to portray people and bring forth their essence."

Fink is humorous and light about his work and his art, as well as being touching and insightful. "I like what I do because I am an animal and like any other animal, complex as we may be in abstraction, we also like to sniff each other. So a cat or a snake makes a portrait by smell or touch or intuition or impulse, but we, being more complex, try to find the soul of the other, and transform it into matter."

This winning combination of the deeply philosophical and analytical has brought Fink much of his success and although he considers fickleness to be a pitfall in his personal life, he says, "Fickleness is not necessarily bad in a photographer. If, indeed, you fall in love with everything that you perceive or see or experience, then you can track formative gestures and possibly a good photograph manifests out of that ."

He loves photographing people who match his emotional energy and complexity. "People who really put a magnet inside my mind and my heart and pull me as hard as I would pull them. Those people don't necessarily have to be a celebrity, or anybody that we know of in the intellectual or social forum. They can be farmers, but because of the manifestation of their energy, their soul, and upbringing, they live life with an attitude and a spirit which is transformational."

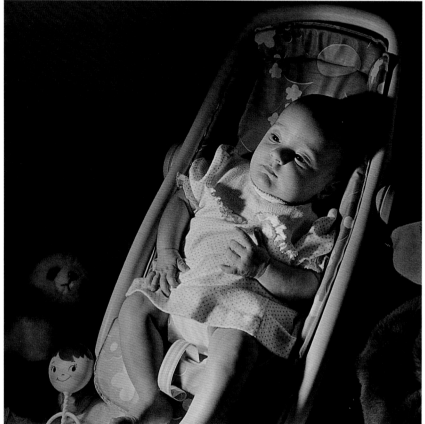

Molly
Aged 3 months, 8/79.

Norman Caplan and Molly Fink
(*facing opposite*)
Hardinsburg, KY, 10/2001.

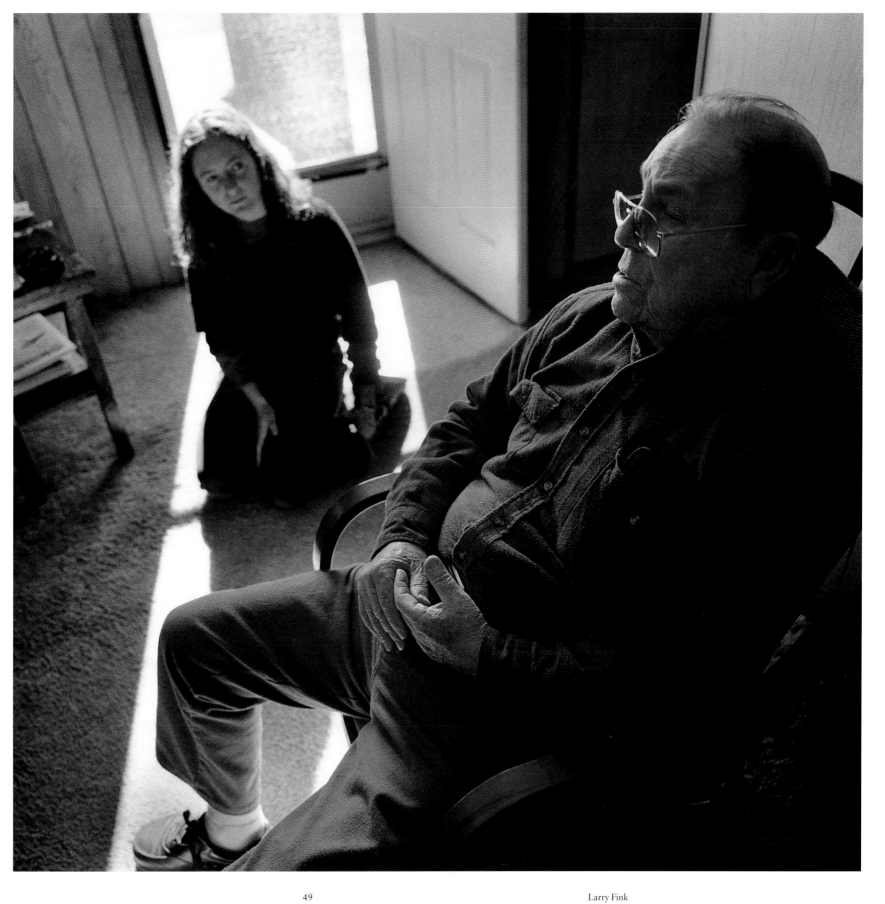

Larry Fink

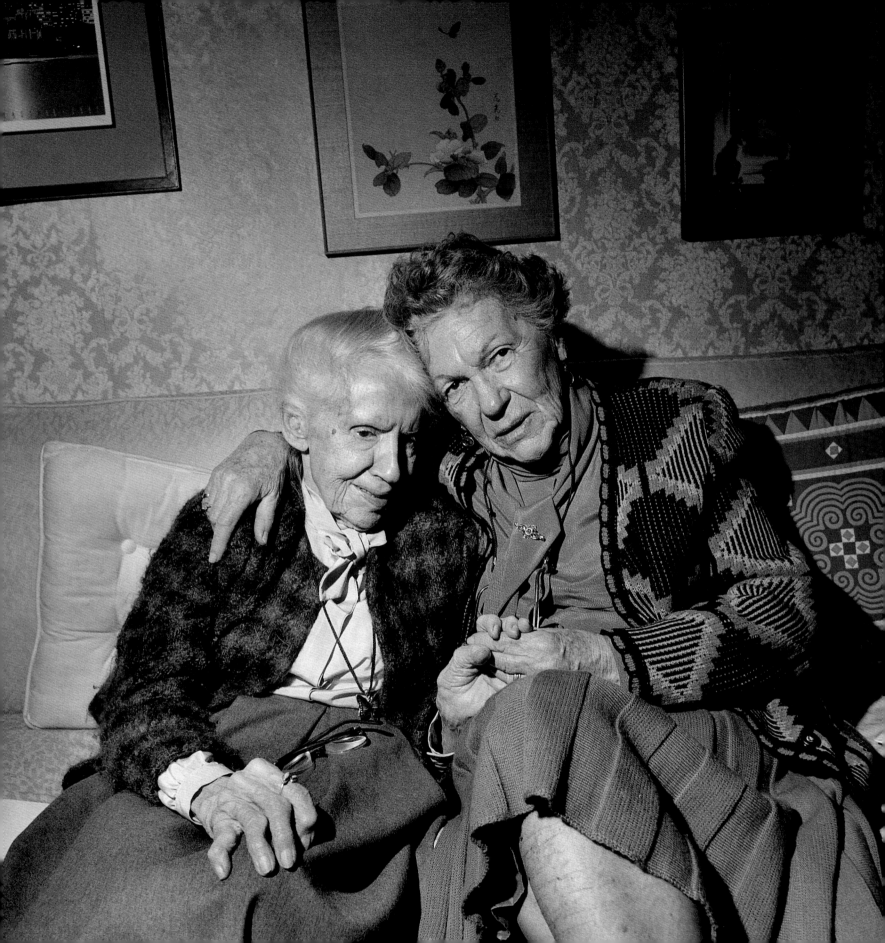

Self-portrait with Molly
10/82.

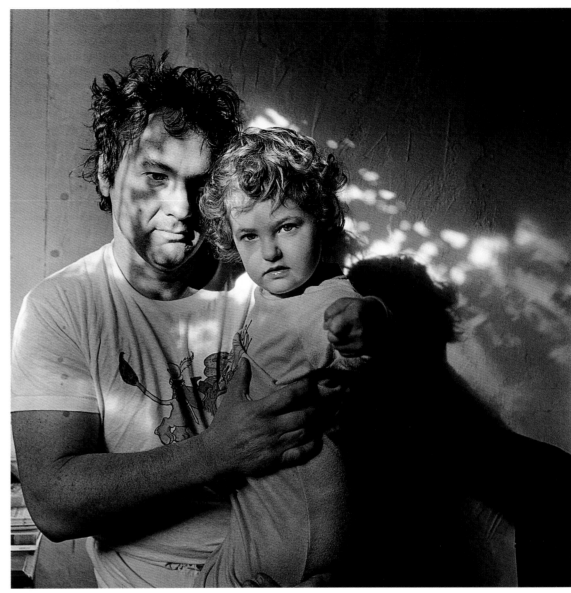

When Fink speaks of his work, he realizes that he is known for highly emotive and dramatic pictures. "The photographs I am known for, their style is done with a kind of mask, a flash, high drama, and so forth. The photographs seen on these pages are more of my family, so they are more familial, however they exhibit the dramatic tendencies."

"There is something to do about style, and the style of course is something which is developed out of a need. If style is only developed for style itself it becomes a commodified look and something which we can rely on, but not necessarily anything that reveals anything much. Hopefully these pictures, and the pictures that I make in the world, are imbued with style; not because I am a 'stylish' guy, but because I have a deep and distinct need to transfer what it is that I experience in front of my face, in such a physical way, to the printed image, so that it somehow or another begets the same, or at least a similar kind of physical and spiritual resonance. I hope my pictures are alive."

Fink admires the work of many younger photographers. "Mitch Epstein comes to mind and I admire Steven Shore, a colleague at Bard College. I certainly admire Robert Frank, for his romantic, pessimistic soul and his unbelievable insight in to how to make that soul ring true within the parameters of a picture."

There are many others Fink admires, from his first teacher, Lisette Model, to Henri Cartier-Bresson, to Brassai. Born in 1941, he was a second-generation beatnik, right on the cusp of the social revolution of the 1960s. "I was born into the right time. I had no alternative but to do what I did; it was an obsession with me from the very onset." He ponders about what might have happened if photography hadn't called to him so powerfully. " I might have become a criminal," he supposes. "In the early days, I was up to no good at all. I was a young fellow who was stealing cars, getting kicked out of school, taking narcotics, and basically being anti-social in extreme degrees. I was also a nice kid, kind, and I was smart, but I was bored. Or, maybe I'd have been a doctor, because the solutions and conclusions are so profoundly human, not necessarily simple in technique, but simple in the sense of meaning. Then again, I could have been a tractor driver! There are a lot of things, but I am a photographer and I am a teacher."

When asked about his greatest achievement, Fink replies, "The greatest achievement that I have is to be alive and to somehow or another be able to share whatever it is I have inside myself with others, and to be able to impart to my students (and to whomever) a sense of mission, clarity, and kindness, and to be consistent in that regard." Fink considers that every subject has its own quality and there is no best or worst. "It's another critter out there that you are interested in for at least a moment or two, or an hour, a week, or a year, and you just try to do their humanity and their mystery some service."

Patrick Fraser

Raised in Norwich, England, Patrick Fraser graduated with a degree in Fine Art from Oxford Brooks University in 1995. As a child, his father would hand Patrick his Yashica camera on family holidays in France and he would take the pictures. At some point Patrick realized that he was never in any of the shots because he had become the shooter, so when he was around 14, his father bought him his very own Pentax SLR. "That camera had no built-in light meter, so I just guessed the exposure, the best way to learn I suppose—by looking."

He majored in painting in his fine arts degree, but after a trip to India during the summer of his first year at Oxford, he became very excited about the potential of photography. "I came back with all these intense portraits of Indian men and women I had met. I used mostly black and white film on that trip." He discovered that he really enjoyed taking pictures of people, all kinds of people.

It didn't take Fraser long to immerse himself in the world of professional portraiture, albeit via a unique entrance. "I got a tip from a friend that Rankin needed another pair of hands and got a job working on a few shoots there in his studio in the back office. One day I was painting the walls in the studio bathroom when it hit me that perhaps I should start shooting, make a book, and hire someone else to paint my studio bathroom." For four years he assisted and, as with many burgeoning photographers, he found it to be incredibly beneficial. "You can learn a lot from assisting. It's free training—in fact, you get paid to learn."

When he was 26 years old, partly sponsored by a grant from the Ashmolean Museum in Oxford, Fraser embarked on a nine-month photographic expedition along the ancient Silk Road, visiting China, Pakistan, India, Iran, and Turkey, with his friend Will. For Fraser, this was a tremendously triumphant experience and a magnificent accomplishment.

Robert Evans, producer, author, and film-maker
"I had read that Evans was really into tennis. I turned up to his house in a tow truck as my car broke down on the way to the shoot. Evans was already sitting by his pool and in make-up at his infamous house. When we got on to the subject of tennis, which I also enjoy, we hit it off straight away. He started lengthy stories about when Connors used to play on his court near the screening room. I decided then to do the tennis court shot and he was really into the idea."

Mamiya RZ, 65mm lens.

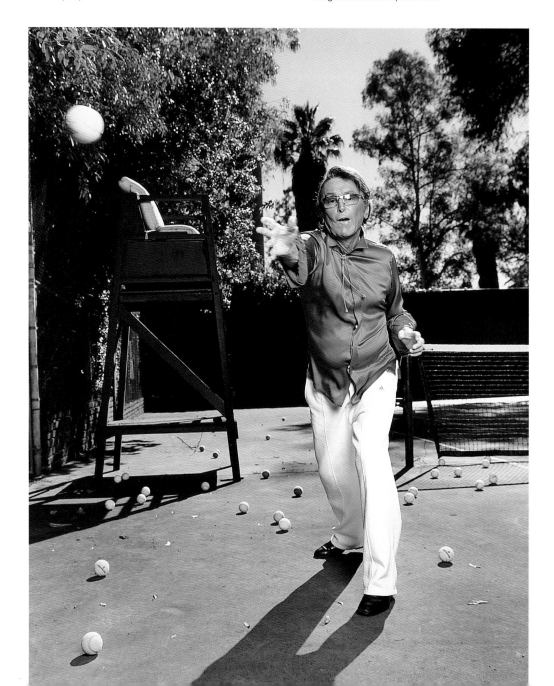

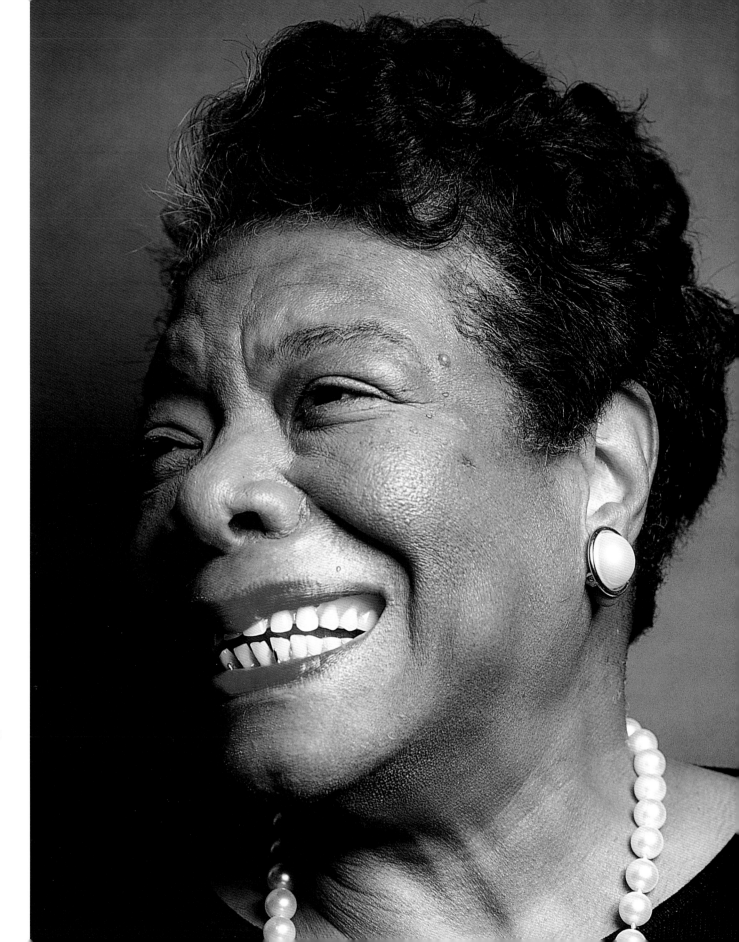

Maya Angelou, writer
"I had a short amount of time with Maya Angelou in a hotel room in Santa Monica on her press tour for her new book. I was called by *Weekend* in London early the same morning and by 12 noon I had completed the cover shoot. I remember her being extremely formal and polite and she is the only person ever to call me Mr Fraser during a shoot."

Mamiya RZ 6x7cm, 140mm lens.

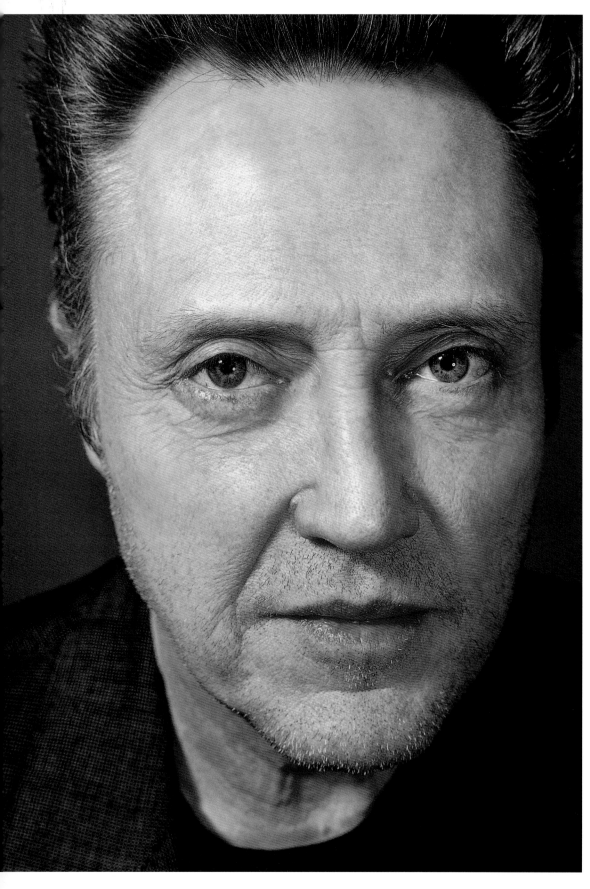

Christopher Walken, actor.
"I had no idea what to expect from the shoot with Walken. I had heard that he does very little press and this was a rare occasion. The shoot was for a feature which came out with the Spielberg movie, *Catch Me If You Can*. It turned out that Walken was in the middle of shooting a movie in Brazil and was in LA for just a few days. I felt he was still in character and had his mind on his job. He asked me to count to three and he looked round and I clicked, that's how he wanted it done."

Mamiya RZ 6x7cm, 110 lens.

Penny, Wyoming rancher
"I flew up to Gillette, Wyoming, to illustrate a feature on methane drilling in Wyoming. I had to locate five ranchers who lived around Gillette over a three-day period. I remember the driving distances to be huge and when I did set up, the wind out there was mighty strong which caused my light to blow over a few times while I was shooting. The magazine wanted individual portraits of every rancher. Penny had a great face and for me represented a real hard-working American."

Mamiya RZ, 6x7cm, 65mm lens.

After that, the wide-open spaces of the American landscape, including all of its freeway intersections, cheeseburgers, and positive attitudes, drew him to Venice Beach in Los Angeles, where he now lives. "I like to respond to what is put in front of me. I don't mind if it's the janitor or Christopher Walken. Also, the contrast between the man-made and nature interests me. I have always been curious. I am just as turned on by a freeway intersection in Los Angeles as the wide-open planes that lie at the foot of Mt. Ararat in eastern Turkey."

A blend of skill, curiosity, humor, and respect have earned him a reputation for shooting portraits that are "classic with a twist." Fraser's style is much sought after by clients such as *Rolling Stone* and *Interview*, as well as fashion clients and celebrities.

There are many things that Fraser likes about his work, but first and foremost, "I like the idea of starting a day's work with a blank canvas." He loves capturing a special moment in time and has compiled a notebook full of story ideas. "I try to capture humor, spontaneity, and energy in my pictures. Sometimes I have to draw this out of the subject, but when you get a glimmer it can make the pictures shine." Among his favorite qualities in any subject is a genuine personality, one that he can pick up through the lens.

He also loves trying to shoot something in a slightly different way. "It might be a new lighting set-up, paper color, or using a location I saw when I was driving. When I look at my images together, say on a website, I see a common thread. But, ultimately, they are all separate moments in time shot by the same person."

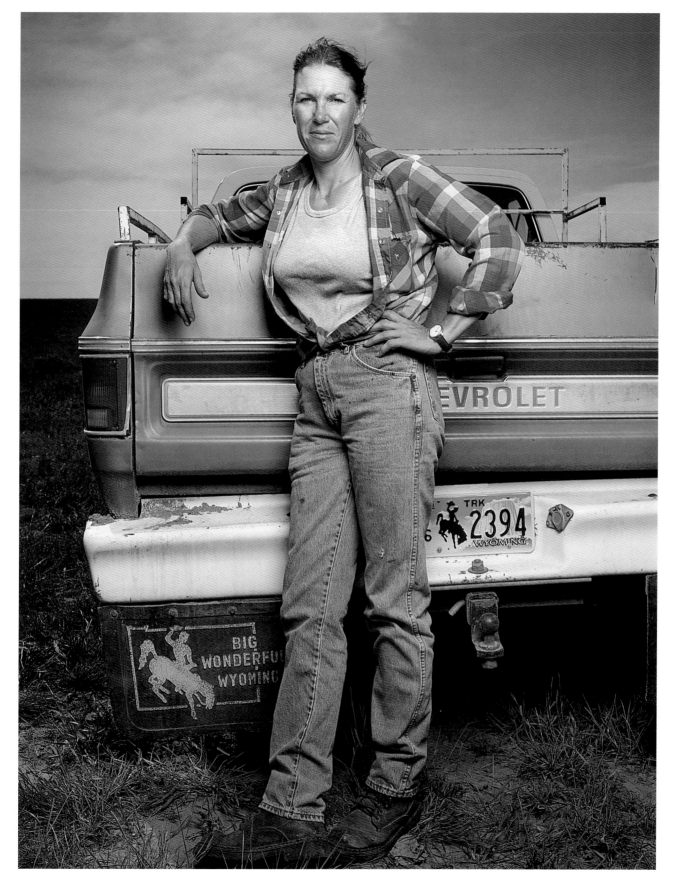

Patrick Fraser

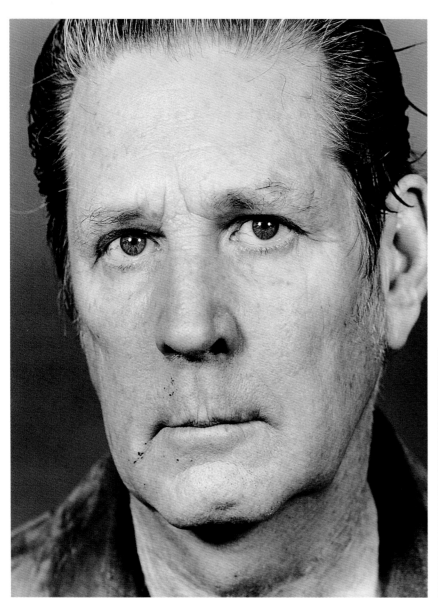

Among the stellar personalities he has worked with to establish a unique portrait, his favorites include Morgan Freeman, Maya Angelou, Brian Wilson, and Christopher Walken. He would also love to shoot Al Pacino, David Bowie, and, given his admiration for Magnum photographers, it is no surprise that Mongolian Nomads are on his wish list.

To keep things simple, Fraser carries only the equipment that he knows will get the job done, that is his RZ 6 x 7, Rolleiflex, and his Leica M6. As far as his book goes he loves to mix it up with his portrait, music, and fashion work. "I find that the image you least expect the client to like is the one they rave about and remember you for. You never know. I show what I consider to be my best pictures. I want the pictures to speak for themselves."

Fraser is a pretty funny guy, which is epitomized by the glib advice he has for young photographers just starting out in the business of photography: "Check and see if you don't have a trust fund you didn't know about. If you're a woman, find a rich lawyer to marry: if you're a guy, ditto!" But he urges those at the start to remember, "You are as good as your last job and if your work is a high standard, clients come back for more."

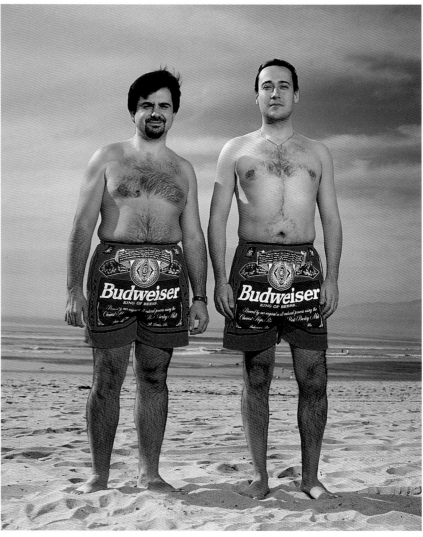

Brian Wilson, musician.
"This shot was the last set-up from a shoot I did at Brian Wilson's home in Bel Air. I remember all his little poodle dogs running around the house while I was setting up three sets. The most memorable experience on this shoot was setting up a light in Brian's music room while he played Beatles covers on his piano. I was determined to shoot tight on his face as I knew his eyes would tell some stories from the past."

Mamiya RZ 6x7cm, 140mm lens.

Italian tourists
"This shot came about from having a walk on Venice Beach. I spotted these two guys by chance wearing matching shorts. I saw a strong image here and asked them if I could take their picture. We met back up in half an hour and I shot a couple of rolls of them. From their reaction, I think it made their holiday in Los Angeles."

Hasselblad 500CM, 80mm lens.

Morgan Freeman, actor.
"This shot was part of a story I shot at Morgan Freeman's ranch in Mississippi for *Venice* magazine. I flew down from LA and spent the day on the ranch which is deep in the country. I spent most of my time with him cruising around in his beat-up old truck. When I first met him I didn't recognize him in his barn in cowboy shirt and boots with his horses. He was just as I expected, kind, interesting, and interested."

Hasselblad 500CM, 150mm lens.

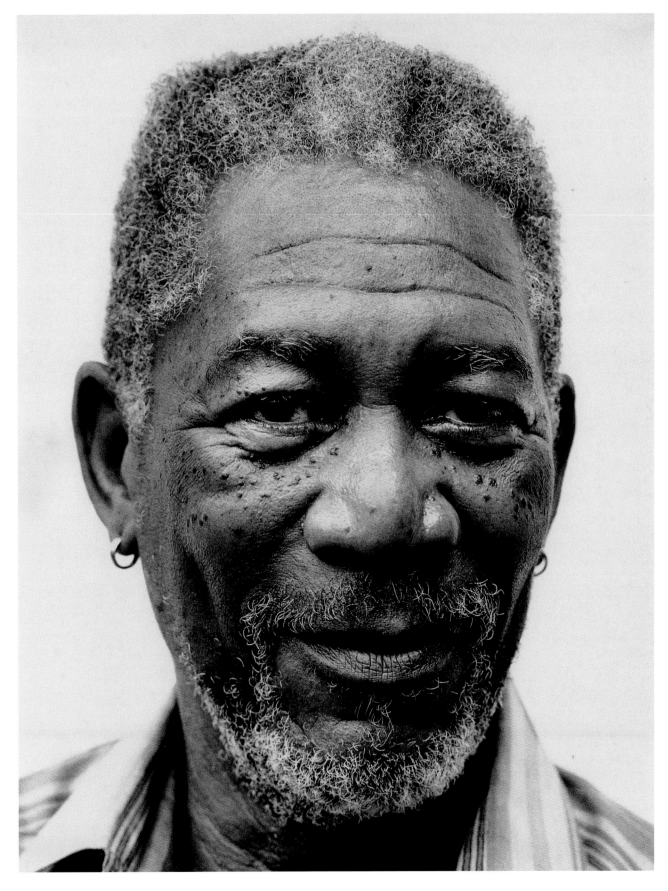

Patrick Fraser

Greg Gorman

Gorman was born in Kansas City, Missouri, USA, in 1949. He discovered his calling after taking a borrowed camera to a Jimi Hendrix concert in 1968. "I was sitting in the audience, high as a kite, just taking pictures from the third row while Hendrix was on stage performing. But it was those pictures that made me realize that I wanted to be a photographer. The whole process of capturing an image and processing them in the darkroom myself and making my own prints…there was just a whole mystery about it that I loved."

He studied photojournalism and received a Masters degree in cinematography from the University of Southern California in 1972. Gorman has published two books; the first, *Greg Gorman Volume One*, published in 1990, showcased his skills as a supremely incisive portraitist and photographer of nudes with a dazzling sense of clarity and elan. His second, *Greg Gorman Volume Two*, published in 1992, focused on his nudes.

His portraits of artists are unusually revealing in that, "their appeal lies in their ability to unmask the celebrity personality, while still preserving the fantasy of the dream factory. I need the interaction [of portraiture] and I've always enjoyed getting to know people, getting into their heads." Additionally, he chose personality portraiture over fashion because he feels that with fashion you work with people who you can add to what you want them to do. "With personalities it takes a little more coaxing. It's about psychology and trying to get into their heads and get what you want out of them."

Gorman likes the symbiotic relationship of personality portraiture even though people can be difficult at times. "For me, it's a joint relationship. It's about two people working together, not apart. I get great satisfaction out of breaking down the barriers and connecting with someone. Oftentimes I make a lot of good friends from the shoots… sometimes not!"

"The majority of talent—some of the bigger stars—they are insecure being themselves. I find it's a lot easier for them when you're shooting them as a character, where they can hide behind the persona of an alter ego. And when they have to strip that bare… try to figure out who they are as an individual, that's more of a challenge. I think that is something I do well—directing people and being able to make them relax, trust me, and make them feel confident. Coming up or down to somebody's level. I check my ego at the door. One ego in the studio, when you're doing a photo shoot like that, is enough."

Gorman uses strong lighting and lots of shadows. Telling about a person, but at the same time not answering all the questions. "When I first start shooting, my pictures looked like interchangeable postage stamps. The light was right over the camera and the picture was a glossed-over portrait that spelled out all the answers. I find pictures more intriguing today when they leave you wanting to know more about a person."

Gorman compares his love of portrait photography to his love of wine, and admits that had he not become a photographer there is no question that he would have pursued winemaking. "It's a big passion in my life. There is a correlation between that and what I do. Different bottles of wine are like different people. Very similar characteristics to people."

Johnny Depp, actor.
"I love this because it was my introduction to digital. It was one of the first times I used it on a big photo session. Johnny and I'd been friends for years… He's a real regular guy, a real sweetheart and very bright. I have great respect for Johnny… We share wine in common. He loves wine as much as I do, and you know, we had great wines flowing that morning when he arrived! I said 'Listen, I've just started to shoot with this digital camera, shall we just knock off a few images?' And it was the quality of that image which made me realize digital cameras are coming into their own life and able to produce images that are pretty amazing. Everything is moving in that direction."

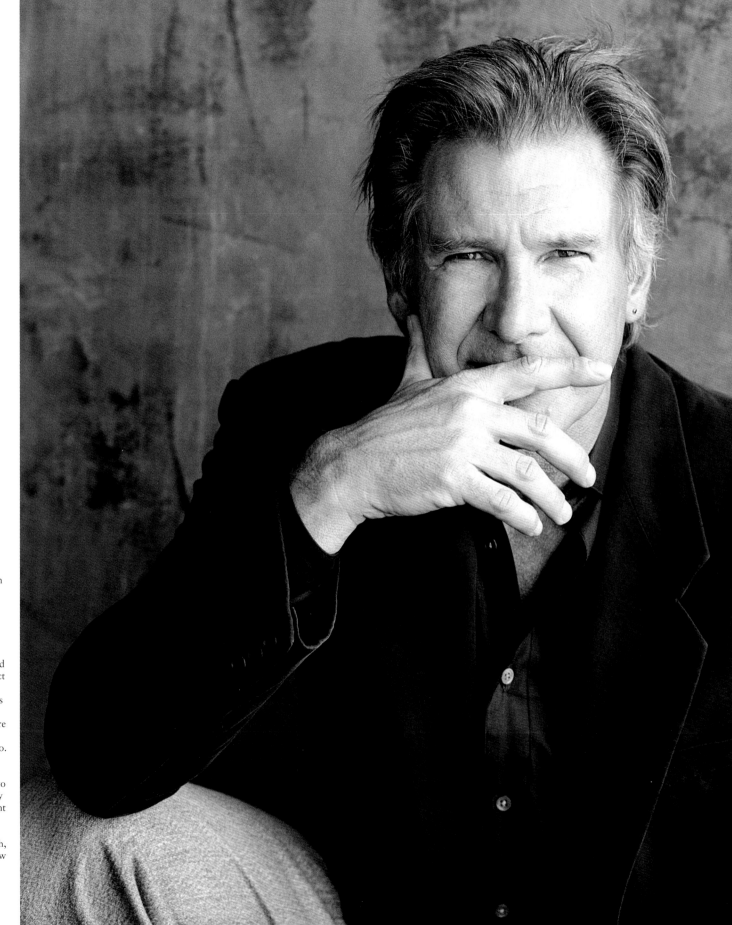

Harrison Ford, actor
"Harrison was tremendous. He didn't come with an entourage, he didn't come with a manager, a publicist, or an agent… all the bullshit hierarchy that follows these people around and drives photographers like myself crazy… There are always a handful of actors that surround themselves with jerks to protect them and isolate them… but that was one of the great things about Harrison. He drove himself to the session, was there on his own. No pretenses. Nobody that I had to answer to. This picture was taken in natural light on the roof at my studio. And I was just talking to him, we had a banter. He's very into digital so we had an instant bonding there. He had the same kind of camera that I was actually shooting him with, and he said, 'God, I wish I knew how to use it.'"

Donald Sutherland, actor.
"This was taken during a shoot for *The Italian Job*. It was shot in Venice, Italy. I'd never worked with Donald before… One of the production people kind of pissed him off and shuffled him around, said 'Come on! We've gotta do this really quick because Greg's gotta shoot Charlize Theron after you.' And I think it really annoyed him. It gave him a little feeling of less self worth. He felt like he was just being shuffled in and out and he came in with kind of an attitude. I set him straight. I said, 'I don't know who told you that, but it's bullshit. Of all the actors on this movie you're the one actor I was most excited about working with.' So we started working and we ended up having dinner that night. People can be put in a negative frame of mind and it is out of your control. It is part of what I find most amazing about this profession. It was really in my court to bring him around and bring him out of that negative space. It took me quite a bit of time to get him wound down. That's a big part of what I do."

Philip Johnson, architect

"What an amazing wit Philip is. Classic as an individual, lots of fun. One of the things I noticed was his incredible sense of style. He dressed impeccably. I was limited with what I could shoot because I was in an office space but I loved that Eames chair. I loved the lines of it and I loved his profile…the profile, the line of the chair, the starkness of the black and white. If you look at Philip's architecture, he is very aware of lines and shape and form; that's really very much a part of Philip's work. I was very conscious of the lines of the image."

Traci Lords, actor

"I met Traci on John Water's film, *Crybaby* about ten years ago. That was right after Traci had gotten out of all the 'stuff' she was doing and was making the cross-over to regular movies and whatnot. I loved her honesty and her vulnerability. She and I became friends socially. When she was writing her autobiography, she asked me if I wanted to shoot the cover of her book. I always found her to be a very elegant person and a very good person with a great sense of humor. Traci was not that keen on her past. She was shy about it and I think it was a very cathartic thing for her to write this book. It's just so not a part of the girl that I know, but it's a part that she'd lived through and survived. So we wanted a portrait that reflected her coming of age, a little bit older, a little bit wiser, but still very sensual. But that look in her face… that's probably from trying to keep her eyes open in hard sun! It was direct sunlight and it was very bright. I was shooting her in a daylight studio up in the Hollywood hills. But I still think the picture has a certain wisdom to it."

Greg Gorman

Hugh Jackman, actor.
"Hugh was extremely accessible, open, with a great sense of humor, very generous with what he was able to deliver working with me. We ended up shooting on the streets of downtown LA. This was taken under a bridge. There was a real calm about him. He's a very centered, grounded person."

Sara Foster, actor.
"I love this picture. I do a lot of male and female nudes. This is a nude portrait but it is still a portrait. Even without her looking at the camera. It's a portrait of Sara Foster, the daughter of David Foster, the music composer. It was a job where I had a great degree of freedom."

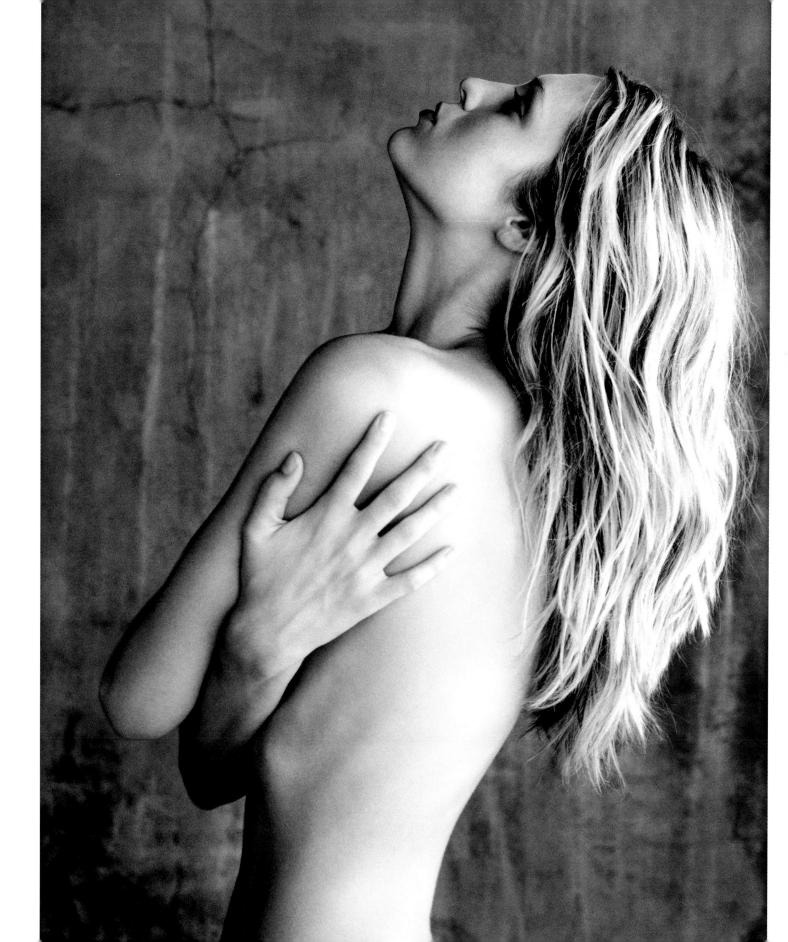

Fergus Greer

Greer was born in the UK and brought up in Southern Ireland. He studied a BA (Hons) at St. Martins School of Art and Fashion in London, the capital's most highly regarded art school, and then, in an unlikely twist, graduated from the Royal Military Academy, Sandhurst. Upon graduation, he served as a lieutenant in the Guards' Brigade, Infantry.

After leaving the army and, afterward, working for a number of photographers, he won the prestigious position of assistant to both Terence Donovan and Richard Avedon. After gaining the skills he required, he started as a freelance photographer and was based in London for six years on contract to the *Sunday Times Magazine*, among others.

In the fall of 1997, Greer moved to Los Angeles and began basing himself in the States, while simultaneously continuing to tend to his European editorial work and freelance clients. Some of his editorial clients include: *Vanity Fair*, *New Yorker*, *Forbes*, *Newsweek*, *Marie Claire*, and *GQ*. His advertising work is vast and includes such major companies as IBM, Winston, Caldwell Banking, and JP Morgan. Greer has published two books to date, as well as editing this edition, and has had exhibitions all over the world.

Greer became a portrait photographer mostly because he finds people interesting. "A portrait tells a story like a book, like a piece of music, like a painting. It's not necessarily about the face. Some of my portraits aren't about the face. A portrait of someone can be abstract, but it must capture an essence. People are a record of their past, where they've been, what they've done and seen. And somehow that is recorded in their essence. What I'm capturing is really a pool of this huge amount of history that they are carrying around, or have been through or seen, and I suppose I try to take that and convert it from something which is ethereal into something which is physical and permanent."

He fondly recalls a black and white photograph taken in his grandparent's backyard, which may well be the first picture he remembers making an impression on him. "It was the day my parents got engaged. A picture of them holding a bottle of champagne in the garden and the sense is of that moment—a moment of immense happiness. Yes. That moment, that time, that 1/30th of a second at f4."

Leigh Bowery, performance artist and fashion designer: orange pom-pom head
"This is just one in a series of pictures I took of Leigh over a period of six years. We'd get together and record a series of new outfits that he had produced. I was just starting out as a photographer, so in a way each session was a new costume to him but I was putting into practice new elements I was learning about the process of photographing, so it was a growing process for me over those six years. Leigh was fantastic. He saw the point to it. The pictures were an extension of what he was doing and creating a legacy. He never let on to anyone that he was dying until the very last few weeks. He wasn't one for self-indulgence and self-pity. He always had the view that this would be a legacy."

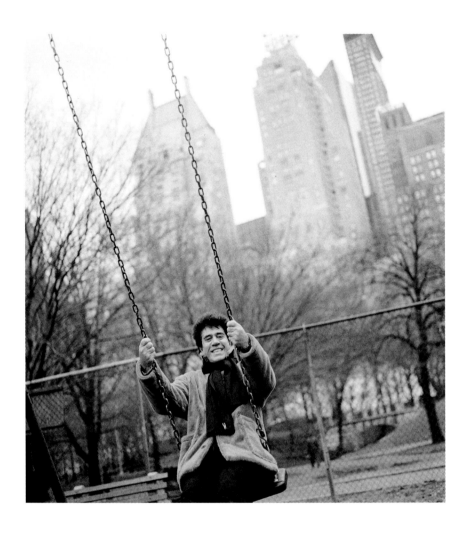

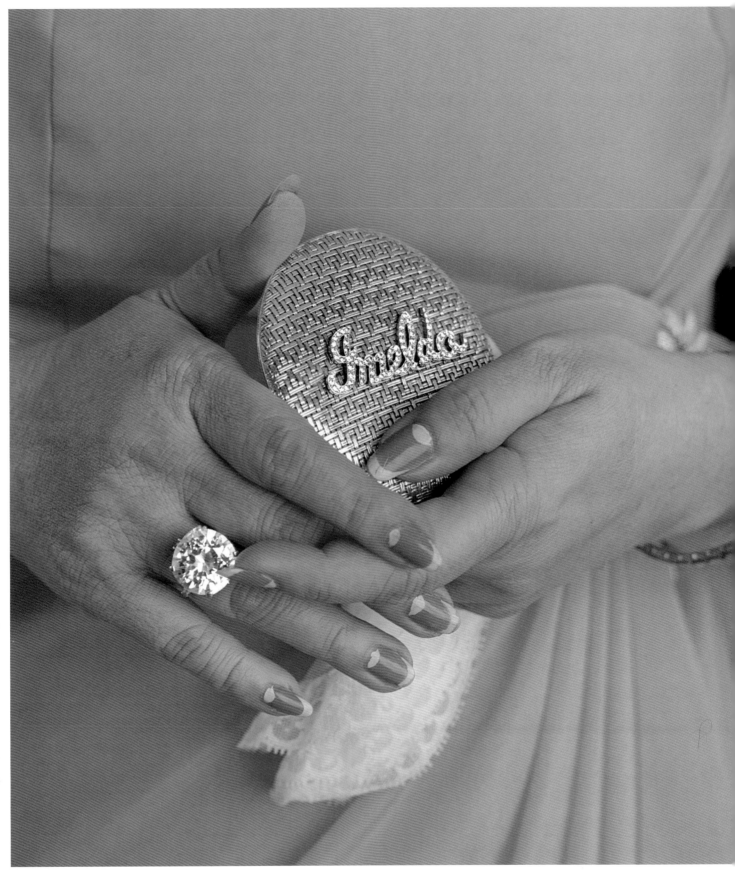

Imelda Marcos, politician.
"I was on assignment for the *Sunday Times Magazine* just outside Manila in the Philippines, to do a story on Imelda Marcos. I'd spent a number of days there following her around not taking any pictures. But during the week I saw that, although she was a very strong person with huge confidence, she had this inherent nervousness which was reflected by the fact that she'd take out a compact she had and a lace handkerchief and touch her face with it the whole time. So by the end of it what became very apparent was that this compact—gold and diamond studded with her name on it; her nine-carat diamond engagement ring, which symbolized the nine days of courtship before she was married, and the very high-quality lace handkerchief and her French nail polish which was coming away at the cuticles —this sort of reflected better times now crumbling. So I decided to focus on that. I asked her permission and she couldn't understand why, but she let me and then became bored. I used a Hasselblad on an 80mm lens using 400 ISO color negative film."

Pedro Almodovar, director (*left*).
"I'm a huge fan of Almodovar's work. This was for the Director series, and I had put limitations on myself. I turned up in New York and he had five minutes before a press call. And I was to meet him at the Trump Tower Hotel. I was just standing there waiting for him and I saw the children's playground. It was early morning, about 7 o' clock. A winter morning, it was misty and there was a certain calmness about everything. I asked him if we could go to the playground, and he immediately spotted the swing and jumped on it, and it was the moment. The picture was captured in a matter of moments."

Fergus Greer

Cheetah

"This is Cheetah, the chimpanzee from the old Johnny Weissmuller Tarzan films who lived out in retirement in Palm Springs and was now 64 years old—in man years. I drove out there and his handler, who'd inherited Cheetah from his father, brought him out in men's clothes, human clothes. This slightly distressed me. It made me feel uncomfortable so I asked if he could wear no clothes, and so the handler—his owner, his friend, whatever, agreed to it. So he took off his clothes. And there was a certain resignation in Cheetah's eyes, which could have been interpreted as somewhat weary… weary of being photographed, of being the object of interest, without any choice in the matter. Or it could just have been that he was tired and old but still had a lot of fight in him. I treated him like any other subject. I did focus on his face, and it reflected his past. As it turned out the portrait struck a chord with a number of people. Peter Blake, the artist, saw it on the front cover of the *Sunday Times* magazine and liked it and incorporated it into a joint exhibit of pictures called 'Now I'm 64,' all about Cheetah, which appeared in the National Gallery, in London. There was no difference whatsoever in photographing him and a human. It's all a relationship."

Someone gave Greer an old Box Brownie camera, which took 120 film, when he was five years old and he began to shoot the family dogs. He doesn't consider it serious picture-taking, but the photos had a certain quality. "They're appealing, they capture a moment. I must admit I was never particularly interested in the process of developing film and printing the images, but the actual taking of the picture and seeing the finished image—I always thought there was a huge magic to that. And still do."

For Greer, photography is the struggle to capture a finished piece which satisfies everything he wants to achieve, that moves you emotionally and aesthetically, is something that Greer doesn't always find enjoyable. Yet, he is always in pursuit of harmony. "When you do get that picture, and you stand back and regard it, and in some way you achieve [harmony], then it's hugely satisfying. It has to be personally satisfying. It's nice to have positive critical attention and recognition for what you do, but I think that is more from a perspective of insecurity, to have to have that, but I don't think that is where the underlying sense of achievement comes from. Ultimately, it comes from oneself. You have to be happy with what you've done yourself and that's a continual struggle… but that's where the satisfaction comes from."

Baz Luhrman, film director.

"This was shot underwater in the Chateau Marmont Hotel swimming pool in Hollywood. It was for a personal project—a series of film directors around the world. I'd set myself a lot of limitations for this project. Having moved to LA I found that the production levels, and the number of people involved in the process of taking photographs had grown to the point where the actual photograph itself was almost secondary, so I wanted to set limits. Get back to basics, I suppose. The limits were: no preconceived notion of the image would be created before meeting the subject; the subject would choose the length of time I had to photograph them; and I would only use available light; and black and white film. I used a Hasselblad inside a fish tank that I'd weighed down with sandbags. The shot was inspired by the beautiful moment where Romeo and Juliet first see each other in Luhrman's film. They're looking at each other through a fish tank."

Damien Hirst, artist.

"Damien had just had his first show. He was the new *enfant terrible* of the art world, at the very beginning of what would become known as 'Brit Art.' He was the standard bearer and getting a lot of media attention. At his studio he had a tarpaulin over something. I wasn't quite sure what it was and I asked—it was a pit of formaldehyde containing a lot of carcasses, which were his raw material for a number of sculptures. It really identified what he was doing. It seemed the best way to identify him with that subject matter was for him to be naked, just a carcass himself. I asked him if he'd do it, so he thought about the idea and felt it was in line with his thinking and he appreciated it. I managed to climb into the rafters and photograph him from above. He wasn't the slightest bit self-conscious. But I was ill for two days afterwards. The smell of the formaldehyde—toxic, nauseating, poisonous."

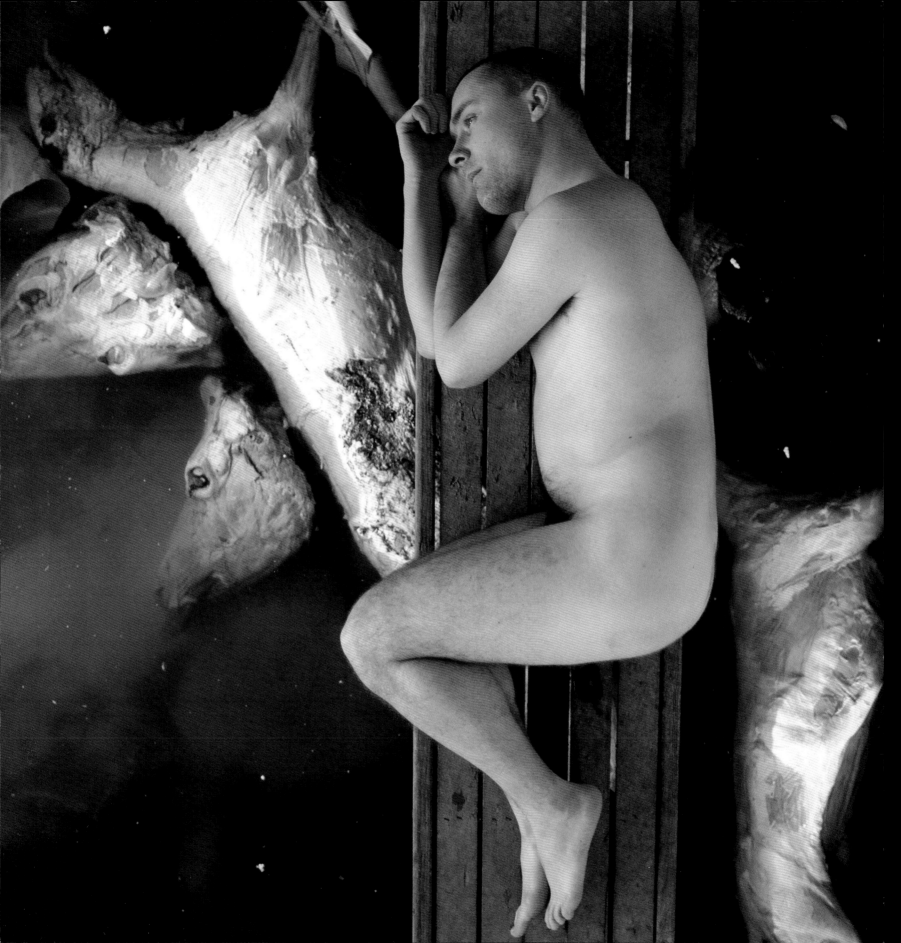

Lou Harrison
Shot in Palo Alto, California,
USA, in 2001.

**Bruce McDonald, Canadian
film director**
Shot at the Magic Castle,
Hollywood, California,
in 1992.

Fergus Greer

Dominick Guillemot

French photographer Dominick Guillemot has a clear and obvious passion for portraiture. "What I love in doing portraits is to capture the inside of someone, to really capture the soul of that person, who they are," he says. "To get something close of that person in the shot. To show a side of them that people have never seen, and hopefully [a side] that is different."

Guillemot enjoys a successful career shooting for commercial clients and fashion magazines as well as doing a large amount of celebrity portraiture. He has a fantastic ability to capture the spirit of his subjects, and is particularly gifted when it comes to bringing out the beauty in women. In this he is helped by his love of lighting.

"Even when I am speaking to people, I still love to check out the light." The creative use of light is evident in the magical moods he creates with his images. "I am also in love with people," he admits. "There are a lot of sides to photography— it's not only about taking the picture. It's getting everybody to agree with your idea and work on that plan, getting ready to give their best, and the crews I work with are fantastic. I really enjoy this side of my work. Of course, I love beauty also, so my job combines all of those elements. I am a lucky man!"

Guillemot studied drawing and painting while living in Paris, and early in his career was given the plum assignment of shooting artist Salvador Dali. "That was so amazing, so cool." During a break in the shoot, Dali invited him and the assistants to lunch. Guillemot wanted to capture shots of the artist at the restaurant, but was trying to be discreet. Dali exclaimed to him, "You don't need to turn your head to the side. Just sit down and hold your camera and take the bloody shot! At least then you look like you are doing something." This pleased Guillemot and Dali both, and the shoot ended up lasting three days.

Because of the many various assignments he has been on in his life, Guillemot has developed an expression he uses with everyone, including clients and subjects, "No problem!" Because his strength lies in several areas, he is able to deliver this statement with confidence. "It's my personality with people, I am very friendly with people and they don't get tense, which is very important for portraiture. Along with this, I have creativity and technical expertise. I know exactly how to get what I want technically. I have never had a day in my life where I couldn't shoot. Whether it's raining or whatever, it doesn't matter. I am relaxed on that side."

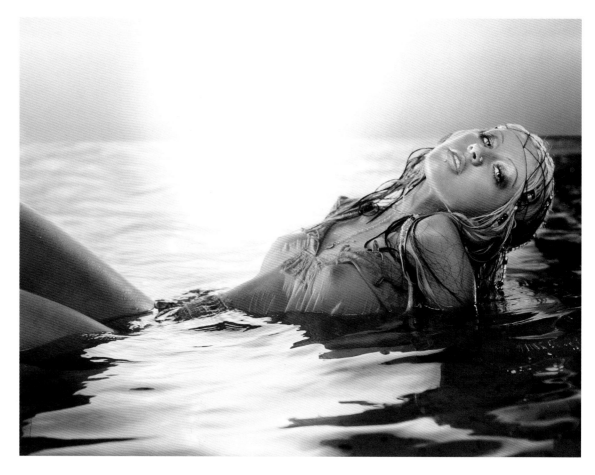

Christina Aguilera, musician.

For years Guillemot had considered his perfectionism a weakness. His use of the new digital technology has assuaged his drive for the perfect picture. "I am learning to 'let go' for the moment. I have to say that now I shoot digital, and that settles the perfectionism. It's there and you see it. It has settled a big issue with me, where I wanted perfect, perfect, perfect. Now it's no problem. You have it on a big screen and you see what you get and it's done. If you don't get it right then you can always do it a little later, so you don't have to sweat the small details. For me, I am pushing every client to shoot digitally and I love it."

When working with subjects, he appreciates that there are many sides to each of them but feels that there is a "realness" to all, and that is the aspect he loves to draw out of people. "You have to be strong to open up and you can feel it when you take the picture. You can feel when that person is really giving something (or not), and it's great when they do."

When first starting out as a photographer, Guillemot was inspired by the likes of Henri Cartier-Bresson. His current muse is Gregory Crewdson, and his favorite shot is the one featured on the cover of Crewdson's book, *Twilight*. "Gregory is really amazing. You will love his work I am sure!"

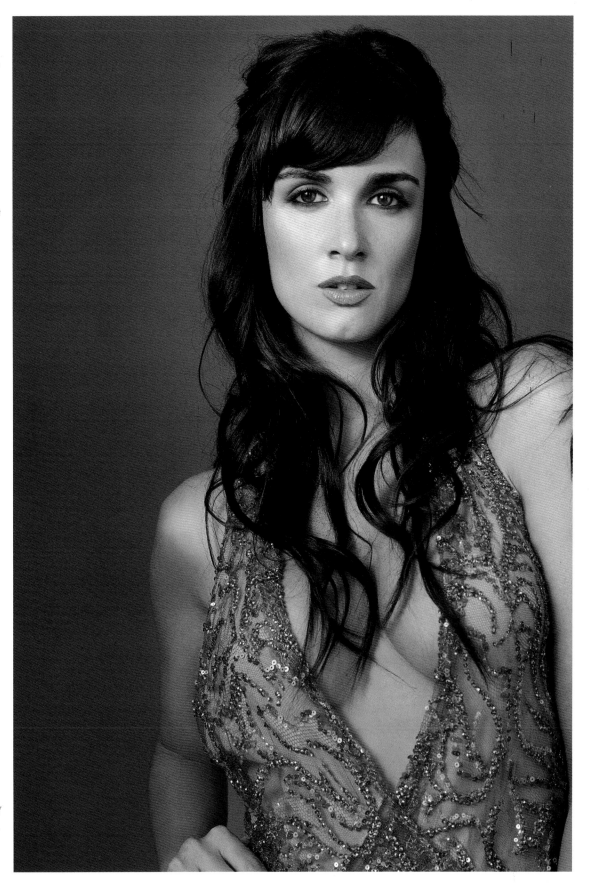

Paz Vega, actor.
"I wanted the pictures to be very simple and chic. I wanted the lighting to match her elegance."

Hasselblad HI, with digital back, Imacon 24 megapixels, f11 at 1/60sec.

Dominick Guillemot

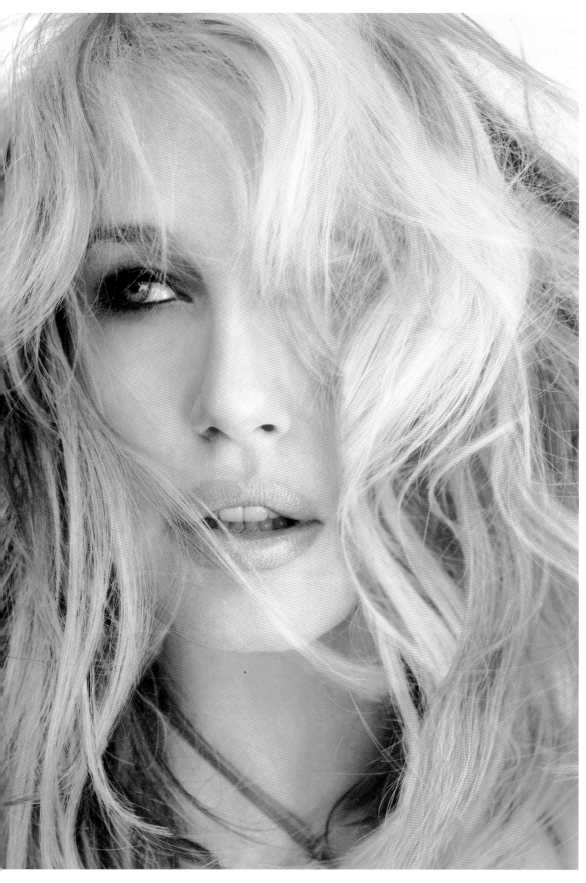

Of his own work, he fondly recalls his first time behind the camera. "It was my first snowman and I remember taking the picture. I was happy to actually be able to keep the moment. It was an important moment at the time, and I think that is what photography can bring out—a certain moment that you want to show. It can really provide guides for people in life. If they see people happy, they want to be happy; if they see people in love, they want to be in love. It's a great way of communicating and to have that moment always."

Guillemot feels that the world of photography has changed tremendously since the early 1980s. "Photography was static 15 years ago and it's not now. It's so alive, so real, so fun and so art!" He and his photography are certainly partially responsible for the shift in the trend.

Happy to acknowledge that he lives a richly spiritual life, it is no surprise that the one person he would most like to shoot is the Dalai Lama. "I have seen him, but to be able to do a portrait of him would be amazing," he says. Interestingly, had he not become a portrait photographer, Guillemot believes he would have ended up teaching yoga and windsurfing. "I am happiest when I am windsurfing with my wife and son near our home in Malibu, California," he says.

Guillemot, who is giddy and childlike in his fascination with life and art, proudly tells of what he considers to be his greatest achievement. "My family, without question—my wife and my son, who is 10 years old." Further, he is happy to share his philosophy and credo (the principles that keep his work and life magical and enchanting): "In life, do the best you can—every second is thinking about how to get the most out of it."

Daryl Hannah, actor
"This shot was about capturing the movie star Daryl. It demanded patience and trust to take such an intimate shot. She was 600% there."

Hasselblad H1, 50–110mm zoom lens.

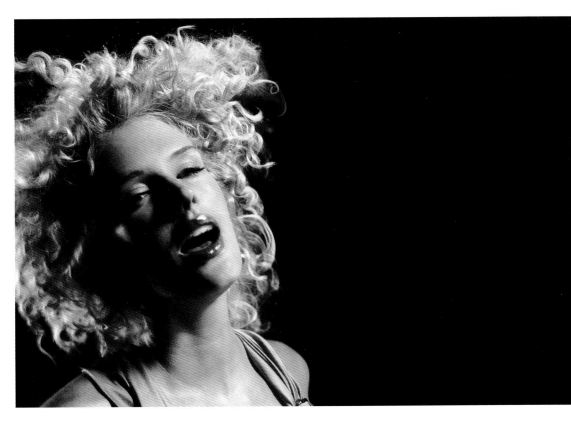

Kylie Bax, actor.
"Kylie was really into the shoot when she saw the polaroids. She saw the possibility of what was happening and gave the best of herself. The crew and myself were excited. She was feeling it and thriving on it. She was flying. The concept of the shoot revolved around knowing that Kylie was a great mover in front of the camera...so we figured a simple shoot in the studio would capitalize on her strengths. I relied on simplicity...less is more."

Mamiya RZ 6x7cm, 127mm lens,
Kodak 160nc, f11.5. at 1/30sec.

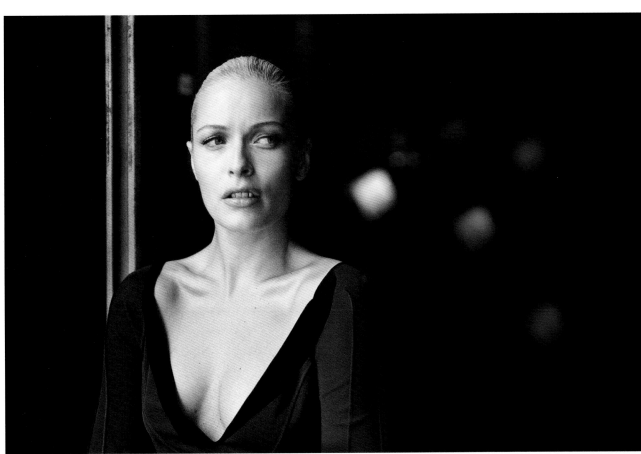

Rie Rasmussen BW, model and actor.
"We were shooting for Neiman Marcus doing great shots in an old classic show theatre and at the end of the day I wanted to snap a few personal shots. Her mood was influenced by the darkness of downtown Los Angeles."

Mamiya RZ 6x7cm, 140mm lens,
TRIX 400 film.

Dominick Guillemot

Russell James

How Russell James became a photographer makes interesting reading. "I started as a metal worker in a factory and eventually, believe it or not, I became a cop. While I was there I started doing some surveillance work and I became very interested in cameras." Shortly after, he quit police work and made his way to Europe. "I initially thought I liked landscapes until I was touring, looking for landscapes in Greece, and a gentleman sat down in front of me and I took a picture of his face. I thought that was very interesting. That led me to portraiture."

James developed his energetic and emotional style while living and working in the cutting edge photography markets of London, Paris, Tokyo, Stockholm, and Milan from 1987 to 1996. He debuted as a commercial director in 1997, his unique print style translating seamlessly to motion film. In 1999 he began directing a ground-breaking feature film and multi-media project called *Nomad*, due for completion in 2004.

Known also for his love of natural locations and dramatic architecture, James has shot on some of the world's most beautiful beaches, in the outback of Australia, on the ice floes of the arctic circle, and in the more civilized realm of designer homes in New York, Los Angeles, London, and Paris.

James's images have been prominent in major publications, including *Vogue, Elle, Marie Claire, W,* and *Sports Illustrated*. Renowned as one of the world's leading fashion photographers, his array of work spans from fashion and beauty, to celebrity portraiture, advertising, and art projects.

James loves the intimacy of a photo shoot. "Whether I'm shooting a naked celebrity or a poor young person or child, you have a bond that forms, probably just for the few seconds or minutes, and that's a really cool feeling. And, of course, the ultimate thrill is when you get the film back!"

"Sensual" and "intimate" are the words that best describe James's work. "I love a sensual approach to an image, whether it's a person or a landscape. I love something intimate and sensual about a picture. Some people have said my work is sexy, and I try to walk a very fine line on that. In fact, I would say my work is somewhere between sensual and sexy."

Which celebrities or people James would like to shoot most changes throughout the day, as he is driven by mood and fancy. "If you ask would I like to shoot David Bowie right now. Then, yes, I would. Would I like to photograph an old lady in Greece? Yes, I would. As a matter of passion. I'd have to say that my favorite subject is anything that reflects reconciliation. This is the theme of the *Nomad* project I am working on. By reconciliation

Adrianna, model.
"This picture was a behind-the-scenes picture at a real shoot. I thought it was a perfect moment in the midst of all this chaos. The point was just to photograph this girl, despite everything going on around her—the hair and the cigarette and the whole thing—she just looks stunningly beautiful. So many times with these beautiful lingerie models we have this feeling that they are living in this sexy environment. Of course they're not, and you can also see a kid in her right there, which is what I love—she's just a kid. That's what grabs me the most about it."

Shot on a Hasselblad HI camera with black and white film, TRIX 400 film that I rated at 200 and pushed a half a stop.

Faith Hill, musician.
"This photograph is precious to me. Faith is one of the nicest people I have ever met, and I don't mean nice in the "on the surface" kind of way. After several days of shooting she seemed to be the most sincere and honest person I have ever met, so that is why I have a personal attachment to this image, to this portrait. We used the kind of rain machine you have on a full-blown movie set. There was no way I wanted to let this drift into a wet T-shirt competition but, because she is a very powerful person, I wanted her to feel the power of water. She reacted to the water and we shot it very quickly. She trusted me enough to go into it, and I got these images out of her that I feel very strongly about."

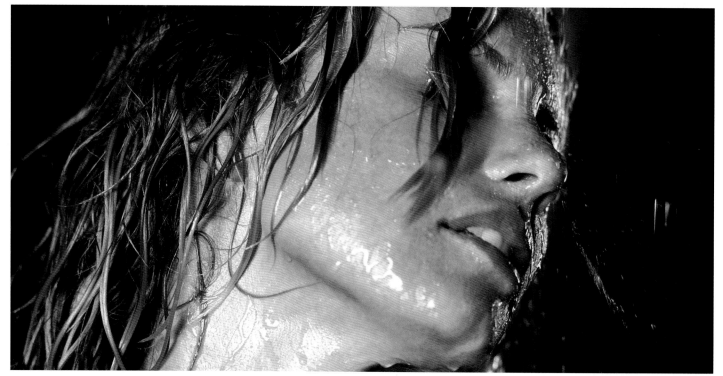

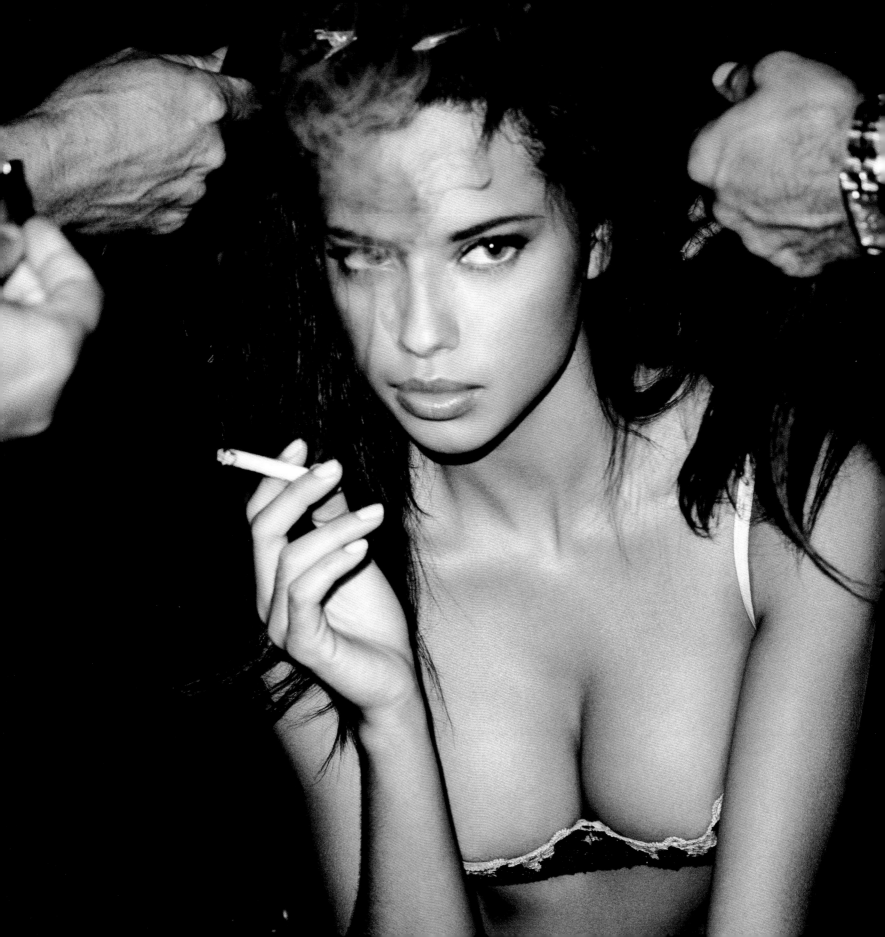

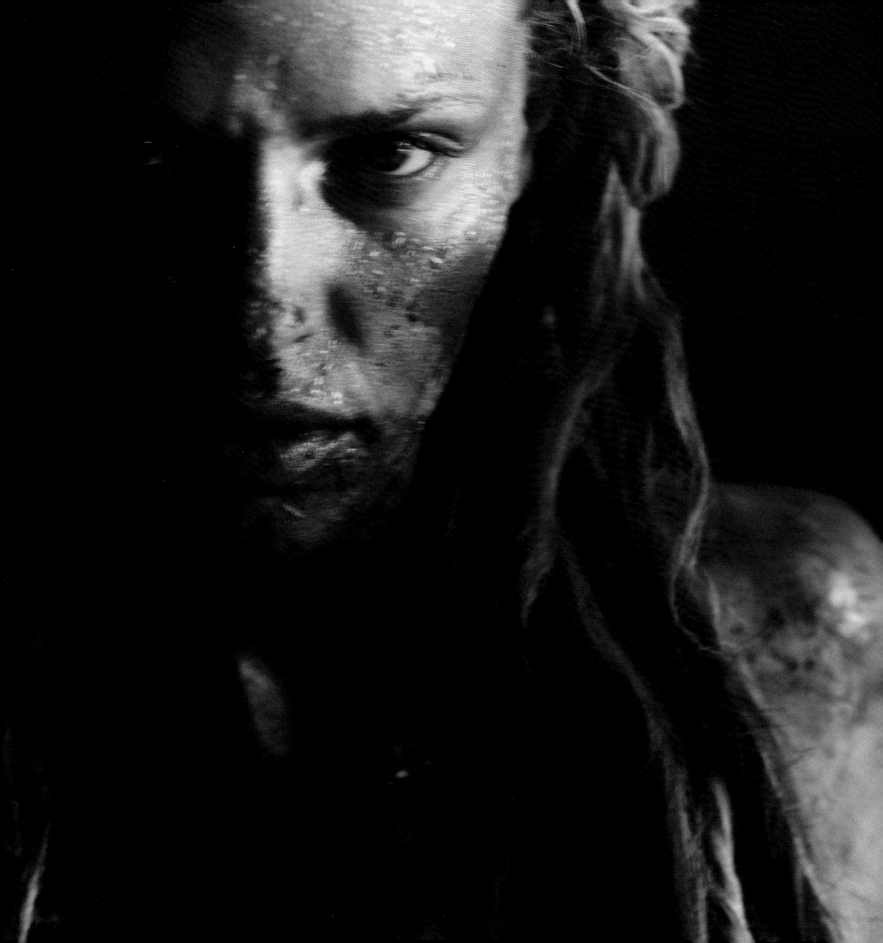

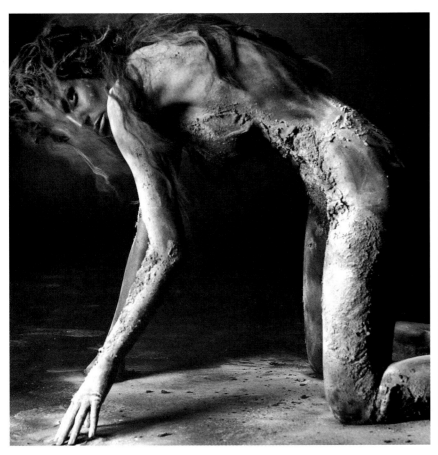

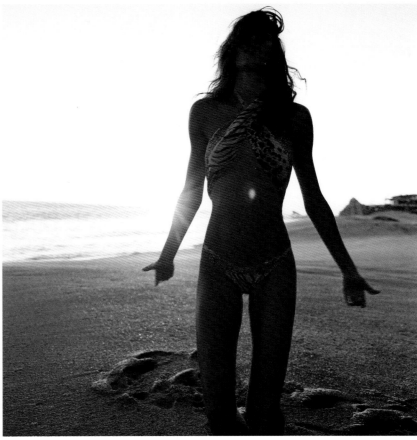

Rachel Roberts, model.

"This shot of Rachel, was, for me, recreating a period of time. It is supposed to represent a time that I call "Inhibition," the period when ancient knowledge and wisdom meets this modern wisdom. Here we have this modern beauty, and I tried to capture the anger, the mistrust, yet the pure beauty that is somewhere underneath the whole thing."

Shot on Optima 100 film/rated 80, 6K HMI light with a lot of side light to it.

Heidi Klum, model.

"This image is a part of the *Nomad* series—'Discovery.' The creative idea behind it is that it's almost a birth from the ground up. She is almost being born out of the ground and that is why she is covered in all of those special effects and things. We covered her in the mud and things you find in giant termite mounds in Australia. Then we had her start very low down to the ground and had her push her way up. Somewhere between a flower growing and the birth of a new kind of animal. And we didn't take any drugs! None! I am a one-trick technical pony. I believe that when you've got it going on, don't mess with it."

It was a 12K HMI, with TRIX rated at 200, pushed about a half a stop.

I mean that there is something going on in the world that has been going on for thousands of years. I don't know exactly what it is, but it is something about old cultures and old people. There is just so much of this 'old world' in terms of knowledge, and now there is a new knowledge that has been formed and has really set us on a course to destroy the way we live on it. And somewhere in the middle is reconciliation."

He has had an interesting journey from the small outback town in Australia where he grew up. "There were probably 500 white kids and 5,000 Aboriginal kids. It was a very offset, weird dynamic, and I didn't realize that I grew up in a very bigoted and sheltered world. Everything has changed now, but at the time I could only know what I knew. I like finding out what the things are that I do not know, learning, growing."

At first, photography paid barely enough to meet the bills. "I lived so many years in my parable of debt because every time I took a picture it just cost me money. I am far from wildly wealthy or anything like that, but I finally did find a way out of it, and it didn't have anything to do with finding money. I just follow my path. You've got to stay true to your path, and somehow the money finds its way to you to help you figure it all out."

James is a man of incredible insight and wisdom, but readily admits that his greatest achievement is his two young daughters. "Just to balance life with them. They cause the biggest lines under my eyes, my greatest stress, my greatest pain, my greatest everything, but somehow it's all working out!"

Giselle, model.

Giselle and I work together a tremendous amount. Much of what we do is commercially driven. Of course, we have had the chance to be on beautiful beaches together, but it is usually under an enormous amount of client pressure. The truth about Giselle is that she is just a kid, a beautiful tomboy. She just loves to play and she is rarely ever able to let that out because she has always got to play the sexy kitten for the pictures. I think that this shot has caught a lot more of who she is—a bit of her wild Brazilian spirit that isn't necessarily about sex. It's about being wild and being free and having fun. I wasn't intending to shoot that moment, but she was just dancing like crazy in the background while I was working and I turned around and said, 'I've got to shoot that!'"

As you can see, it's extremely flared. It's shot on Kodak VC 400 but I couldn't tell you what aperture. I know I closed way up, probably down around the F32, to really knock down the sun a little bit.

Nadav Kander

Nadav Kander was born in Tel Aviv, Israel, in 1961. He started taking pictures at the age of 13 and his style of a sense of quiet and unease are still a part of his work today. Growing up in South Africa, he hated school with a passion, and upon leaving became a practicing thug with nowhere to go until a motorcycle accident at 17 forced him to shift his focus to photography.

The first portrait he recalls capturing, at the age of 13, was at a swimming gala at school. He shot a picture of one of the teacher's little girls with a Pentax Spotmatic he had just bought with his bar mitzvah money. "It was lovely and that's what got me hooked, really."

"I think the most interesting form of life on earth are people," Kander says. He finds it a rewarding challenge to try and get really amazing pictures of very famous people, given the often difficult circumstances and time dealt to him. "Recently I photographed [the rock band] REM right before their concert, so their minds were on other things… you know, timing wasn't brilliant," he explains, "that's what I mean—it's often not at their best time."

The first photograph that Kander remembers that made an impression on him was one of the earth taken from outer space, which is why he would love to have photographed the first man on the moon. "I've got a fascination with the guy who first saw the world as a circle. I think that would be amazing. Imagine being the first person. I mean, it made him a bit crazy, didn't it?"

Of all the influences and impacts on Kander, the work he most admires is that of architect Tadan Andal. Mark Rothko is also a big, big influence. "People who are spatially oriented, compositionally oriented," he says.

Perhaps strangely for a photographer, Kander considers himself to be quite shy. "I sometimes feel that I don't get the best out of people because I'm often too concerned about their well-being. It's something that I get nervous about before any portrait session—the hanging out aspect. But you just do it." The shyness doesn't put a constraint on him taking the kind of portraits he intends, however. When asked if he believes, as some cultures do, that photographs steal a person's soul, he frankly reveals, "I think often I'm actually more interested in the carcass of a person. I'm less interested in what makes them tick, but how I can make them perform or 'become.'"

He describes his signature photograph as, "a photograph that I am really satisfied with…one that always leaves the viewer dissatisfied. I try to make thing ambiguous." In his body of work he tries to insert a sense of stillness or of things about to happen, possibly something disturbing. "I don't enjoy any pictures or art that answers all the questions. It's what separates a pretty landscape from one that might show the thumbprint of a man on that landscape, torn up—something that leaves you with questions."

Benicio Del Toro, actor
"I really admire Benicio Del Toro, loved working with him, and since then he's become quite a collector of my work. I think it was just such a mutual respect. We have corresponded ever since. We send each other CDs. I sent him *Tosca*."

David Beckham, soccer player
"I light with colored gels, and I print my own work. I seem to like the way that I print, and print the way that I like. It was quite a long exposure, maybe six seconds, where he and I both moved. I wanted to see him in a different way. I wanted to find a way of photgraphing somebody who's more photographed than anybody I can think of, in a unique way, and in a way that would fit into the parameters of my own work. Also, I realized that I'm not going to get too much from a guy like that. You're going to get his look in his way."

I used a Mamiya 6x7. I lit with green from one side, and a bit of front light which is singing in his eyes, then... that movement.

Thierry Henry, soccer player (*left*)

Nadav Kander

"I run on not being satisfied with what I'm doing. It is certainly one of the reasons I'm always striving for more pictures, or better pictures of a certain project. I think the day that I'm extremely comfortable with what I'm doing, I don't think I'll be moving on. So I think perfect happiness, as a photographer, is unattainable. And in a way I hope it is always like that, because it's quite a positive thing. It's one of my best tools that I'm not satisfied. I don't even think I am a perfectionist... I'm not trying to reach perfection. There isn't perfection in art."

"It's one of the things that I challenge...preconceptions of beauty are always linked to perfection, which I really want very little to do with. Photographing beauty for perfection's sake is as thin as the paper you print it on. There are far, far more important things to art."

Kander is interested in so many different things, that he is not restricted by the common notion that it's important to specialize, or only to do one project at a time. "I think one of my strengths is that my interests take me in more than one direction at a time."

He loves cooperation, someone helping him with his ideas and being involved with what it is that he is trying to do. "I try to tell them what I am after and I always show people [what I'm after] to get them excited about it. Actors are the most interesting to photograph because you can go places."

Christopher Lee, actor.
"I always start in a similar way—just seeing what people are going to be like. I don't want to start talking in a way which actually stills them or changes what they brought to me. Sometimes I wait until it gets a bit uncomfortable so that I get that at least. And then I might start talking to them. It really depends...I used to be interested in trying to get people to totally drop all emotion, to totally relax so that all I saw was a carcass, and then I'd photograph just two frames and that was the session. Rather than trying to catch what people were about, I was trying to catch what they really look like, literally, as if you opened a drawer in the morgue. But I don't do that with celebrities because that's not what it's about with them really...I was conscious of the patterns, the map on Christopher Lee's forehead. There's also sort of fiberglass inserts of his hair that you can't quite see. It looks like Astroturf under the skin. I got him to take off his hat. He likes to be photographed with a hat on, and he pretended he didn't mind that coming off, which alerted me to it. But I wasn't trying to be cruel or anything."

Benicio Del Toro, actor.
"We worked together on these pictures for about six hours, with his PR agent saying, 'Come on Benicio! Are you mad?' We ended it about midnight. That's pretty extraordinary to have someone so well-known for so long. The vagrant thing came out of us meeting. I could see that's what he would respond to—at night, sitting on a curb— and it just sort of happened. It's really so interesting when you work with somebody good. You watch them going into themselves, trying to find something that would make them feel and look right for the part. It's fascinating and I love that."

I used a 5x4 inch camera, shooting negative film. It would have been 10- or 15-second exposures.

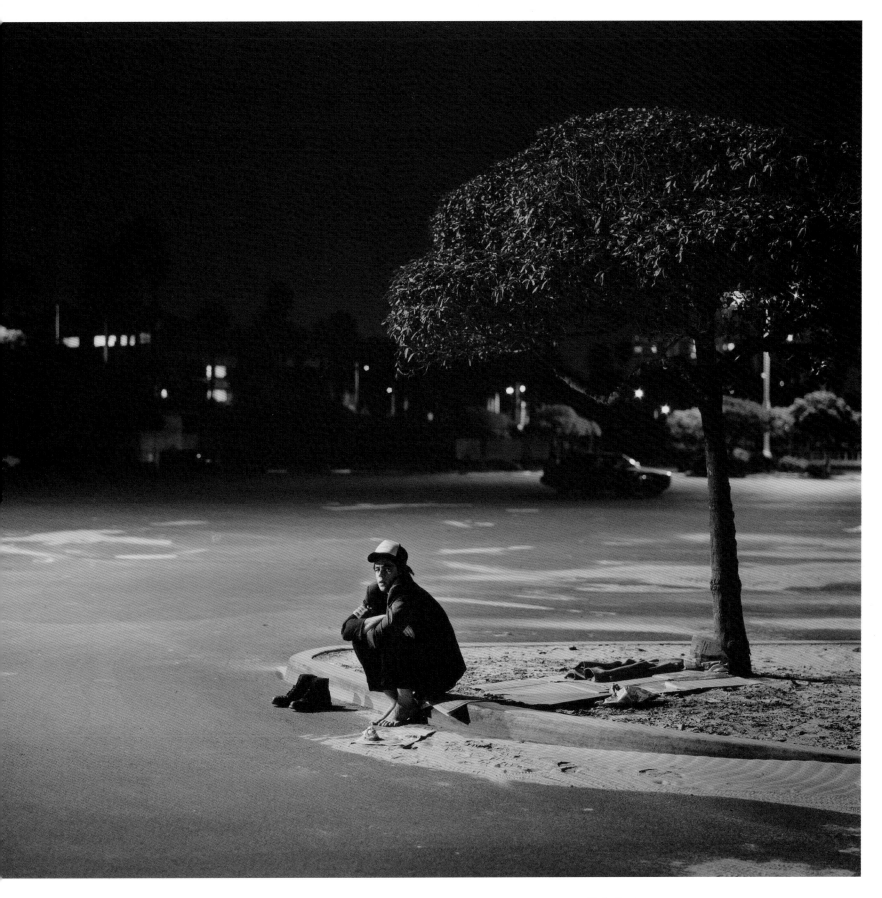

Nadav Kander

Yousuf Karsh

Yousuf Karsh died in 2002, leaving an unprecedented legacy. Arguably one of the greatest artists and entrepreneurs of the 20th century, his work influenced many other gifted people, as well as politicians and icons of the entertainment business. Because of his work, he has become almost as legendary as the people he photographed.

Born in Mardin, Armenia, in 1908, Karsh was sent by his parents to live with an uncle in Ottawa, Canada, when he was 16 years old, to keep him safe during the Armenian massacres. For a time he went to school there, pursuing his ambition to become a doctor, but his fate was sealed when his uncle gave him a Box Brownie camera as a gift. Shortly after, he gave a school friend one of the landscape portraits he had taken. Behind his back, the friend submitted the picture into a competition and Karsh won his first award of $50 for top prize.

His uncle, a working portrait photographer, taught Karsh what he knew about the field of portrait photography, and very quickly became aware of his extraordinary eye and ability, so at the age of 20 he was sent to the United States to be an apprentice to John Garo of Boston. Garo, a photographer of some note, taught Karsh the technicalities of portrait photography as well as his philosophical bent. "Garo prepared me to think for myself and evolve my own distinctive interpretation," Karsh commented.

He was to have been apprenticed to Garo for a six-month term, but this turned into a three-year stay, during which time he watched Garo capture portraits of the likes of Arthur Fiedler, Serge Koussevitzky, and many others from the world of music and theater. Karsh determined that he would take the portraits of "those men and women who leave their mark on the world."

Perhaps Karsh's most historic experience was taking the portrait of British Prime Minister Winston Churchill, a portrait that thrust him onto the world stage. As legend has it, Churchill had no idea that a portrait sitting had been planned for him and gave Karsh a scant 20 minutes to get it done. Karsh was keen on getting the picture without any props and took away Churchill's signature cigar. At the moment Churchill realized what Karsh had done, Yousuf clicked the shutter and captured the picture that is perhaps one of the most famous of the last century.

Having had little experience or knowledge about selling his work, Karsh took an offer from *Life* Magazine. "*Life* offered $100, which I accepted, being then very naive about the value of anything—all I wanted was for the photograph to be published," explains Karsh. He happily admits that the famous shot, "is one of the most frequently published photographic portraits of any person in history."

Martin Luther King, civil rights leader
This shows American civil rights campaigner Martin Luther King. He was murdered in 1968 by the White Supremists.

Sir Winston Churchill, politician.
This shot of Churchill was taken
in 1941, when he was the British
Prime Minister.

**President John F. Kennedy and
Jacqueline Kennedy** *(left)*.

Audrey Hepburn, actor.
Born Edda van Heemstra Hepburn-Ruston in Belgium, the bewitching Hollywood actress, pictured here in 1956, was one of the most graceful and glamorous actresses of the twentieth century. She possessed a poise and elegance that few before or after have matched. She won critical acclaim as Holly Golightly in the screen adaptation of *Breakfast At Tiffany's*. The star remained a public favorite for her devotion to the welfare of children through selfless globetrotting work on behalf of UNICEF.

This naiveté would not last long. Karsh was prolific and sought after by the most famous and influential personalities of the time. It was a privilege to be "Karshed," an expression coined by Field Marshall Sir Bernard Law Montgomery of El Alemain. Karsh traveled all over the world and shot portraits of royals, statesmen, scientist, artists, writers, musicians, all of whom looked forward with great anticipation to being immortalized by Karsh.

To prepare for the sessions, Karsh would learn as much as he possibly could about the subject, while he systematically avoided having a "preconceived notion of how to photograph any subject." Instead, he would seek the essential element that had made them great. "All I know is that within every man and woman a secret is hidden, and as a photographer it is my task to reveal it if I can," he has said. "In a successful portrait sitting the photographer must prepare by learning as much as he can about his subject so that immediate rapport will hopefully be realized, for the heart and the mind are the true lens of the camera."

Karsh rarely used props in his portraiture, and loved including hands as a vehicle for expressing something about the subject. He always kept his portraits simple, making use of distinctive light and profound shadows. He was brilliant with available light sources—natural or artificial. Although he preferred natural lighting, he became a master of manipulating artificial light to produce his results.

Neil Armstrong, astronaut
This shot shows astronaut Neil Armstrong, Commander of the Apollo 11 Mission, and the first man to set foot on the moon in 1969.

Albert Einstein, scientist
This shot, from the 1950s, shows German American physicist Albert Einstein, who won worldwide fame for developing the special and general theories on relativity. He won the 1921 Nobel Prize for Physics for his explanation of the photoelectric effect. Einstein is rated as one of the greatest thinkers who developed and revised the theories on space, time, and relativity.

Yousuf Karsh

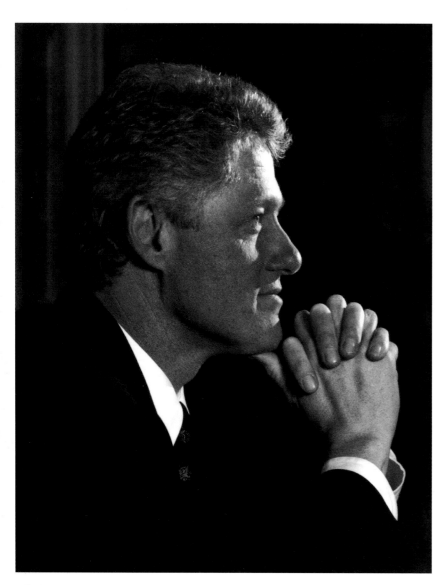

After 60 years of commissioned work, he closed down the studio and moved to the house where he lived for many years, just outside of Ottawa. He collected works of art by many well-known artists but only one photograph, a portrait of his second wife. When he spoke of the decision to retire, he said, "Now, I just want to photograph the people I want to."

Karsh's work has been exhibited in Canada, Great Britain, Australia, China, and the United States, and he has numerous portraits on display in museums worldwide. Most of his extensive archive, amounting to 250,000 negatives, 12,000 color transparencies, and over 50,000 original prints, were sold in 1987 to the National Archives of Canada at Ottawa.

Ever humble, he was a man who rarely heralded his own work. After his retirement, he was quoted as saying, "My best could be the picture I take tomorrow." He loved what he did, and the people he was privileged to photograph. "I look forward to every working day and I feel I am in the most exciting work in the world," he said.

Although he is credited with capturing the images of some of the most famous achievers in the world over his lifetime, he himself has said that he liked to photograph "the great in spirit, whether they be famous or humble." He was constantly searching for truth, beauty, and goodness, and he found humanity in all of the faces that he photographed throughout his long and fruitful career.

Bill Clinton, politician.
Looking to the future, the then American President, Bill Clinton, adopted a determined, far-sighted pose, taken in 1993.

Queen Elizabeth II and Prince Philip.
This shot was taken early on in the Queen's reign and shows the pair as youthful, optimistic, and purposeful.

Perhaps Karsh's career can best be summarized and celebrated with one of his own statements. "When one sees the residuum of greatness before one's camera, one must recognize it in a flash. There is a brief moment when all that there is in a man's mind and soul and spirit may be reflected through his eyes, his hands, his attitude. This is the moment to record. This is the elusive 'moment of truth.'" He was a gifted master at achieving just this and his photographic legacy has fulfilled his intention that we feel "the world is more available than it really is."

Fidel Castro, Cuban leader.
This shot was the product of a three-hour session that Karsh was permitted with the Cuban leader on Cuba's National Day in 1971. Castro had just given a two-and-a-half hour speech and was exhausted. The refreshment was Cuban rum and coke. When Karsh asked the tired Castro if he could recreate the warmth and spontaneity of their first few minutes together, he replied, "I am not a good enough actor—I cannot play myself."

Humphrey Bogart, actor.
This shot was taken in 1946.

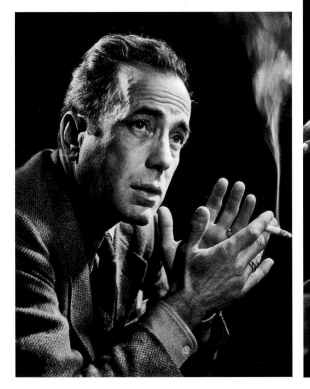

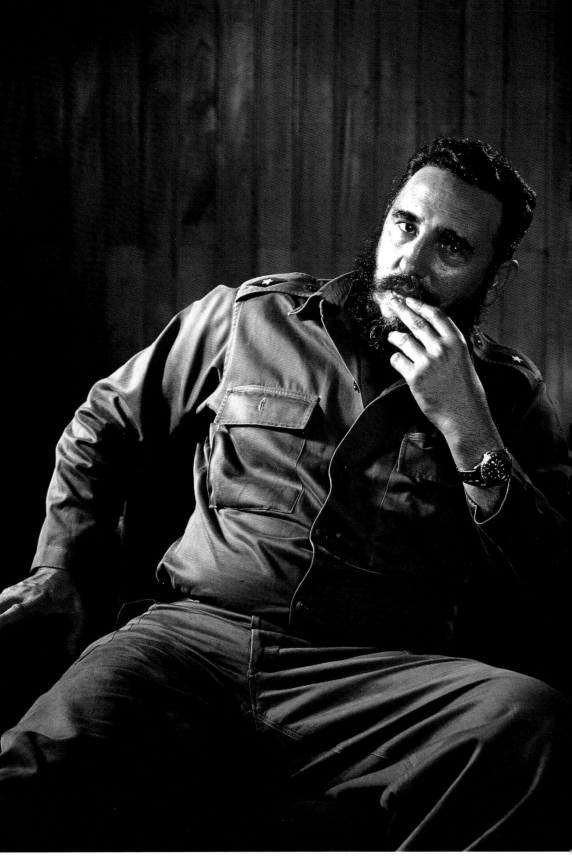

Yousuf Karsh

Richard Kern

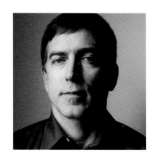

Kern was born in Roanoke Rapids, Virginia, USA, in 1954. He never set out to become anything or do anything, except take pictures. "Only in retrospect can I say that I am doing portraits." His work has been shown in galleries throughout the world, including the United States, France, the Netherlands, Italy and Sweden, as well as in selected one-person and group collective shows since 1985. He has also had several books of his personal work published.

He studied Art Philosophy at the University of North Carolina at Chapel Hill, and says he "was just trying to set myself up to have an enjoyable occupation. I honestly wanted to be able to do something that I wouldn't mind doing at 80." There was a time that he seriously thought about painting, and still does. "I wish I painted! I did it in school and I have painter friends, and I think to myself, 'Man, I wish that is what I did.' But I have never been able to paint what I see in my mind's eye as well as I can capture a photograph of it. Painting can be extremely frustrating for me."

When he approached his favorite philosophy professor to ask what he might do with a philosophy major, his professor replied, "Well, you could hope to get a job in a bank or something like that, and you will learn to be somewhere where you can actually just think about life." It was then that Kern switched to art. "At least with art I could wind up being a teacher or a comedian!"

His first memory of taking photographs was when he was a child. He started by building model cars then photographing them to submit to *Model Car* magazine. "I never won anything," he admits. "I was just seeing the car—what I imagined it to look like, not what was really there. With real photographs, when you get the magic going, that is a whole other thing. That's when you become a real photographer I think."

When asked why he likes what he does, his answer is, "Do you know what I do? I shoot naked women! Even shooting someone with their clothes on, it's not a disagreeable job. It's like you are having a one-day relationship with someone, and it doesn't even have to be intimate, but you get to know the person anyway."

Asia.

On the subject of achieving perfect happiness with his work, he says, "I don't think that could ever happen, because if it happened there would be no point. I know I get happy when I get the film back and there are nice photos, and that's what everybody is going to say—that's pretty much it. Also, you can be happy if you are getting paid to do what you like to do. That's a pretty good job."

After pausing for thought, he adds, "The biggest happiness for me is when I get to find a model that nobody else has gotten, that nobody else ever gets." Although he would love to shoot Kate Moss—"only because I have seen her forever, and everybody else has shot her"—he would most like an exclusive.

Kern is extremely comical, so it is natural for him, when asked to define his art, to quip. "It has a person in it! There you go, it has a person in it!" It's easy to see that nothing inspires him more than people. "I love a lot of movies, books, and movements—the youth movement. I am inspired by walking around the streets in New York, especially in spring. Everybody is throwing off their winter coats, and it's almost like being at the beach."

Kim and Joyce.

Richard Kern

Recalling whose art has inspired him in the past is a difficult thing for him. "There was stuff in my youth that inspired me. When you are 20 you have lots of hard-core influences, but as you get older it all kind of blurs together, and you realize that it's all kind of the same—not the same, but everybody is working out their own stuff." His current inspiration lies in the film work of Sweden's Lukas Moodysson and the photographic work of Terry Richardson. "I get a kick out of Richardson's stuff because he doesn't give a damn. To me that's inspiring."

Admittedly, Kern wonders if he isn't missing a golden opportunity to mention more of his mentors and people whose work he has admired and been influenced by. "I remember when I would read an interview when I was younger, and I would go look up everything about that person, to learn."

The thing that most impresses Kern about his subjects is when they are willing to do anything. "To not care what it is. I've had a few models like that, when they say, 'Okay, sure,' to whatever I ask. In commercial work that doesn't happen. They say, 'I'm not doing that!' So I think it's great when a model trusts you and you really trust them."

Like so many others, Kern considers his greatest accomplishment to be not his photography, but his son. "Yes, I guess it's my son. That's a corny answer, but it's probably the truth."

Nick Nolte, actor.

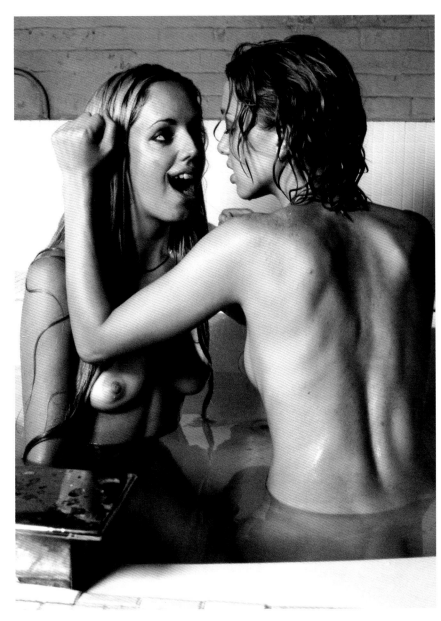

Joyce flosses Kim.

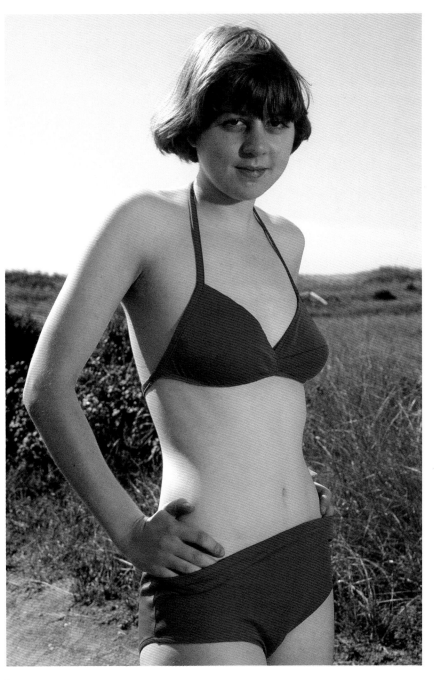

Lucy.

Richard Kern

Lord Lichfield

Patrick Lichfield started taking pictures early on in life. "I used to pick up my grandfather's camera from the hall table at home and just take pictures because I was fascinated by this box. Then I would put the camera back on the table again and he would be a bit surprised when the film came back from processing!"

He was sent off to boarding school at an early age and found that he was homesick. "I needed to take something with me that reminded me of home, and so by taking a photograph of my sister, or something in the garden or my dog, something very simple, it was kind of a talisman or keepsake that I had with me."

At boarding school, Lichfield's peers had a tradition of swapping photographs of each other as souvenirs. He quickly discovered that he was very good at taking the portraits and he could do them less expensively than the school's photographic shop, so he took all the pictures for his class. Forty years later, he had the unique experience of being able to photograph the same boys again at a reunion. "Some fare better than others, but men on the whole tend to grow more interesting, their faces become infinitely more interesting to photograph when they are nearly 60 than when they are nearly 20."

"I wasn't hell bent on doing portraits, I was just keen on taking pictures," he explains. "Portraiture has become something of a specialty for me because when I went to work for *Vogue* I was given a lot of portraits to do, and so I started. I never really meant to specialize in it, but I don't see myself as essentially just a portrait photographer."

"Taking photographs is an immensely satisfying occupation I think, in that you have something to show for your endeavors at the end of the day. I have now completely embraced digital photography. I haven't shot any film for four-and-a-half years now. With digital I see my results instantaneously and the satisfaction of taking a photograph or achieving what you set out to do is most pleasurable. Another great thing is that you can see exactly what you are getting, you can really look at the detail, you could never do that on a Polaroid."

Once Lichfield found digital he never looked back. In the small format, he works with the new Olympus E1 system and on the larger format he uses a Hasselblad with H1 digital back. "Which is really fantastic, that you can be shooting 22,000,000 pixels and you have gotten all the information you need for a very big file."

"I have done posters for the street, billboards for advertising agencies on the Hasselblad, which I could never have done in the old days." Lichfield finds it funny how some professional photographers have been reluctant to move into the digital arena. "Capturing as we go along is the main thing we do. And the great thing with digital is that we are able to show the subject the way we are going. They can come and take a look at the screen and I am able to find out if they like the direction in which we are going."

Lichfield enjoys his work most when he has completed a job that pleases him and his client. "It could be a private portrait, it could be an advertising agency, it could be an editorial. I am happy when I am making everybody else happy, when you do a job well and there is a general rejoicing, which is a nice thing."

He believes making a portrait is something of a joint effort. "It's not just me taking a picture, it's me taking a picture of somebody else who is coming halfway to meet me. I tend to rely on my ability to engage people in the procedure and with the same endeavor that I am trying to achieve."

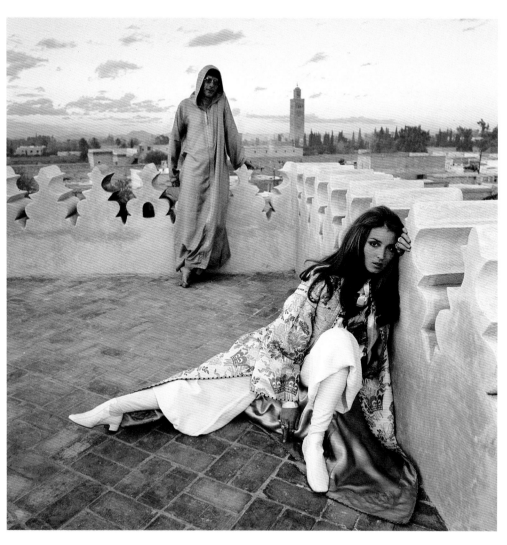

Paul Getty, business executive and one-time world's richest man, and his wife, Talitha. "This photograph was taken at Paul and Talitha's house in Marrakesh, Morocco, for American *Vogue*, in the late 1960s. Talitha was a great hostess, and used to hold enormous house parties to which the jet-set flocked. Wild and flamboyant, even by the standards of the time, Talitha's parties were fabled, and many of them took place on the roof shown in the picture, and lasted for days on end. Talitha is draped, as usual, in some of the beautiful, bizarre clothes that she loved to wear."

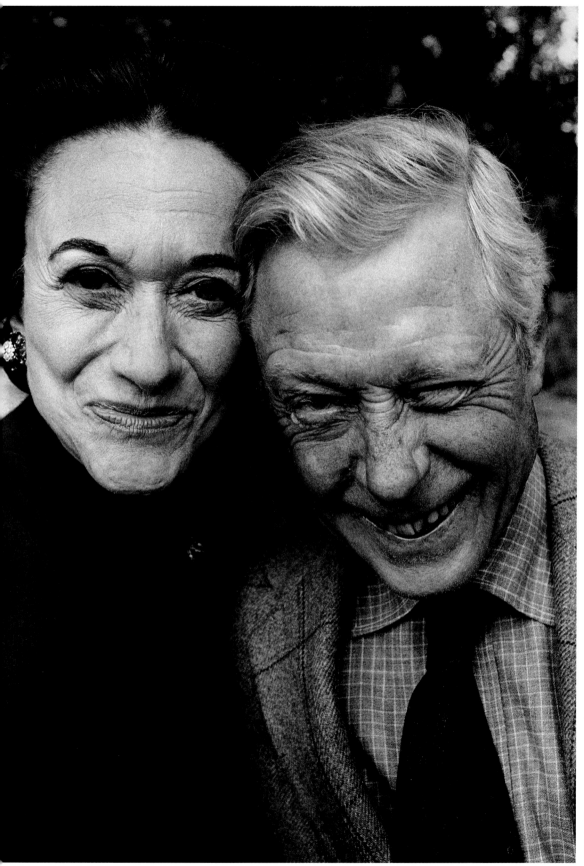

The Duke and Duchess of Windsor
"This was my first assignment for American *Vogue* in 1967 in France. I fell off my chair deliberately to try to get an expression. They were not famous for their expressions, as Richard Avedon discovered. He had to pretend something awful had happened to get some expression out of them. But I just fell off a chair. I deliberately slipped and took the picture on my way down!"

Sir John Gielgud, actor.
"This was 1988, he was a famous Shakespearean actor, one of the great figures of the British theater from the 1930s through to the 1990s. There's not really much more I can say about this one…"

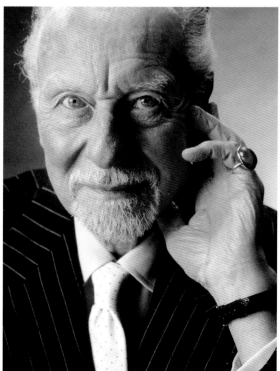

Lord Lichfield

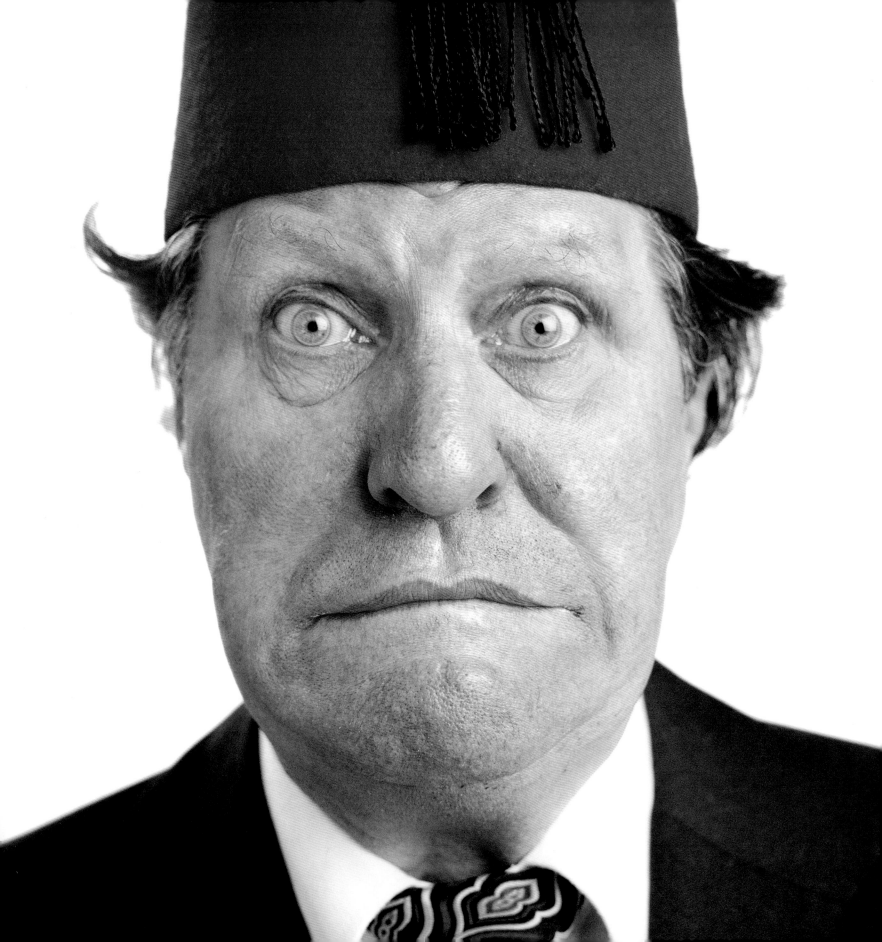

Tommy Cooper, comedian.
"Tommy Cooper was one of the great English comedians of the 1960s, 1970s, and 1980s. He was famous for wearing that red felt hat that he's got on. It's no more than just a shot—it's a picture I did for a magazine, and I quite like it as a portrait. You can see he's a comedian, can't you?"

Harold Macmillan, politician.
"This was on his 90th birthday, the ex-Prime Minister of Britain, and he was extremely old! All I remember is that it was starting to snow, and it was awful, my fingers were freezing, but I got it. This is just a nice shot."

Brooke Shields, model and actor.
"Brooke Shields, age 16, in New York City, 1980. She is probably the only person I only ever shot one roll of. I just realized that in one roll I had it. Something about Brooke just amazed the camera. I think the only other person I have been able to do that with is Audrey Hepburn."

When his subjects are open, he finds that his work moves much more smoothly. "I try to get people to be as open as I can when I am photographing them. Sometimes people are all buttoned up and you're trying to get them to relax, that is terribly important. You're not going to take a good photograph of someone who is resistant. I need people to open up, and if they are, my job is easily done, my job is halfway there."

When it comes to portraiture, Lichfield tends to rely on experience rather than forcing himself to think of new ways to approach something. "I think that when you get older, you have this wealth of experience that you can fall back on which is immeasurably useful, but maybe when you were younger you didn't have [it], so you pushed out your creative feelers a bit more. It's a question of pushing, and my weakness is not pushing myself quite far enough sometimes."

He also believes that he doesn't take tough enough pictures. "I think my pictures tend to be a tad too friendly. With most of the stuff I do, I am paid to make people look good rather than make people look as they really are. They lack a certain realism; my pictures tend to be flattering."

Lichfield admires the work of his old heroes Irving Penn and Richard Avedon, as well as contemporary artists such as Annie Leibovitz, whom he thinks is extraordinarily brilliant. "Snowdon, in his own way, is one of the great portrait photographers. We have a photographer here in England called Clive Arrowsmith who I think is quite good. Bailey, mostly because he is an old friend and I think he has got astonishing flexibility, he can turn his hand to almost anything, and is very polished."

Approximately four million photographs have been shot and collected by Lichfield thus far in his career and he is tremendously proud of his archive. "It's some kind of legacy," he says, "and I suppose most of them are pretty indifferent, but it's the story of my life. It's a pictorial story, in a way—a diary—in the same way that a bit of music can evoke memories in a nostalgic sense, so can a photograph. I can almost smell and sense where I was when I took the pictures, just by looking at one, which is a lovely thing to have, a lovely memory."

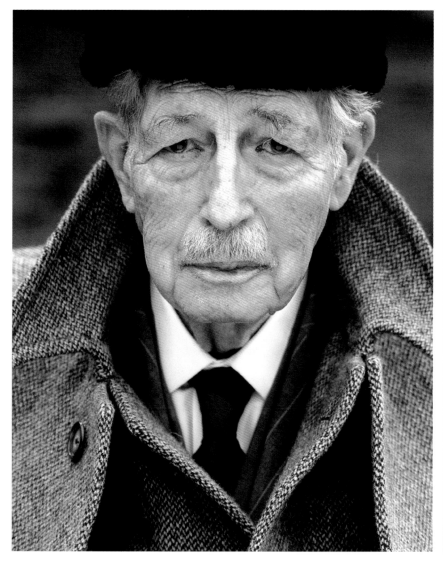 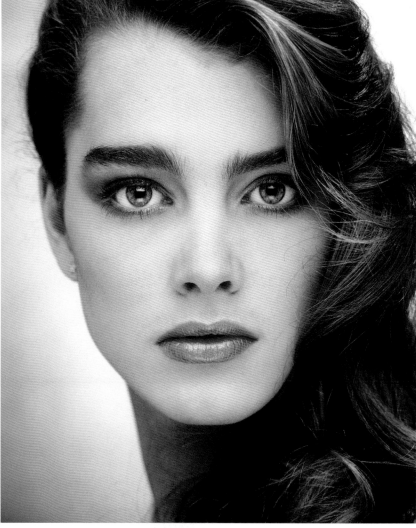

Lord Lichfield

Mark
Liddell

"You can only perceive the beauty that lives outside you, when you feel the beauty that lives within." A man of few words, Mark Liddell speaks through his photography.

In humble fashion, Liddell claims to have somehow stumbled into portrait photography. "I started as a fashion photographer in London, shooting campaigns for Versace, Fendi, etc., and now mix fashion with celebrities. I don't class myself as a portrait photographer, that seems so old-fashioned [to me]."

Liddell is an artist who lives life on his own terms and surrounds himself with visual beauty. He likes taking pictures of people because he feels he is "able to connect with another human being, have them trust me enough to capture real emotion, and find the beauty from within them, all under pressure in a short period of time."

He possesses the enviable qualities of patience and tenacity. He believes in the goodness of people and is able to realize that "even the most difficult or demanding subjects must have a soul." Getting straight to the point may well be another winning quality that Liddell embodies. If he has a weakness, it is that he can't abide being involved with the whole PR routine and entourage that surrounds many of his subjects, and he avoids it all all costs.

For Liddell, the most enjoyable opportunities come in situations where he is able to photograph subjects who are instinctively trusting by nature, and of his work. It is then that he is able to fully express himself through photography and create his best work.

Reluctant to define his photography as any particular style or approach, all of Liddell's images project a humble quality, perhaps reflecting what he considers to be his greatest achievement and a powerful philosophy, "believing in and accepting who I am." As fatalistic as he is philosophical, Liddell feels that there is really no other path he could have pursued but photography.

Christina Aguilera, musician Michelle Pfeiffer, actor

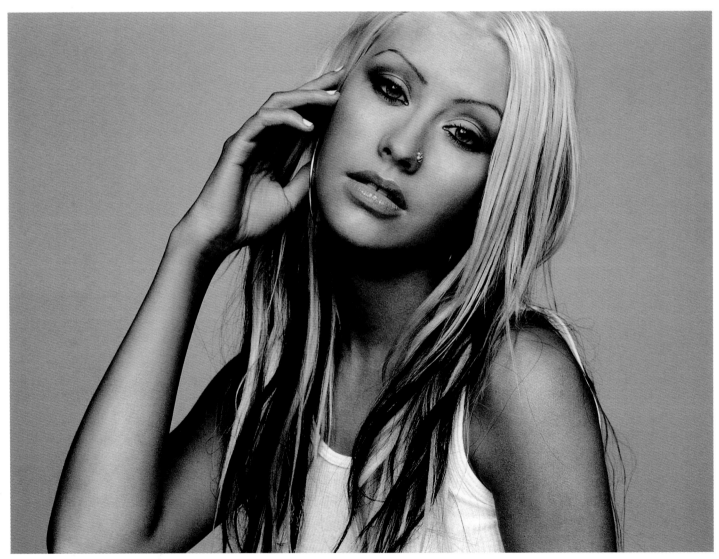

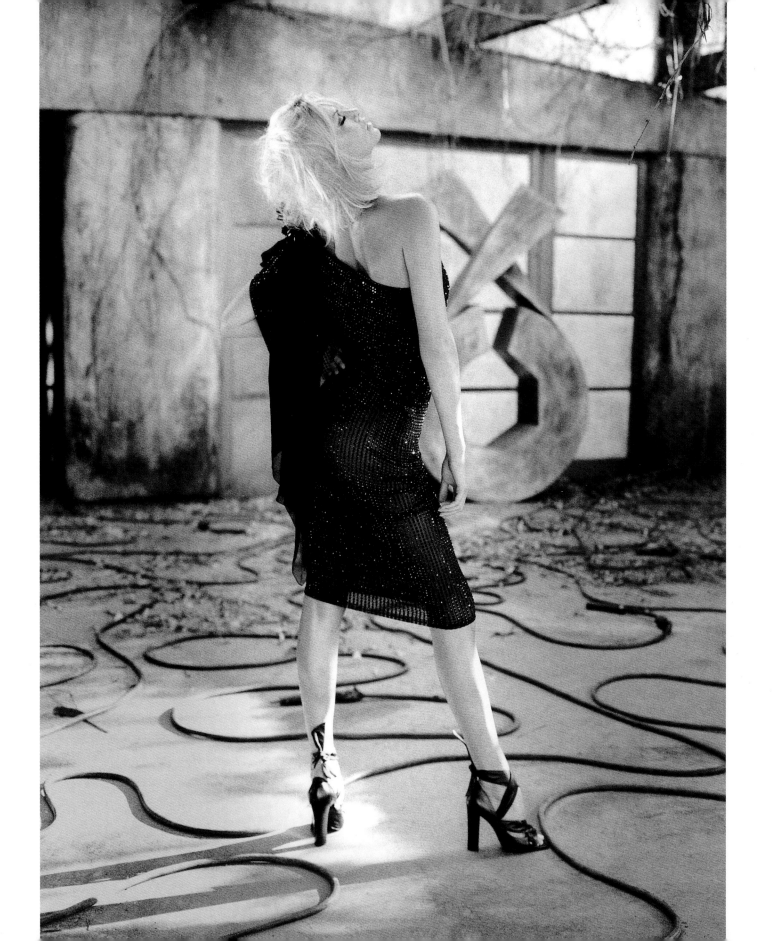

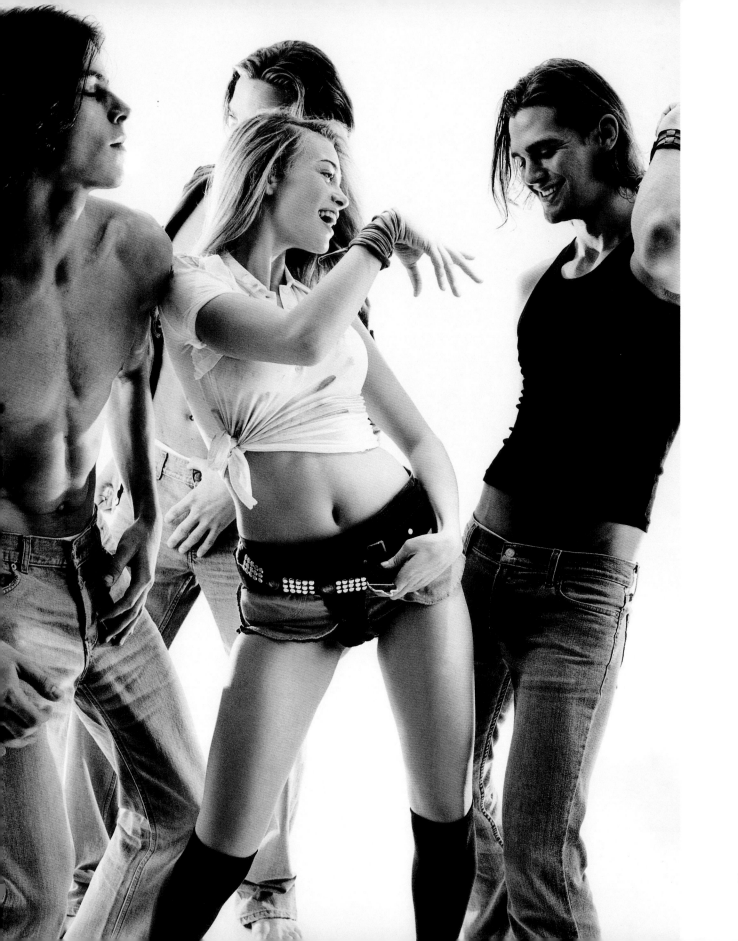

Beautiful young things, dancing.

Jennifer Connelly, actor

James Franco, actor

Mark Liddell

Sheryl Nields

Sheryl Nields was born and raised in Los Angeles, California, and after studying at New York's Parson School of Design she assisted Patrick Demarchelier and Stephane Sednaoui, among others. She has emerged as one of the hottest celebrity photographer in recent years, completing assignments for such high-profile publications as *Arena* (UK), *Elle* (UK), *Entertainment Weekly*, *Esquire*, *GQ*, *Harper's & Queen*, *Interview*, and *Premiere*.

Nields has shot a wide variety of celebrities, including Tobey Maguire, Heather Graham, Milla Jovovich, Naomi Watts, Sheryl Crow, Pete Yorn, Britney Spears, Christina Aguilera, and Whitney Houston. She is an active member of her community, working with charities that support disadvantaged children, participating with Beyond Baroque Community Center in Venice, California, and a number of HIV/Aids groups, including "Act Up."

Nields has a clever sense of humor combined with a sharp wit. She chose portrait photography, as she explains it, "because I have a knack for finding people's flaws—and besides, there is no money in snuff films any more." She insists, "I am a people person, damn it!"

Given this kind of dialog, it isn't surprising that interviewing Nields is a precarious affair, making it hard to tell when she is serious or when she is playing. "I like what I do, I think. The voices in my head (that make it hard for me to live) tell me so. I would really like to photograph those voices in my head that make it hard for me to live!"

She claims that the portraits she takes speak to her and considers that she will find happiness, "when all the portraits I've taken stop talking back to me. They won't shut up…they just go on and on…can't you hear them? Can't you hear their incessant little voices: pushing me, chiding me, laughing and laughing and laughing…" The little voices are obviously helping her along. Some say that Nields's ability to connect quickly with her famous subjects, and her innate ability to impart a sense of personality and energy to the photographic image are the cornerstones of her success.

Nields acknowledges and appreciates that her greatest strength (in relation to her craft) is her complete acceptance and understanding of the fact that there is nothing new in art. "There are no original ideas, is no new ground to break, no boundaries undiscovered. That knowledge keeps me fresh." Conversely, but typically, Nields reveals that this is her greatest weakness, too.

For Nields, inspiration is derived from a wide and eclectic source of people. "The CIA, Henry Lee Lucas, Stalin, Charles Manson, Idi Amin, Keyser Sose, Dorathea Punte, Ed Gein…the cat who works for the *World Weekly News*. Did you see the shots of Sadaam and Bin Laden's gay wedding? Breathtaking." There are more, "Doss, Stephen Jobs, Wozniac, Christopher Guest, Michael McKean, Failure, Egon Schiele, Willy Nelson, Tim Burton, D. H. Lawrence, Diane Arbus, Miss Moneypenny, The Jordanians, Ms. Good Victory, K-hole, Lak, Keith, Hollista…"

Heather Graham, actor

Heather Graham, actor

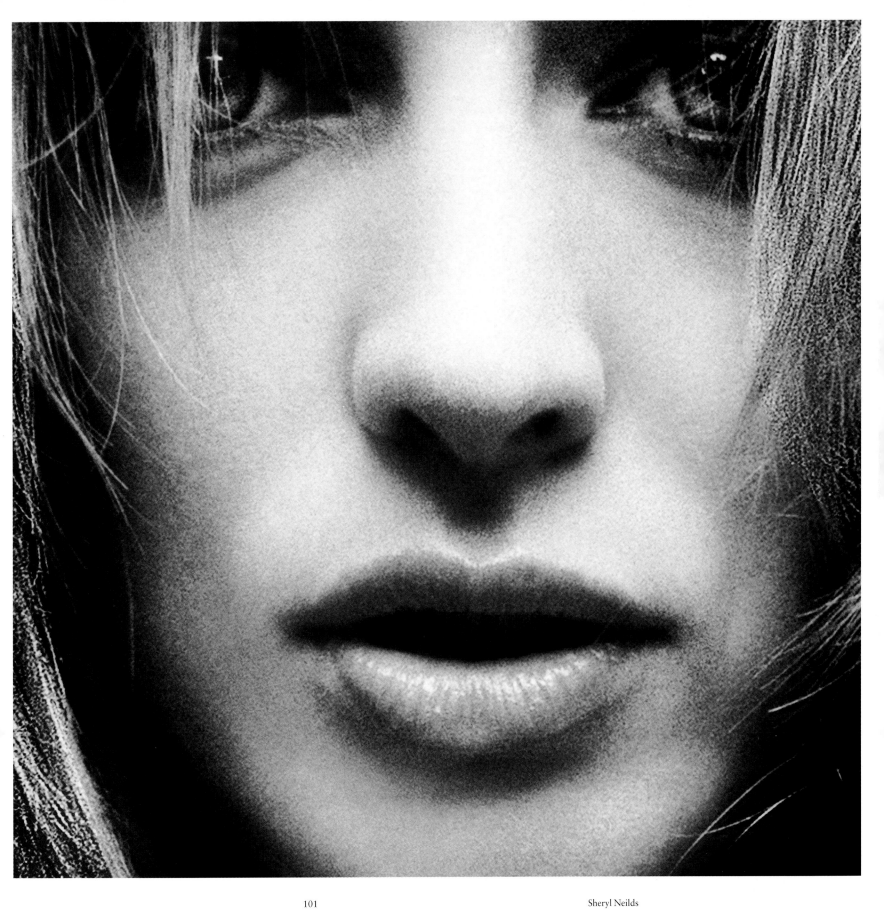

Sheryl Neilds

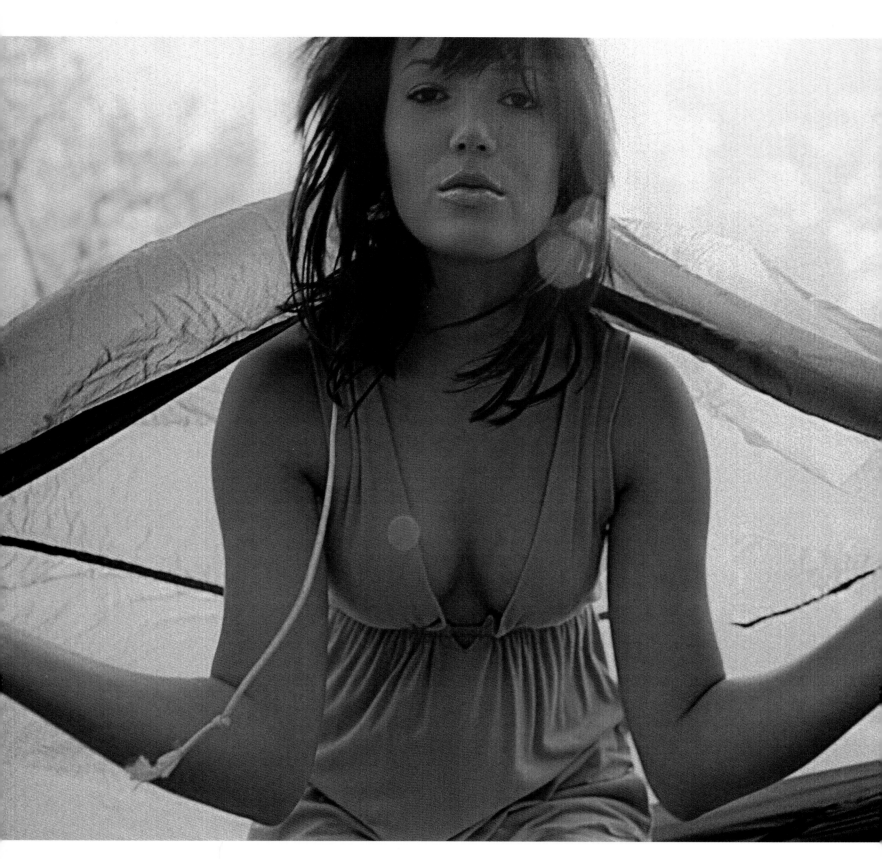

In keeping with her wit, she talks about the first photograph she ever took. "A Polaroid of Roman Polanski in a hot tub with…wait, scratch that… I think it was my thumb." As she considers what else she may have done with her life, she thinks for a moment. "A motivational speaker or an artist for the *World Weekly News*. I thought of Bat Boy waaaay back in the day," she muses, "maybe a haberdasher, I dunno, what are the hours?"

There are two things that Nields considers as her greatest achievements; they are, firstly, her son, Doss, and secondly, "Driving the 405 [freeway in Los Angeles] without ever having shot somebody…" She seeks out certain qualities in a subject: "Self-delusion…Hidden motives…Wealth…Megalomania… Unchecked bi-polar psychosis…Bitterness…Harelip," are some of her favorites.

And that is Sheryl Nields, wild, unchecked, and documenting the most amazing people in the world, capturing their greatness and their flaws. She is a delightfully unique addition to the community of portrait photographers, but would probably never take herself that seriously.

Mandy Moore, musician Tobey McGuire, actor Naomi Watts, actor

Sheryl Nields

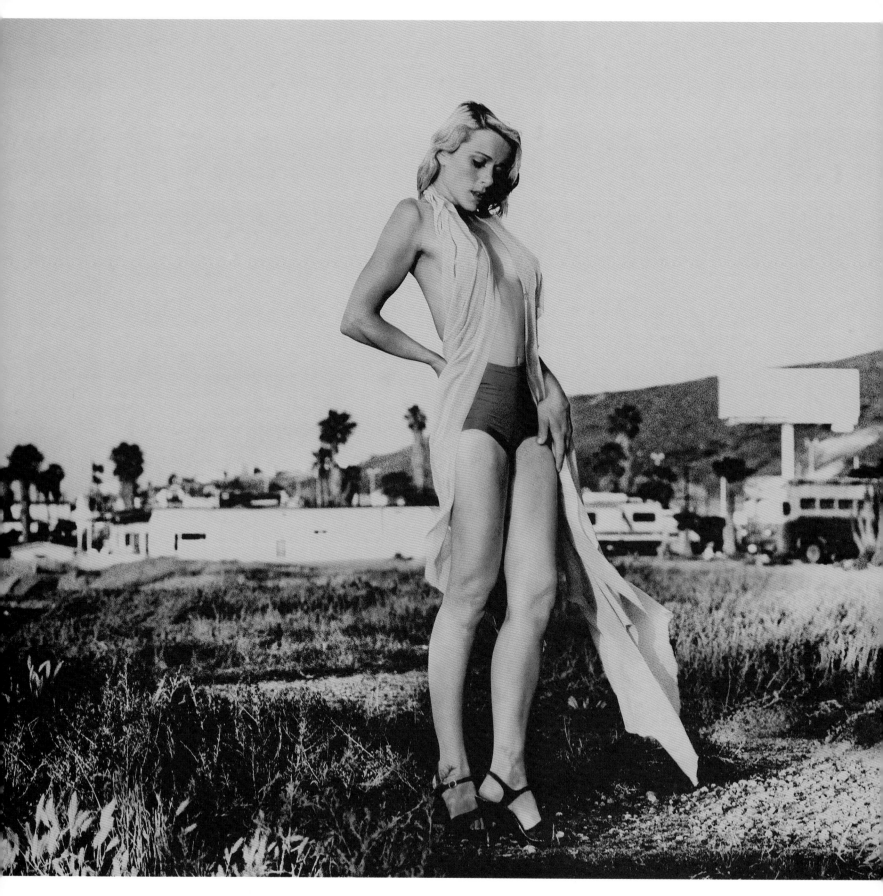

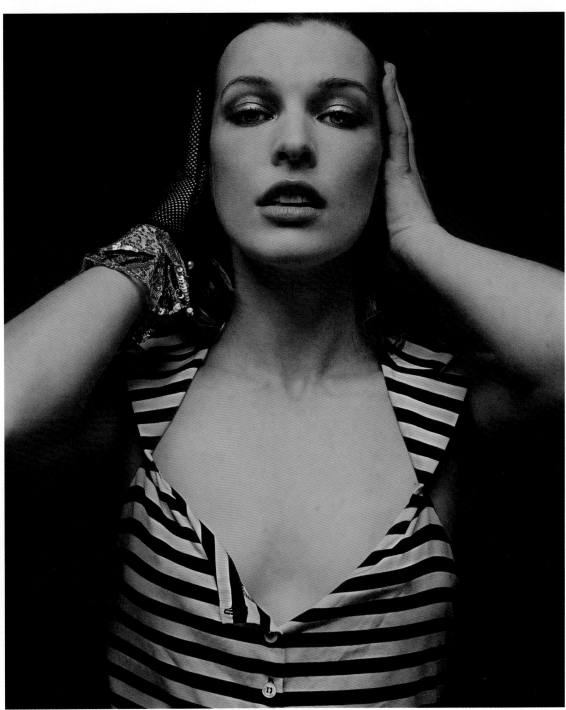

Holly Palmer, singer
and songwriter

Milla Jovovich, actor

Sheryl Nields

Terry O'Neill

Terry O'Neill was born in 1938 in the East End of London. Throughout his youth, his one passion and ambition was to become a jazz musician. "I started out as a jazz drummer, that was the really important thing." Pursuing that dream is what led him to celebrity photography. When he was a teenager, he left school and decided to get a job as a flight attendant with British Airways. "I saw it as a means of getting to New York where I could study the jazz greats," O'Neill says.

The airline had no positions at that time, but serendipitously hired him for a position in their technical photographic unit, which is what occupied him while attending art school. As he pursued his studies, he found himself more and more interested in photojournalism. He captured a shot of a sleeping politician at Heathrow Airport and sold it to the *Sunday Dispatch* where it was featured on the front page. The editor of the paper then offered him a job as their photojournalist covering Heathrow, which he accepted.

He began working in Fleet Street and, at 21, O'Neill was the youngest photographer to ever accomplish this position. He took pop pictures for the *Daily Sketch* and within a short amount of time, found himself part of the trendsetting group of young photographers, which included David Bailey, Terence Donovan, Patrick Lichfield, and Brian Duffy, who kick-started what became the "swinging" London of the 1960s.

"No one thought for a moment that it would last. I've lost dozens of negatives from that period because it didn't occur to me to hang onto them," O'Neill says. During those years it never occurred to him that his work would someday be exhibited at major galleries and museums, including the National Portrait Gallery in London. "My only concern was worrying about getting a proper job," he remembers.

The point came when O'Neill began to consider the possibility that perhaps his photographic career would have longevity. "Having photographed and interviewed The Beatles and the Stones opened all the doors for us. They threw parties so we could meet all of the stars, and that made me think, 'Blimey, these people have lasted, maybe the 1960s icons will, too.'"

As a staff photographer at the *Daily Sketch* in the 1960s, he used his 35mm camera for portraiture at a time when that simply wasn't done. His desire was to bring a sense of spontaneity to his portraits and was very successful in capturing what has been dubbed "the Decisive Moment." His 35mm camera enabled him to create a sense of depth and intimacy to his images and he

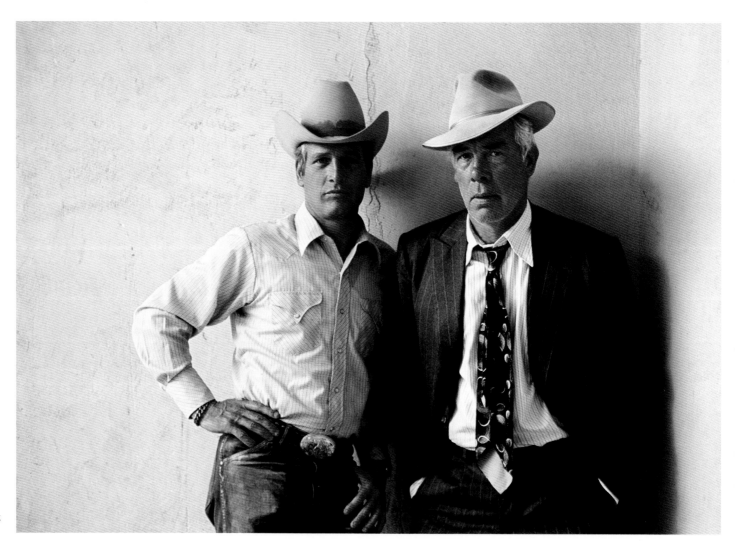

Paul Newman and Lee Marvin, actors
The Hollywood giants relaxing together on set, 1970.

earned a reputation for capturing "imperfect" moments in the lives of celebrities at a time when achieving the semblance of perfection was standard.

It is obvious that O'Neill loves what he does and working with people, which has led him to many high-powered clients from the worlds of politics and entertainment. Over the years he has been commissioned by many major international publications, including *Life*, *Premiere*, *Vogue*, *Playboy*, *Sunday Times Magazine*, *Paris Match*, and *Rolling Stone*. He has shot some of the world's stellar personalities, such as Winston Churchill, Joan Collins, Groucho Marx, The Beatles, Dean Martin, Clint Eastwood, Robert Mitchum, the Rolling Stones, Isabella Rossellini, and Steve McQueen, to mention a few. Uniquely, his commissions also include a portrait of Queen Elizabeth II, which was used as the basis for an engraving that appeared on a British banknote, designed by Alan Dow of De La Re.

He has numerous gallery and museum exhibitions to his credit, including a recent one on celebrity at the National Portrait Gallery in London. He simultaneously published a book, *Celebrity*, to wide acclaim.

When O'Neill accepts a commission, he approaches it like a film director with a movie script. "You can't just walk into a room and hope that Sinatra will make a great photograph. You have to create the scene, the kind of atmosphere that results in a great shot. Lots of people think that being given a great star means you can't miss—but you can. The harder you work and the more pictures you take the more decisive moments you capture. It's all down to experience, being ready for it, anticipating it."

Michael Caine, actor.
British actor Michael Caine pictured in the 1960s. Among Sir Michael Caine's most notable roles are 1966's *Alfie* and *The Italian Job*, and his role as Harry Palmer in a trilogy of films. (CAMERA PRESS/ Terry O'Neill)

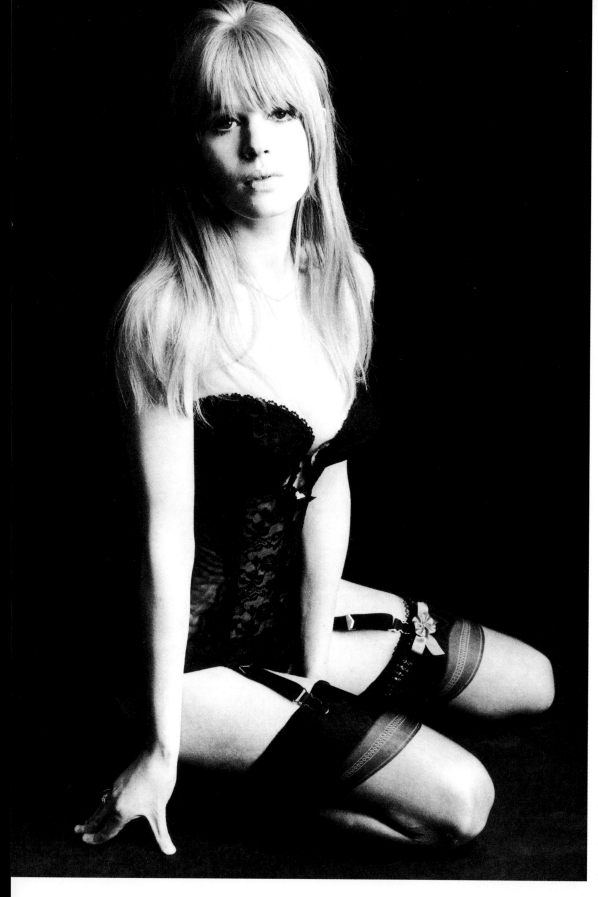

In his well-received book, *Legends*, O'Neill describes how he has developed relationships with each of the celebrities that feature in the book—indeed, he was married to Faye Dunaway. His black and white portraits show O'Neill to be a gifted artist. He captures the candid moments that the world adores: Janis Joplin preparing to perform, Jane Fonda resting between takes during filming, Albert Finney exercising, and special times: a pregnant Sharon Tate showing off baby clothes just ten days before her death, Peter Sellers goofing around with Lord Snowdon, the first meeting between Elizabeth Taylor and David Bowie. There are shots of Mick Jagger dressed in a business suit, Frank Sinatra on location in Florida with his bodyguards, Sammy Davis Jr. rehearsing, Laurence Olivier in drag. A glittering photo album of stars.

O'Neill still holds out hope for a second career as a painter. "I've always wanted to paint. I love Francis Bacon—the way he expresses himself is pure emotion. Four years ago I got around to taking art classes, but it didn't work out. I found I couldn't express myself emotionally the way I do with a camera. Photography is all about emotion. I'll have another go [at painting] when the time is right."

O'Neill is a veritable historian of the world's life and times. He continues to document events and people with his unique and engaging point of view and his ability to freeze a moment in time, capturing the "unquantifiable X-factor of celebrity."

Marianne Faithfull, singer
Marianne Faithfull was a key figure of the swinging sixties. Famed for her liaisons with Mick Jagger and other members of the Rolling Stones, Faithfull was also an acclaimed singer. Fame and rock excess from an early age led Faithfull into the underworld of drink and drugs. But she has made several comebacks, culminating in her autobiography *Faithfull* in 1994, and a string of acclaimed albums, including *Vagabond Ways* (1999) and *Kissing Time* (2002). (CAMERA PRESS/Terry O'Neill)

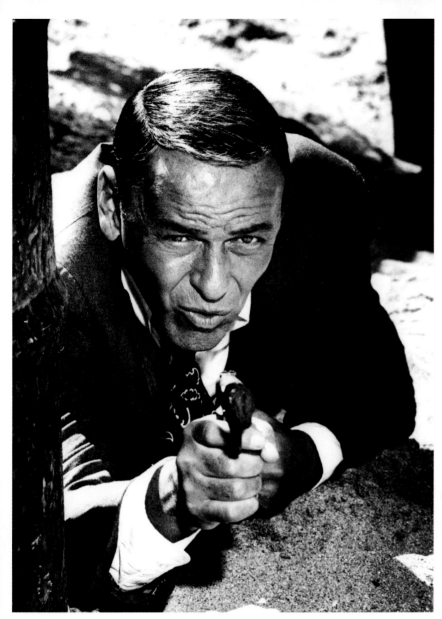

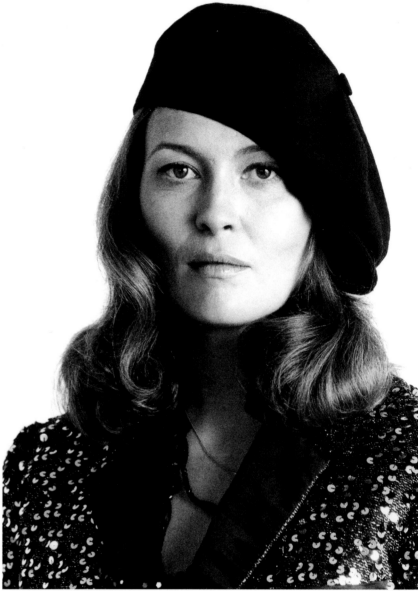

Frank Sinatra, singer and actor.
Shot during filming of *Lady in Cement*. (Camera Press Digital)

Faye Dunaway, actor.
American beauty and leading Hollywood actress, Faye Dunaway, pictured 1975. Born on 14 January, 1941, Dunaway came to prominence in the 1967 film *Bonnie And Clyde*, in which she co-starred with Warren Beatty. (CAMERA PRESS/Terry O'Neill)

Terry O'Neill

Frank Ockenfels III

Ockenfels is a New York-based photographer who has spent 17 years working as a portrait photographer. His images have graced the covers of *Rolling Stone*, *Esquire*, *Premiere*, and *Newsweek*, among a vast and impressive list of publications. He has photographed musicians, celebrities, corporate heads, and probably your next-door neighbor.

He shoots movie posters for Paramount, Miramax, Warner Bros, Focus Features, and Universal, and has also done television campaigns with all the major networks. Seven years ago he began pursuing directing as well. He has overseen many major music videos as well as commercials for the likes of Nike, Converse, K-Swiss, Canon, and *The New York Times*.

He is certain that his first picture must have been taken on a bad instamatic. "My mom said I used to take the camera out and shoot pictures of cars. Then, when I got to the point that I had my own camera, I'd go shoot cemeteries."

Frank sees portraiture as a conversation and, "I like conversation," he says. "In the process of how I shoot, there is always a conversation, whether it be with the person [I am shooting], or in my own mind. I am having a conversation with myself, and trying to actually solve the problem at hand. I am always trying to find the answer to a situation. And trying to make a conversation that people could easily be part of."

"I'm a photographer that believes that you don't make people jump through hoops, you kind of go with them. I always say things to people like, 'if you turn your head that way, does it seem natural?' Otherwise it feels like I am imposing my will on them. And I don't feel that that is a portrait."

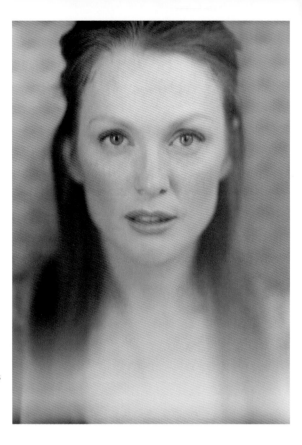

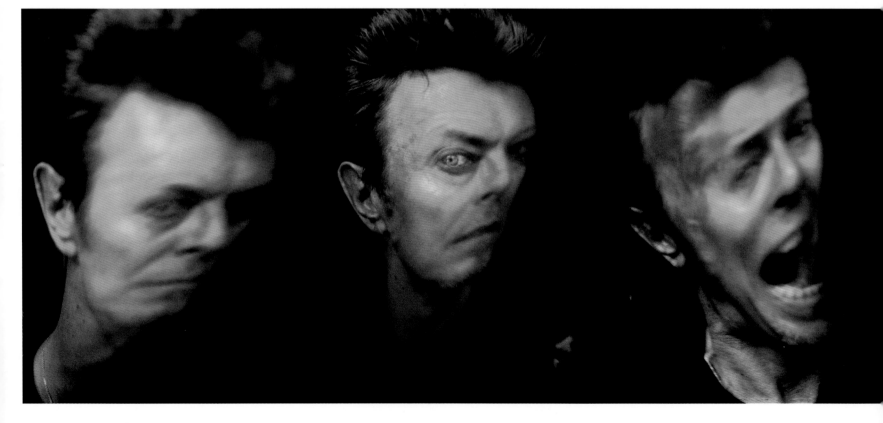

Julianne Moore, actor.

"I think this is a great photo that encapsulates who I am. It was a shoot for *New York Magazine*. When she showed up she apologized, and said she couldn't stay very long to do the portrait. I thought we should go outside, so I quickly threw together a few things that were available, and we went outside and shot the portrait in 20 minutes. We shot two different ones and this was the first one that we shot. It's a mixture of three different kinds of light. Her sheer beauty is something you can't really get beyond, she could be wearing a burlap sack and be gorgeous. It's a total collaboration between photographer and subject; she was present. You'd don't need any more than 15 or 20 minutes with her because she is so present and gave it so much."

Chloe Sevigny, actor.

"I have always liked this picture and it's really funny, because I am always somebody who loves shooting someone's head and shoulders. The picture of her standing on the roof was probably much more honest than probably the other portraits I shot of her that day. I allowed myself to step back and use a camera I'd never used. I think I used that camera once and that's the picture I took. And then I got rid of the camera because I could never find any use for it again. I carry about six or seven different formats when I travel, I have a base from which I shoot, but I never know what camera I am going to use."

David Bowie, rock star.

"The Bowie pictures are definitely mine. I've shot Bowie about 15 times, and I guess I always look at these as anti-Bowie pictures. I think they are kind of great and he liked them too, but they are definitely my obsession with Francis Bacon, distorting beauty and what everyone saw as beauty. A musical icon, and I've chosen to remove his beauty and show only the distortion."

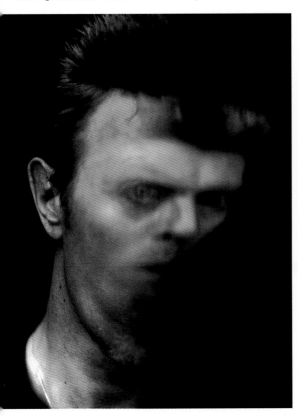

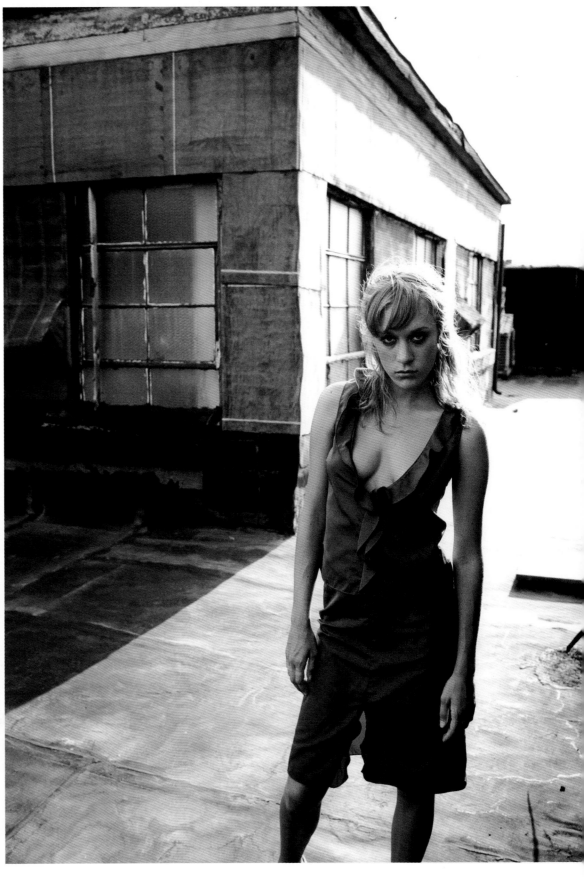

Frank Ockenfels

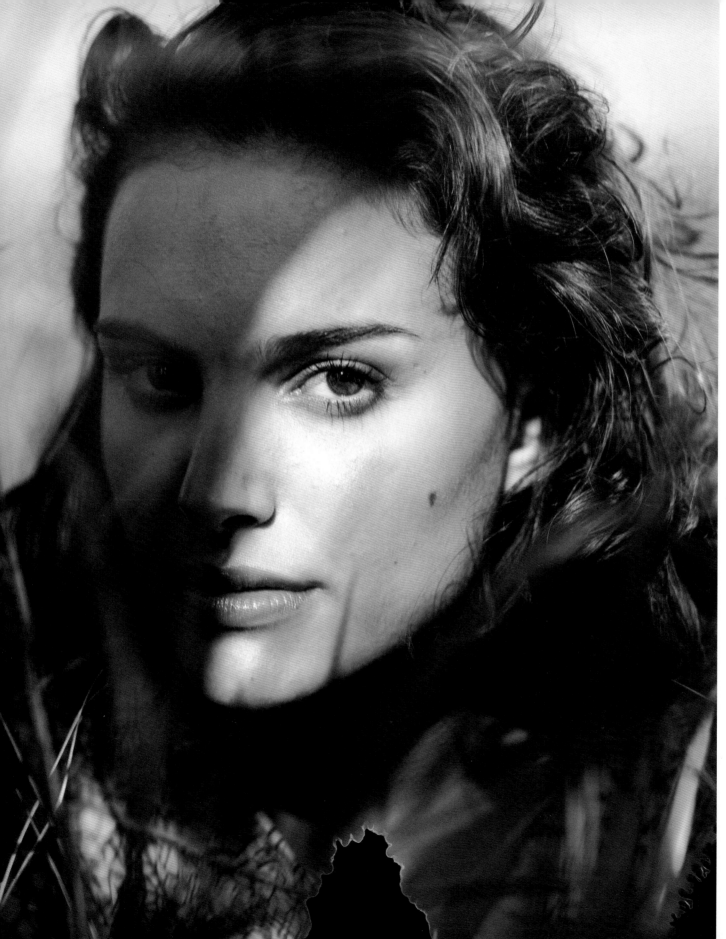

Natalie Portman, actor.
"We were photographing her and the hair and make-up person bent in, and that's his shadow across her face. It was this moment, and I said, 'Stop.' He was leaning there and I said, 'don't move,' and then I was talking to Natalie and he just sat there right next to me. We were all kind of huddled in, in this grass outside of Boston, out by the ocean. She was lying in the grass and there was this nice little moment. It was very contained. It's funny that it's so intimate, because we were in this big field, and there were like ten people standing around, but it had this really nice moment about it, I guess."

Ockenfels probably approaches his career differently than most, in that he feels it has taken a long time to do. "I probably don't have half the status or money that most of my contemporaries have. I enjoy being a photographer and I took the slow process, because I really wanted to learn and I still maybe have 50 percent of what I am supposed to know in life."

Each day, Ockenfels wakes up and it's a clean slate. "When I look at the cameras, and choose which cameras to walk out the door with, to go and see somebody and find that moment, it's rejuvenating." He named his company Purge for that very reason. "When I found the definition [of purge] in the dictionary: start anew, to cleanse oneself of evil doing, the idea was perfect."

Clearly a man of enlightenment, it is no surprise that he loves finding the perfect light. "Walking into a piece of light of the moment. A piece of light that's bouncing off the glass building, or a shaft of light that seems to appear out of nowhere in New York City, and for the moments you are allowed to have it, you use it.

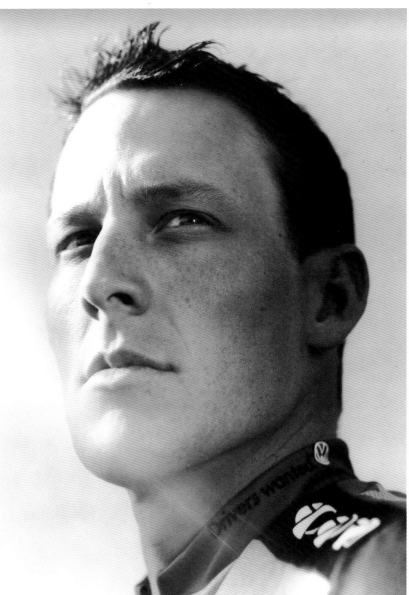

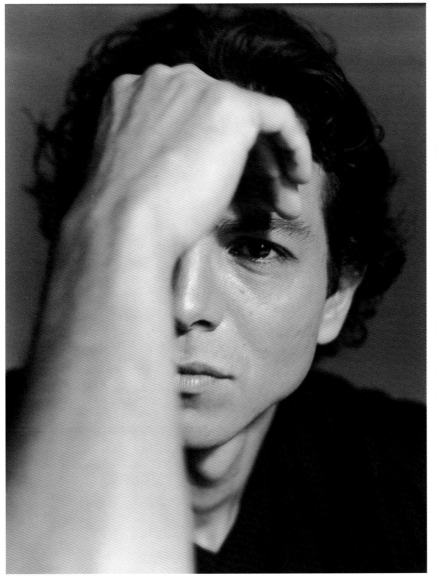

Benjamin Bratt, actor.
"I like the intensity of the Benjamin Bratt picture. This huge hand. And I like pictures that are timeless, like the picture of Conrad Mohammed (*overleaf*)."

Lance Armstrong, cyclist.
"It's like an Olympic portrait of this very black-and-white, Arian, beautiful, strong face looking off kind of thing, and then you realize that it's now, and that intensity, that beauty. I was embracing the moment, we were on the side of his stucco house up in Santa Barbara and the light just happened to be coming off the roof and I used the stucco house as the background instead of using the sky. It was like all these things just kind of happened, when the flare came in and I shot 12 4x5s and only one had the flare in it and nothing had moved, it was like, 'How did that happen?' It was that happy accident that I like."

Frank Ockenfels

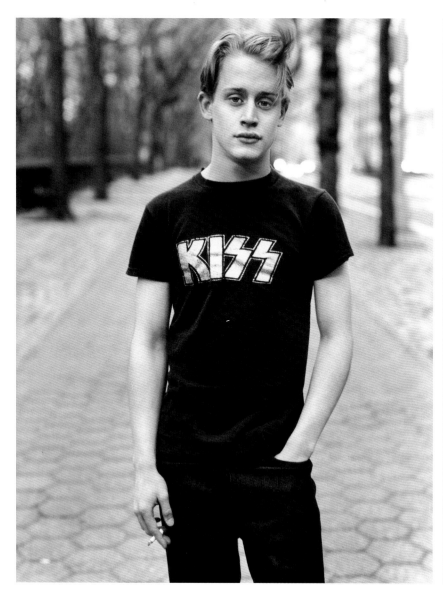

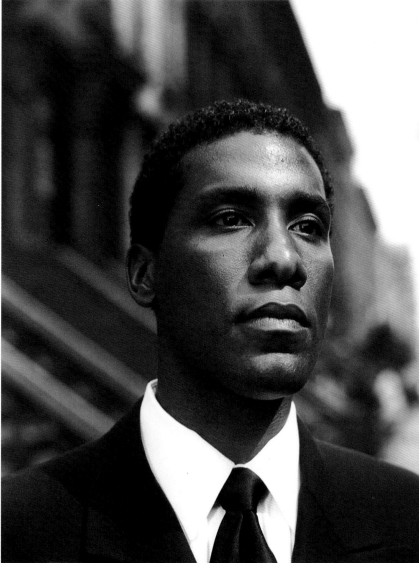

So you embrace that found light, whether it be practical or natural. Or you drop the silver card to the ground and the light bounces off the floor and there's the picture. Happy accidents, that's my favorite thing in the world. The bigger the mistake, the happier the accident, I guess."

Ockenfels' knack for turning on a dime; to accept, and work with whatever that moment is, keeps him moving and learning. "More power to the people that have huge concepts and props and sets, but it's never been my life to create pictures like that."

Perhaps the most profound aspect of Ockenfels is that he is able to allow himself to constantly change. "To reinvent and try different things. Being open enough to know that I don't know anything. I am still learning so much." This is perhaps why he enjoys teaching photography so much. "There is nothing better than when I'm teaching and I see someone get it."

"I always look at the eyes of everyone, and what is common about my work is that there is always something going on in the eyes. You can look at a contact sheet of the exact frame over and over, with the person looking at the camera in just the same way, and there will always be one where the eyes are just right at you."

Ockenfels treasures an honest 15 minutes. "To me, you can shoot someone and spend an hour with them and they'll never actually be there. If they just give me 15 minutes of their time, I will have the picture that I need. I know I got it."

"Paul Auster says: 'As one of my earlier contributors so eloquently put it: I am left without an adequate definition of reality. And I said, if you aren't certain about things, if your mind is still open enough to question what you see, you tend to look at the world with great care, and out of this comes the possibility of seeing something that no one else has ever seen before. You have to be willing to admit that you don't have all the answers, and if you think you do, you will never have anything important to say.'"

McCauley Culkin, actor
(far left).
"I just like this, I don't know, it was kind of a funny moment. He was just standing there smoking a cigarette and he was staring at me and into the distance, so far away...and the stylist named Mary said, "My t-shirt would be perfect for him to wear," so she took her shirt off and handed it to him. It had the word 'kiss' on it, and he has those amazing lips, his eyes and his lips, and he had the cigarette in the lower part and this childlike moment on the top, with this cigarette in his fingers and the cigarette is held with no awkwardness, it's truly like he's holding it like an adult would hold it. Like it was very normal for him to be smoking a cigarette. It has that many levels of who he was without trying too hard."

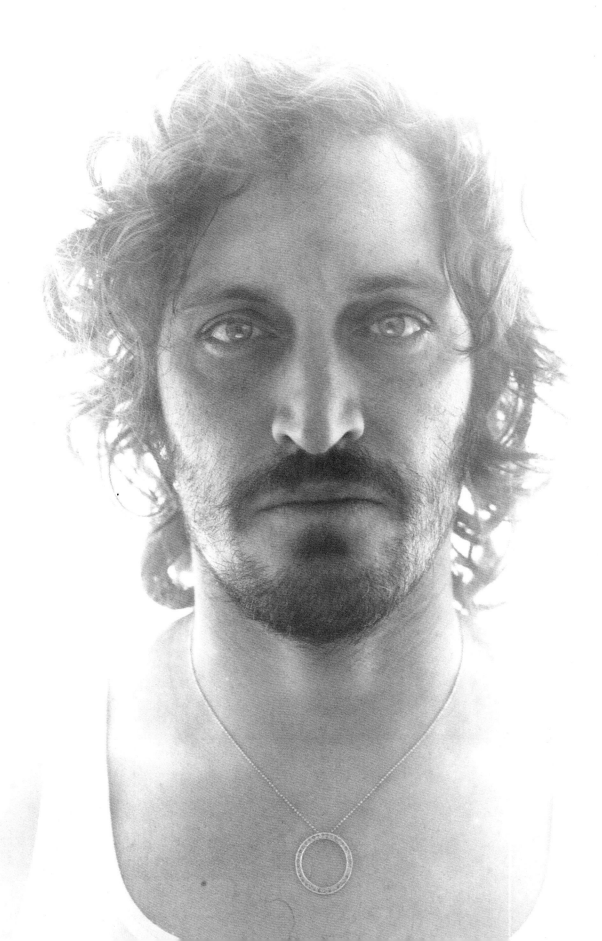

Vincent Gallo, actor and film director
"I just love this because there is such an intensity to it and he is who he is, even his comment when we saw it was, 'this is probably the most honest picture taken of me,' because he has no make-up, there was nothing in the styling, he was just wearing a t-shirt. At that point, you are looking right through his eyes and you see everything about him. He's vulnerable, but at the same time almost too intense for his own good, and on top of all that, the idea that the magazine wanted for the cover was to illustrate the word 'Air,' so to me it was a complete moment of all those things."

Conrad Mohammed, hip-hop minister *(left)*
"This was shot in Harlem, in 1999 or 2000, but it looks like it was shot way back when Malcolm X was around. Conrad was next in line to take over the nation of Islam and he got way too close to the young rappers and everything, he left the whole nation of Islam, too. I shot him for *Esquire*, it was a good shoot and I enjoyed it. It was easy, his whole demeanor, what he was doing."

Martin Parr

Martin Parr was born in Surrey, England, in 1952. As a young budding photography enthusiast, his passion was encouraged by his grandfather, George Parr. "My grandfather was an amateur photographer, so I sort of got the bug from him. My father was an obsessive bird-watcher, so I got my obsessive gene from him. You have to be obsessive to find your passion and make photography work."

He has never seriously considered pursuing anything but photography since the age of 16. Among the first of his influences were copies of a *Creative Camera* magazine and his own grandfather's images. "They were broadly pictorial, but still broadly appealing, but of course, I wasn't as averse to pictorialism as I would be now."

Since studying at Manchester Polytechnic, UK, he has developed an international reputation for his innovative imagery, his oblique approach to social documentary, and his impact on global photographic culture. In 1994 he became a full member of Magnum. In recent years he has developed an interest in filmmaking, and has started to use his photography within different conventions, such as fashion and advertising. In 2002, London's Barbican Art Gallery and National Museum initiated a large retrospective of Parr's work.

Last resort
"I used the same technique as with the Tupperware party (see page 119), maybe with Kodak 400 ISO color film. I started out using Kodak but they stopped making the kind of film I liked so I moved later to Fuji. They're much the same. This is also the Mia Plowbell 55mm wide-angle lens. I was out in the water paddling around and just watching all the things happening on the edge, so I'd have been in and out of conversation with these people. I don't think I needed to ask permission, it was understood."

Ascot [racecourse]
"Ah yes, the phone in front of the phone. It was taken at Ascot and really there's nothing more to say. It's self-explanatory. It's obviously a bit of a joke and a pun. It's one of those things that falls into your lap and you just see it and you do it. Ascot's a very interesting place to photograph people. It was Ladies' Day and there were all these hats and phones. I was working on the England project at the time, where I was exploring my feelings about England through photography. You just know when you see something that's going to work and you just hope you can capture it. This was done with a Nikon with a ring flash. It might have been the SB 28 or 29 with a 60mil macro lens, with 50 ISO Agfa Ultra film (608)."

Martin Parr

Parr considers being a portrait photographer only 5 percent of his work. "A portrait is something you set up. Otherwise, it's just a documentary picture, including people. Sometimes I ask permission because I photograph very close up. Sometimes I don't."

Of Parr's many distinctive qualities, what stands out most about him, and his art, is his honesty, and his ability to enjoy his craft for the sake of it. There are rare occasions when he knows that something is happening in a photograph, and that makes him happy—"When you know that you're on to something, which isn't very often, to be honest." On the other hand, he believes that as a photographer, he has become known for producing a style,

and he is humble enough to recognize that he gets hired to replicate that style. He considers this to be a flaw, if an inevitable one. "You are basically copying what's been done before. But for commercial purposes it is necessary. Not being adventurous enough is another way of putting it."

For Parr, the question of how influential he is is not something he can evaluate himself. He says, "It's not up to me to say anything about my personal qualities. I try to have humility. I think humility is extremely important. I mean, I'm just interested in doing the next thing rather than sitting around congratulating myself, or indeed my peer group. I suppose the only achievement

[in art] is being paid to do your own work. I'm very privileged to be in a position to do that."

Among the artists that he admires are Gary Winegrand, Fenway Jones, Chris Killip, Robert Frank, and William Eggleston, and claims that the quality he likes most in the people he photographs is energy. "A photograph has its own language, it has its own ability to communicate, and it's a magic thing. When it works it's very endearing, and very strange and weird and ambiguous. And that's what one is after—not, therefore, the soul of the person in front of you. You might be interested in capturing the spirit of the time, but not the soul of a person."

West Bay, England, 1996.
West Bay is a small seaside town in Dorset. The series this is taken from starts with suburbia and then moves toward the sea. Although documenting one town, it is representative of many places around the British coast.

Tupperware party.
"This was in the mid-eighties when I was doing a project about shopping and consumerism. It just struck me at that point in time that this was something that hadn't been explored by photographers. I also decided that home selling, and inevitably therefore, Tupperware, came up as an idea. And I remember eventually getting permission—it took some sorting out—to attend a Tupperware party. This was when everything looked right. It's an instinct. You just hope everything looks correct and right. I used a Mia Plowbell 55mm wide-angle lens with a Fuji 400 ISO color negative film and a Norman flashgun. I used a 6x7cm predominantly at that time and I always use the same color film. Norman flashguns are very good overall; quite bright flashguns you can bounce off the ceiling."

Florida, USA, 1998.
From *Common Sense*.

Martin Parr

Nigel Parry

Nigel Parry began his photographic career in 1989 with a show featuring 50 portraits of the members of London's Groucho Club. In 1994 he moved to New York, allowing him to pursue his editorial and advertising work. Since then, he has been commissioned by most of the world's leading publications, including *W, Vanity Fair, The New York Times Magazine, GQ, Esquire, Premier, In Style, Newsweek, Time, The Sunday Times,* and *Amica (Italy)*. He has been privileged to shoot not only celebrities, but also some of the most important political figures of our time.

Parry's expertise has been used by some of the most influential advertising, music, and movie companies in the world, including Pepsi, IBM, Mercedes, BMW, Miramax, Twentieth Century Fox, and Warner Bros.

Parry's work has been exhibited worldwide, and his shows include one with David Bailey at the National Museum of Film & Photography in the UK, and a major exhibition in Perpignan, France. In 1999, Parry had the honor of being the first portrait photographer to be invited to exhibit at the prestigious Cannes Film Festival. Parry has also amassed numerous impressive awards. These include Hasselblad Master Photographer 2004, Photo District News Award for his BMW campaign in 2003, and several American Photography Awards.

His first book, *Sharp*, published in 2002, is available in bookstores worldwide, and Parry is currently working on his second book, *Precious*. In between, he supports various organizations, including the Starlight Foundation and Operation Smile. In the fall of 2003 he went on a mission for Operation Smile to photograph children in remote areas of China.

Parry started out in his teens taking photographs as a hobby. He only ever took pictures of landscapes in color, and one day he bought himself another camera that could accept black and white film, "and then, all of a sudden, almost overnight, I completely lost interest in taking landscapes in color. I started taking photographs of people. From a distance [at first], then I sort of got closer and closer in. I used to take photographs of people wandering around on the streets and this fueled a certain desire, I guess. After a while that got a little bit boring. It was like stealing photographs, I would say."

When he saw this about his picture-taking, Parry realized that he was on his way to not stealing pictures any longer. "I started taking pictures when they knew I was taking pictures of them, and that's how they led to being portraits, really. Coupled with the fact that I really wanted to take portraits."

At first, while working as a designer, he took numerous portraits, including his authors. After some time, he had compiled enough photographs to take them to someone who knew something about photographs to see if the pictures had potential "I was still a graphic designer at that point and I took him my box of pictures. They were literally in a box. It was suggested that I take the photographs of members of an exclusive club—the Groucho Club, in London. They gave me a little exhibition and a party and I photographed a lot of their members. Then I had, again, a box of some fairly well-known and semi-well-known, influential people in the media world. At that point I took my box around different magazines, and about a week after the show *The Sunday Times* called and asked me to take photographs for them."

Gwyneth Paltrow, actor
"Shot at f11, 150 macro lens, and let's just say that she is delightful. It was all very matter of fact. She just came and she was delightful and professional."

Richard Harris, actor
"I used a C-X Hasselblad with a 120 macro lens at about f16 and a small soft spot. This was shot in the back of a theater in Guildford in England. I rode down on my motorcycle and it rained the whole of the way down. I only had one light that was left working because all my lights got wet because I carried them on a backpack on my motorbike."

This was a poignant turning point in Parry's career. "I had nothing to lose and everything to gain. I spent every bit of money that I had on film and framing and all this kind of stuff, because I was still a lowly designer in those days. If nothing came of it all, our savings were cleared out, but at least I still had a job to go back to, which is a good thing."

It turned out to be a fantastic gamble, something Parry proves time and time again that he is willing to risk. "If someone tells me that you can't handle down a half-second, then I will. If someone tells me, 'you shouldn't do that,' then I will immediately go do it. I don't know why I am that way. I was a perfect little child and now I am having all of my adolescent rebel come out. Maybe I'm really only like a teenager in my mind. I think all men stay in their teens; they just get older on the outside."

That rebelliousness is a great asset for Parry when he strives for the perfect portrait. "The moment at which you have taken something, and you realize that the picture you have taken is the 'Be all, end all' is my happiest moment. It's when you realize that nobody has ever taken that before and you won't ever get that again. We hope it is, anyway.

"There is a point at which… I call it my 'sharp intake of breath.' It is when I totally and involuntarily take a sharp intake of breath and I don't know why I have done it, but something has just happened. That is my moment of perfect happiness and it doesn't happen very often these days. Maybe my standards have gone a bit higher, or maybe I have taken something similar to that before, I don't know."

Parry loves to go to the movies and art galleries for inspiration. "I get a lot of ideas from movies and art galleries. I get more ideas from paintings and stuff from art galleries than I do going to see a photo exhibition. I have a terrible way, without realizing it, of copying stuff that I've seen and I try to avoid that. If I am ever photographing something and they say, 'We'll send you some pictures of the subject to give you an idea of what he looks like,' I always say, 'No, don't.' I'll end up literally just ripping off the picture."

You could say that Parry's ability with composition is what makes his portraits so distinctive and bold. It amuses him that most people think that his portfolio is made up of photographs that are mostly 'tight in black and white, wrinkly old men.' "I'd love to photograph women, but I so very rarely am asked to do that. People tend to think of me for black and white, hard, in-your-face portraits, which isn't true. I'd also like to photograph Sean Penn. And Robert Redford, and Clint Eastwood."

Arnold Schwarzenegger, actor and politician
"Available light shot with an 80mm lens. He actually said to me at the point I took this shot, 'Are you sure you are getting all of me in, because it looks like you are chopping half of me off?' I said, 'Yeah, don't worry, I'm just doing some severe cropping.'"

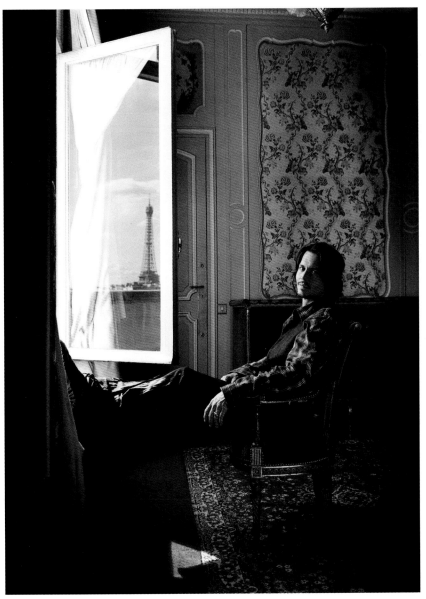

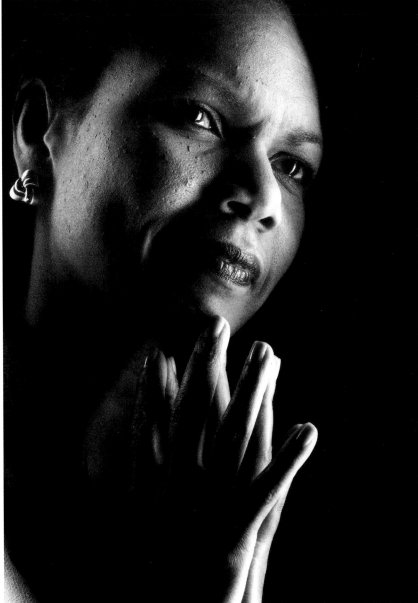

Johnny Depp, actor
"That was available light shot through a window in Paris, about f8.5, 120mm. Just prior to that he stood on a balcony with about two inches for him to stand on and a hundred-foot drop below with no safety nets, just a sheer drop. A very, very nice man."

Condoleezza Rice, political advisor
"I used Pro photo light and 120 macro on f11.5. The only interesting thing about this shoot is that she wore awesome shoes which I complimented her on."

Nigel Parry

Rankin

Rankin has gained recognition as a photographer, publisher and, most recently, a video director, but is perhaps best known for being stubbornly himself — childlike, excitable, happy and, above all else, hilarious. He, along with Jefferson Hack, created *Dazed & Confused* magazine in 1991 while studying at the London College of Printing. They wanted to create a magazine that was different, a publication to document undiscovered talent and ideas while exploring new ways of approaching design and content. By using cover shots of disabled models, big women, models gorging on chocolate, and shots exposing the hands of stylists and assistants, among many other diverse images, *Dazed & Confused* had an impact on the fashion industry's agenda.

Raised in a blue-collar family in England, Rankin made his parents extremely proud by going to college. It was there that he realized he could do anything he wanted to do. "I never thought that I had any talent at anything. It wasn't until I went to college that I suddenly realized that all the people who were doing the things that I really wanted to do weren't any better than me!" So he went on to become a portrait photographer. "Because I didn't

really know what else to do, and I couldn't draw and I didn't want to become an accountant… and I like meeting people. Photography is a great way of meeting people while doing something creative. But mostly I became a photographer because I didn't want to become an accountant!"

At the age of 20, Rankin took his first photograph, and this has remained a vivid memory for him. "I took a picture of a little girl by a swimming pool and she was naked. I suppose that was my first nude! It turned out really pretty and I was so excited about the whole process. I am a very excitable person!" This, then, marked the beginning of a career that would eventually have him referred to as "one of Britain's most notorious photographers." In 2003 he compiled a limited addition book with one of Britain's other notorious shooters, David Bailey, entitled *Bailey + Rankin 2003*.

Unlike other photographers, who are successful and recognized for their own particular style of work, Rankin has made an effort not to have a style that is definable, and to always keep the viewer guessing. "I've never really stuck to one style of image. If you look at my body of work, it's so varied that you aren't sure where I am coming from sometimes. They are all different. I attempt to make them all different."

When asked to reveal the photographers who inspire him, Rankin hesitates. There are so many, he says, that "you could never list them. It would be a book in itself! I love photography. I buy and collect photos all the time, and I go to their shows all the time." When pressed, however, he says, unequivocally, that he most admires David Bailey. "Because he is so cool with me. He took a photo of mine once and after he looked at it he said, 'You're all right, really, aren't you?' and I said to him, 'Maybe in 25 years I'll be as good as you,' and Bailey says, 'Kid, you ain't got it now, you're never gonna have it!' which I thought was really funny. He always calls me 'Kid.' He's like my dad of photography, but more like my older brother because he's such a young soul."

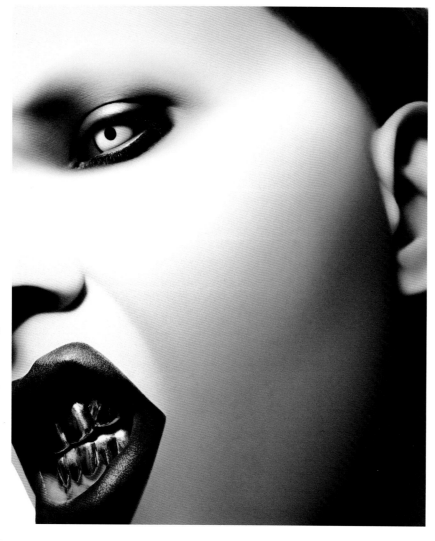

Marilyn Manson, musician
"Manson's a photographer himself. The funny thing about him is that you call him Manson, you don't call him Marilyn. He is totally different to what you think you are going to get. He has all this make-up on and he seems really freaky, but actually he's really quite sensible, rational in some ways, but at the same time completely rock 'n' roll. There are very few people that are as outwardly rock 'n' roll as he is, not in a clichéd way, more in just a 'living large' way. This photo is retouched, it's more like a painting, really. I wanted to do that because I thought that no one had taken him that far before. Really taken him all the way."

Madonna, musician and actor
"That was done for the *Ray of Light* album. We were getting on very well and she was very funny and she said to me, 'You'd better make me laugh,' so I felt like I had to make her laugh. The thing about Madonna is you think that she'd try to be serious, but actually she's cool all the time, constantly. First she puts you at ease, then she pulls it from under you, then puts you at ease, pulls it from under you, and I just thought that this would be a great photo of her. I said, 'Do a couple of fists.' There were lots of really beautiful photos but out of the whole session this was the one that really summed her up."

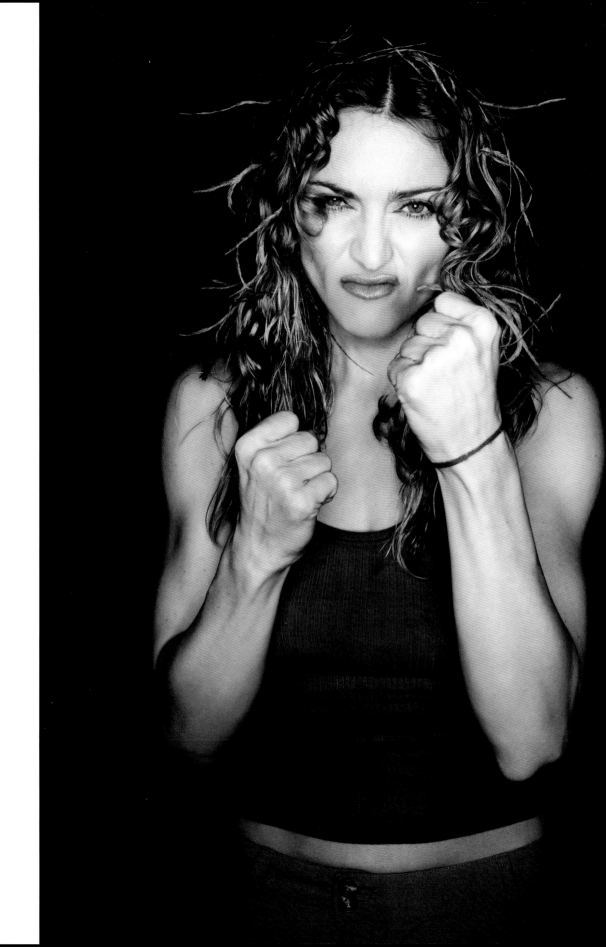

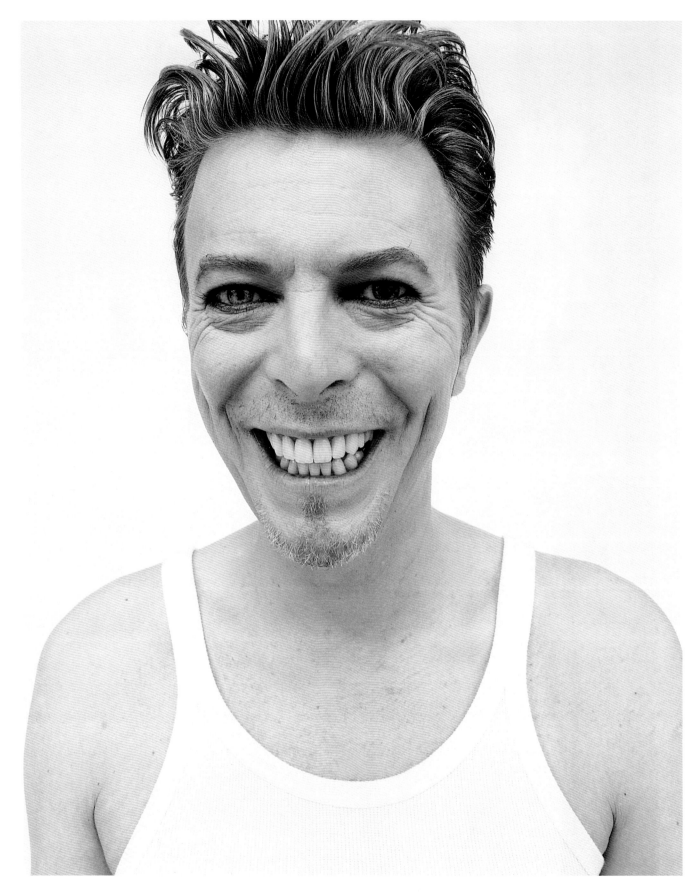

Rankin knows that he has the best job in the world. "It's almost a kind of mapping of your life, a diary of your life. Spending a moment with people who are, nine times out of 10, exceptional. That's very interesting, too, and I love that as well." His favorite assignments are with those he considers "exceptional", but he claims that he would "love to shoot each and every person in the world at least once!" Rankin's current list of those he is keen to shoot includes Johnny Depp and Sean Penn. "I've started to direct now, and I get really exited about working with people that are that talented."

As he matures in his career, he concedes that one of his weaknesses has been not to plan things out. "The older I get, the more I plan my work and the happier I am with the results. The more I become good at delegating and working with my team, the more I can plan ahead and they can plan fully." He also admits that he can be too eager to please. "I get too excited and take on too much sometimes, so I am not working things through. There have been times when people have taken advantage of that."

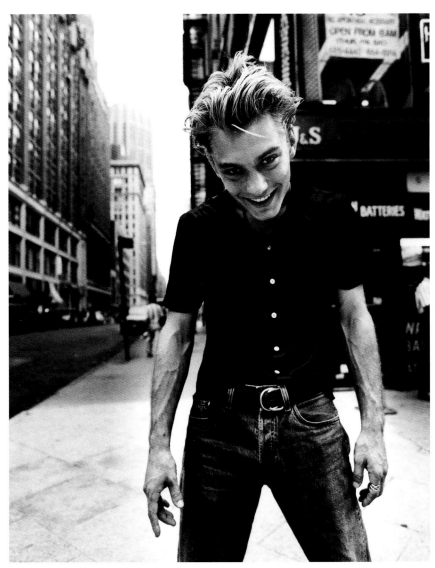

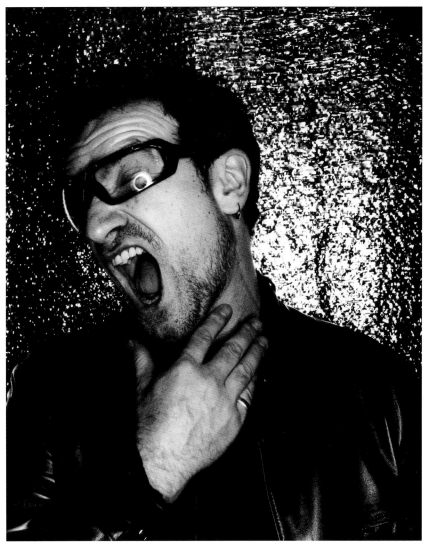

David Bowie, rock star.
"This is very cheesy. I had joked with him about his teeth, and I said, 'Come on, show your teeth to me!' He opened his mouth and I was almost shocked because there were all these new teeth. It's kind of like bathing in a pool that is so brilliant. You are kind of enveloped in this personality. It was a really kind of strange moment, because it wasn't what I expected."

Jude Law, actor.
"This was shot in New York many years ago. I knew Jude when he was in this play off-Broadway. I had actually met him when I was 20 or 21, right when I was starting to take photos. He was a friend of my girlfriend at the time. Jude has an emotion about him—he is always incredible, he is so good looking, so I shot pictures of him. I think we just had a day of fun, not for any reason, apart from, 'Let's just go take some photos.' It was a sunny day and we just hung out and went trainer-shopping after that."

Bono, musician.
"The most interesting thing I could say about Bono is that he's 100% the nicest person I have ever met in my life—the most charming, the most generous. If I didn't shoot him ever again, I would be sad. He inspires me to do things that I wouldn't have done if I'd never met him. This was for a press shoot about five or six years ago when he was on tour. It was only supposed to take five hours but he stayed until after nine o'clock at night. He was yawning at that point and I don't think he was really concentrating when I took the shot. It was an in-between shot, which I think are the best shots."

Rankin

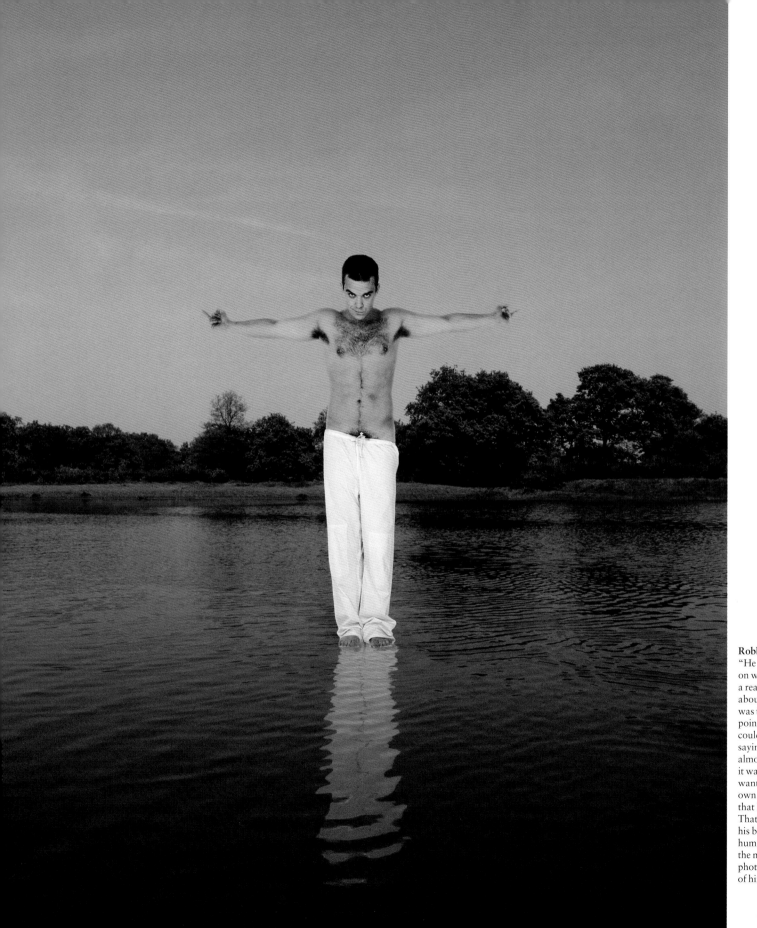

Robbie Williams, musician.
"He is in jeans and walking on water and Robbie has got a really good sense of humor about himself. When this photo was taken he had gotten to that point in his career where he couldn't do any wrong. He was saying that Beatles quote, 'I am almost bigger than Jesus,' and it was brilliant in a way. We wanted to parody him in his own time, as well as the people that look at him as a superstar. That's what's great about him – his brilliant, brilliant sense of humor. He was always taking the mickey out of himself. This photo is about him making fun of himself."

A self-confessed workaholic, Rankin considers his work ethic to be his second greatest strength. "I work all the time, so much so that some people might say that it is a weakness, my great weakness. If I am free for a day I get really jittery, I can't do it." His greatest strength is, "Not taking myself too seriously." It is a quality he values in his subjects. "I like a sense of humor and someone who is self-deprecating, someone who doesn't worry too much about themselves. I really like it when the person I am shooting doesn't stress out too much. They can trust a little bit, you know. I find that most people don't like to be photographed, so by making it fun for them is the best. There are so few people who say, 'Oh God! I loved that shoot, I just enjoyed every minute of it!'"

Although Rankin does use digital on occasion, he still loves the excitement of print. "I've grown to like digital, by pushing myself, but really I still love that moment when the print comes up in the developer, or when I get the contact sheets back… they're in the bag and you open them and you're like, 'ahhhhh.' That's the most perfect moment. I also love it when I get my books back and then I look at them and think, 'I did that.' I get a bit nostalgic about them because, to me, I am kind of amazed that I was there at the shoot!"

His next career move may well take him to Los Angeles, as he adores the palm trees there, with his eight-year old son, a budding rock guitarist, who is also the achievement Rankin claims to be his greatest by far.

Queen Elizabeth
"For me it was a Royal commission so I was actually working for her. She only did the shoot for five minutes and that was it. I wanted to retouch it to make it in the same way I did Manson, but I haven't. I have a really great story about the Queen. When David Bailey met her, she said to him, 'My brother-in-law, you know, is a photographer.' And Bailey said, 'Funny you should say that because my brother-in-law is a queen.' I don't know if that's true; it's a good story though. But the Queen's got a great sense of humor, so she would probably find that really funny."

Rankin

Steve Shaw

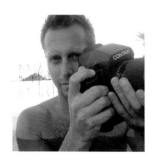

Shaw's interest in photography started when he took classes at school, aged about 14, in Manchester, England. He vividly recalls taking his first picture: "It was of some frozen leaves, frost on some leaves. I think it was the first time I ever developed film as well." He preferred the technical side of the process, the lab work and the developing of film. "I was really into science and chemistry, and I suppose developing was fascinating for me—the way you see the pictures come out in the darkroom."

Once he started working commercially, he shot cars, bedding, and products. "Everything that didn't talk back to me!" He then took a job on a cruise ship in the Caribbean and shot 17,000 portraits a cruise. "It was hell, but a lot of fun. I thought it was a good way to see the world, but it was a lot of crazy work. We took passengers' pictures after dinner on certain evenings. I guess that's what gave me a bit of confidence to be able to talk to people because most of the passengers didn't want to have their pictures taken. I was rather good at it." After that, Shaw and some of his friends drove from Miami to Los Angeles, and he got work at a local 'Glamour Shots', a chain of portrait studios located in shopping malls in the US. "One day this guy came in and wanted to be made up like a woman, and that was it for me." He eventually quit the job.

Shortly after, he found work in a lab in Los Angeles. "I would see the pictures that would come through and I thought, 'what am I doing printing these pictures? I should be taking them.'" At that point he began presenting his portfolio to modeling and photo agencies. It wasn't long before his career in fashion and celebrity portraiture began. It's interesting to consider that he never really intended to become a portrait photographer. "I guess I just kind of fell into it," he says.

Although Shaw loves taking pictures, he has grown to dislike some of the aspects of celebrity portraiture business. "It's dealing with some of the people—the publicists and those who try to control what you do. It seems to be all about the money now and protecting the image—the way the celebrity looks. Ten years ago you could pretty much do what you wanted, but now there are too many people trying to protect the image." Make no mistake, however, Shaw still loves his work. "I don't feel like I go to work. There are times when I complain about it, and then I have to slap myself and realize that I get to shoot girls in bikinis for a living. I mean, how ridiculous! Someone pays me to go do that, and I'd do it for free."

He is a genuinely warm man who is surrounded by beautiful women and celebrities constantly, but he is not pretentious at all. "I grew up in Manchester, and the people there are not impressed by anything or anybody. In Los Angeles I am surrounded by celebrities and imagery, and I am not impressed by any of that. When I photograph somebody, half the time I don't even know who they are. Occasionally, though, there is someone that I know, and that sometimes makes me a bit nervous."

The best moment for Shaw is when he knows he's got the shot, no matter who is in front of the lens. "It's when you just know you've got something, and that makes me happy. I can see it in someone's face, and I don't need to take another shot. I know I've got it—that one picture."

Mena Suvari, actor.
"This is one of my favorite shots—Mena is a ham in front of the camera. Shot at Smashbox Studios, Los Angeles. Lit from above with reflectors to bounce light back in."

Charlize Theron, actor.
"This was the fastest shoot I have ever done! We shot at the Paramour Estate in Silverlake. Charlize was running late anyway and she had to fly off to New York City that afternoon. We shot a cover and four pages in three hours, including hair and make-up. She was fantastic in front of the camera—very professional, and stunningly beautiful."

Steve Shaw

Ray of Light
"This was shot on a freezing cold beach in Malibu. Brighdie Grounds is the model—she's a true pro. It was for *Detour* magazine. We had to do eight shots in two hours. Shot with filled daylight with strobe, on Kodak VC film."

Kylie Minogue, pop star *(right)*. "My all-time favorite person to shoot. Incredibly beautiful and always the pro. She is so tiny but perfectly proportioned. This was from a shoot for her record company and a magazine cover, and the shots have been used all over the world, but I never tire of them. Kylie knows exactly what she wants, but is always willing to try new things. Shot at my studio in London, with natural light filled in with Keno flows."

Estella Warren
(facing opposite, right)
"This was shot for *Movieline* magazine at a nightclub at Hollywood and Highland, which was a dreadful location but I think we made the best of it. Estella was a true pro, plus she used to model so she knew exactly what to do. Lit with Keno flows and HMI."

Shaw is enjoying the transition into digital technology, yet finds digital work more time-consuming than film. "With film, you send it off to the lab, it's processed, you get the contact sheet, pick out the ones you like, and send them off to the client. With digital, you've got to download everything, then process them all and burn them to a disk. There is a lot more involved for me. I edit on the screen as I go, so I can't really have someone else do it. But the quality and convenience of digital is amazing."

Shaw's photographs are sexy, strong, beautiful, and timeless. He is inspired by the likes of Helmut Newton and Richard Avedon. "I also really like Mert Atlas and Marcus Pigott. They do Louis Vuitton and Sony campaigns, and every single one of their pictures you could have on your wall. They're modern, but beautiful pictures. The magazines that have a picture of theirs in them, I could never throw away. I suppose that is what you want ultimately—a picture that someone won't throw away."

Of all the qualities that he appreciates in his subjects, intelligence is his favorite. "Intelligence comes through, and it shows." Of course, much of the time he is struck with the challenge that can present itself when he photographs actors. "It's difficult at times because you are dealing with somebody who is trained to be completely unaware of the camera and move around, yet you are telling them to stay there and be still, to look at you and play some kind of emotion. It's foreign to them. Kevin Spacey is always fantastic, though. He is a smart guy and it comes off. He gives it off. He's very animated, and has a good personality. He gets it."

Shaw is famously easy to work with, and is renowned for drawing out the sensual side of his subjects. His self-effacing charm is what wins him the jobs he loves, and he considers it a great achievement to continue getting paid for doing them. "I get to shoot for *Playboy* and *FHM*, and they pay well. I'd do that for nothing!"

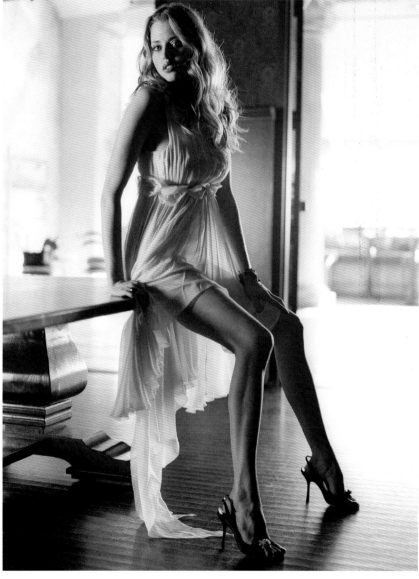

Steve Shaw

Lord Snowdon

Born Anthony Armstrong-Jones in London in 1930, this master photographer became the Earl of Snowdon following his marriage to Princess Margaret in 1960. While studying architecture at Cambridge, he was encouraged to take portraits of people in the theater by his uncle, acclaimed stage designer and artist, Oliver Messel.

For over 50 years Lord Snowdon has photographed many of the top figures in the world for the likes of leading publications including *Vogue*, *Vanity Fair*, and the *Telegraph Magazine*. He has also built an impressive portfolio of documentary photographs that express his passion for a number of humanitarian causes.

As Snowdon pursued his portrait photography he deliberately veered away from the stuffy tradition of fashion and theatrical portraits. He prefers to capture an intimate side of the subject:

"You have to strip people of their poses and disguises." He breathed new life and a fresh style into the world of formal portraiture, and is renowned for it.

In the 1960s Snowdon documented the swinging mood in London at that time more profoundly than any other photographer on the scene. "In the old days I did appalling, gimmicky pictures, but I've tried to become simpler. Now I wouldn't even mind taking a boring picture if it revealed something truthful about a human being."

His subjects hail from a vast cross-section of the arts and public life, and are striking in their simplicity and often comedic edge. Dancers, actors, politicians, painters, and pop stars from all corners of the earth, Snowdon has captured their image and been acclaimed by *Vogue* as "one of the principal visual historians of the age."

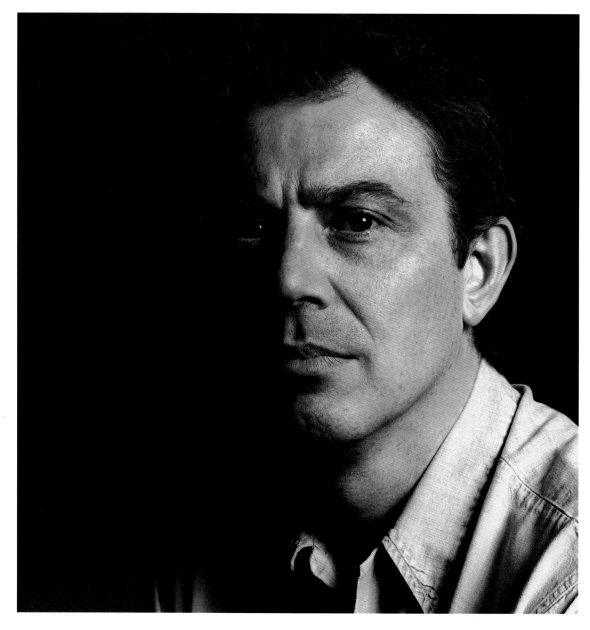

Princess Margaret
(facing opposite)
President of the Royal
Ballet, 1967

Tony Blair
British Prime Minister
1997–present. Featured in
Vanity Fair.

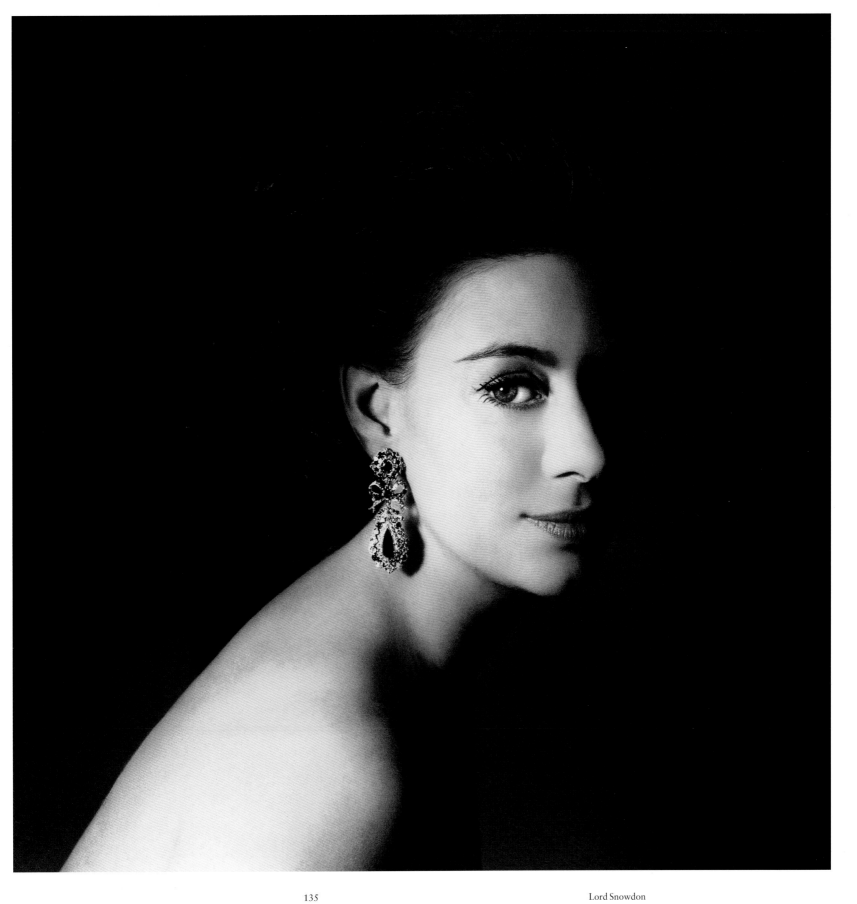

Lord Snowdon

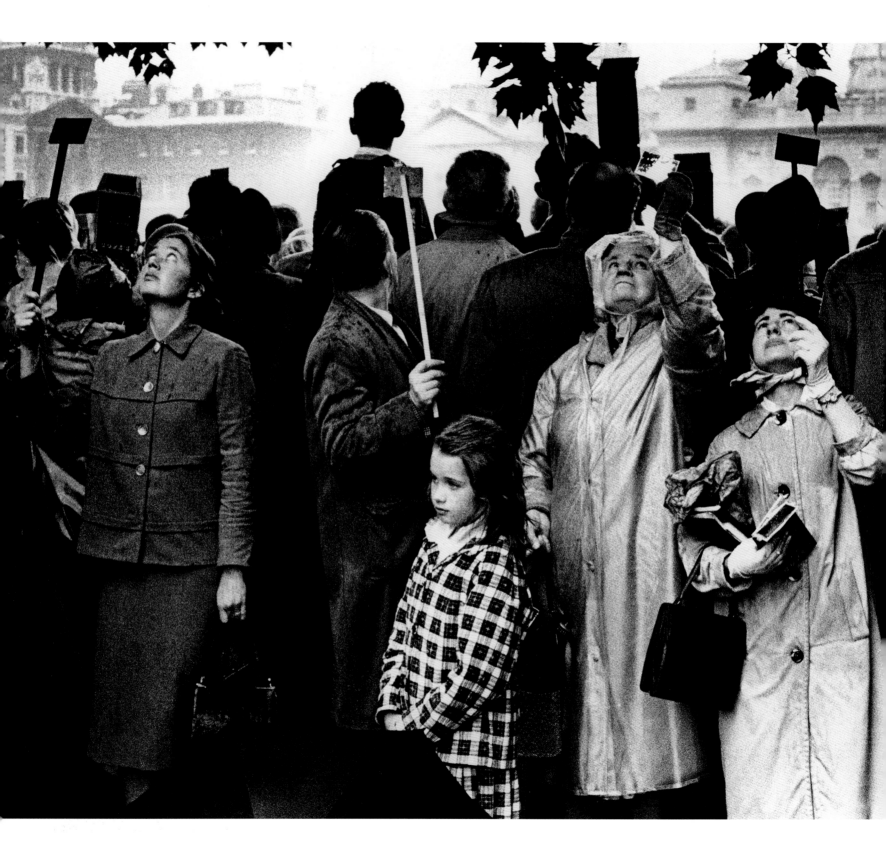

His subjects include many leading actors from theater and films—Uma Thurman, Nigel Hawthorne, Peter Ustinov, Fiona Shaw, David Bowie, Jude Law, Greta Scacchi, Rachel Weisz, and Tom Cruise, to name a few. Snowdon has also captured the images of famous directors, designers, and writers including Alan Bennett, Arthur Miller, Harold Pinter, and Alan Ayckbourn. He is also the official photographer of Queen Elizabeth II.

Snowdon considers any description of his work as an art form to be pretentious. "The subjects are what is important." His view is consistently authentic, albeit not always kind, and when viewing Lord Snowdon's acclaimed work it is hard not to classify it as fine art. His unique talent is his ability to capture the character and emotion in each of his subjects, and to reveal what is referred to as "interior moments" in each of them. From the rich and famous, to Angolan children suffering from polio during an outbreak of the disease, he is truly empathic and selective about his work. Having had polio himself, he went to Angola as part of a campaign to photograph both stricken and recovering children who had been vaccinated. "I hope my pictures help to send a strong message to governments and donors around the world."

While he is best known for his fashion photography and his society portraits, his frank display of life from alternative perspectives is honest and thought-provoking. When he speaks about his work he remarks thoughtfully, "To me, the goal is to move people, to make people think, but never, never at the expense of the person you are photographing. To laugh with, yes—but never to laugh at." Perhaps Snowdon, his philosophy and his work, can be best summed up with a few more of his own words, "It's no good saying 'hold it' to a moment in real life."

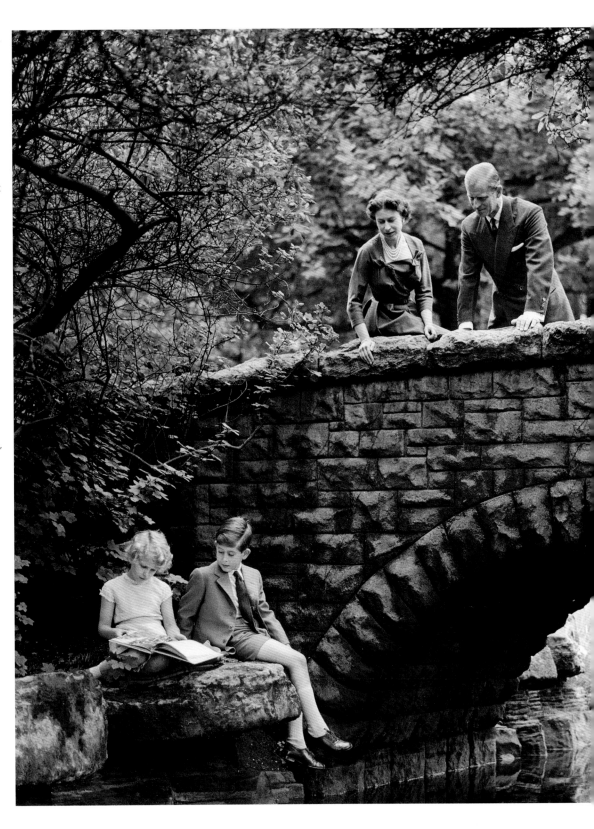

Spectators
Spectators making every effort to brave the rain and get a glimpse of the royal Trooping of the Color. In 1958 Tony Armstrong-Jones published a book simply entitled *London*. In the introduction he states that the book was about the British capital, its people, and the way they live. In his comprehensive coverage of London he caught the locals going about life in Chelsea, Victoria, Portobello, Cable Street, and Rotherhithe, among other places. He wanted to keep the photographs simple and respectful, and the book's achievement is to freeze a special era in London and to provide a warm observation of the people that were part of it.

The Queen, Prince Philip, and family
Taken in the garden, Buckingham Palace, 1957.

Peter Cook *(above left)*
Writer and Comedian (1937–95),
Camden Town, featured in
American *Vogue*. (*Vogue*/
CAMERA PRESS, London)

John Hurt *(above right)*
Actor (born 1940) as a
pantomime dame. Featured
in *Vanity Fair*, 1995.

Peter Hall and Leslie Caron
Peter Hall carries Leslie Caron
over the threshold after their
wedding in 1956.

Marlene Dietrich
Actress and singer (1901–92),
The Café de Paris, 1955, as
featured in *Tatler*. (CAMERA
PRESS, London)

Lord Snowdon

Isabel Snyder

Born in Switzerland, Isabel Snyder started working in the arts at a young age. She remembers taking a picture at the age of 12. "I was up on a carriage over the heads of these horses that were flying away as we were driving up to a castle, and I took a picture. When I saw the picture I thought, 'Wow, this is really cool!' I fell in love with photography then because that picture captured spirit. I cannot describe it in words, but I can describe the picture. That is why I became a photographer and not a poet!"

That love of capturing spirit compelled her to attend and graduate from Zurich Art School, at which time she began teaching art to both scholars and teachers. Her growing curiosity in art and style led her to delve into the theater and design world. In the late 1970s she ventured off to South America where she spent two years living in poor, isolated communities. It was here that she began to hone her visual sensibilities. To this day it is the "divine nature of each individual" that Synder strives to capture through her lens.

She eventually landed in New York, where she made a name for herself in fashion photography, then relocated to the West Coast, where she works solely in portrait photography, and has become the chosen photographer to countless musicians and theatrical personalities. She has worked for American, Italian, and German *Vogue*; and American, Italian, and French *Elle*, as well as *Newsweek*, *Esquire*, and *Rolling Stone*.

Her recent book, *Hollywood Portraits*, features 39 of her portraits. An exhibition of the same name, featuring her photographs, was mounted at the 54th Locarno International Film Festival, Switzerland, in 2001. She is currently working on several projects, including a children's book, and a coffee-table book on the Blue Balls Jazz Festival.

Snyder settled on portrait photography because, she says, "I love people. I love human beings, and portrait photography allows me to connect and be with people who are inspiring and interesting. I also feel I have an innate ability to connect with people, and, therefore, when I do a portrait of them it reveals something about the person. That, to me, is the importance of being a portrait photographer."

Having control of everything is another reason why Snyder loves what she does. "I am totally independent, and I love that!

Janice Dickinson, model.
"Shot at my ranch in Calabasas in 1998. I had just gone through my divorce and was in a very depressed state of mind, when Janice came over and said, 'Come on, Isabel, let's do pictures. You got to stop sitting around and crying. Come on, I'll do anything you want me to do! Sit naked on a donkey… anything!' She is the most fun ever."

Mamiya RZ 67 on Kodak TRIX rated at 200.

Denzel Washington, actor.
"Shot at 5th and Sunset Studios in Culver City in 2002. He had just finished directing his first big movie, and we had quite a discussion about how much your perspective shifts when you are behind the camera instead of in front. His intensity and sharp mind touched me deeply.

Leelee Sobieski, actor.
"Shot in spring 2001 in Los Angeles. Leelee had just finished filming the mini-series *Jean of Arc*. I wanted to express in this picture that short period in a woman's life where you are not a girl any more but you are not a woman yet either. She was right there."

4x5 Toyo field camera on Kodak Portra 400 VC.

Isabel Snyder

Pamela Anderson, actor and model.
"Shot in 2002 at my ranch in Calabasas. Pamela is truly perfect from head to toe. Just about everything about her is absolutely gorgeous, most of all her skin. She is the quintessential blond goddess. She is one of my favorites."

Mamiya RZ 67 on Kodak Portra 160 VC.

Going out in nature or being in the environment are things that I really enjoy, and photography allows me to do that. So photography is really the craft that allows what I like to do most in life." Further, she says, "I am happiest when I am truly creative, which means not copying anything or anybody. When I am truly creative there is a kind of energy surge that I physically experience, and that is when I am truly happy."

Of those people or places she would like to photograph, she admits that the list would be too long. "I am drawn to people where there is a mutual inspiration, where there is creative freedom, and those are the people I like to photograph." She finds that, in Hollywood, creative freedom has become something of an "endangered species." The process before you shoot, while you shoot, after you shoot, and when you do your edit, is controlled by a whole number of people, and just doesn't allow freedom."

Synder's work is always spirited and earthy. Her belief is that it always includes a lot of love, which is clear in her ability to capture a broad range of expressions from her subjects. "Openness, curiosity, and selflessness," are qualities that Snyder looks for, and most appreciates in those she shoots. "Some people are really open for a creative process, when they are willing to experiment, and when they are also courageous."

Hugh Jackman, actor.
"Shot at Miauhaus in Los Angeles 2001. He had just finished shooting *X-Men*. Since I was born and raised in Switzerland, *X-Men* comics weren't part of my upbringing. So when I interpreted the character of the wolverine having eyes like a feline, and put fake pupils into Hugh's eyes, the publicist was disapproving of it. But Hugh seemed to enjoy it."

Mamiya RZ 67.

Lisa Marie Presley, musician.
"Shot in summer 2003 at 5th and Sunset Studios in Culver City. I remember being struck by the resemblance to her legendary father when she flashed me that expression. It gave me the chills."

Mamyia RZ 67 on Kodak Portra 160 NC in daylight with fill-flash.

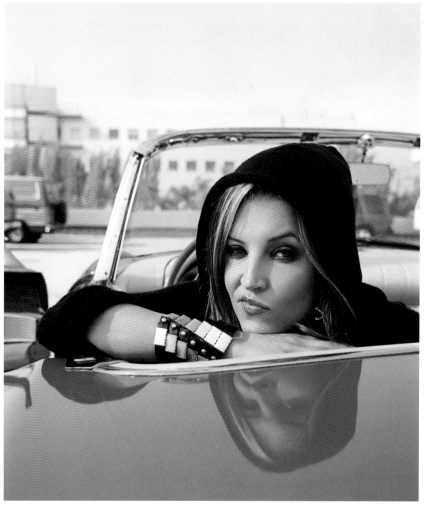

Isabel Snyder

Sally Soames

Sally Soames was born and continues to live in London. Her first assignment was for the *Observer* in 1963 and she continued to freelance for not only the *Observer*, but *The Guardian*, *The New York Times*, *Newsweek*, the *Sunday Times*, and various television and film companies. In 1968 Soames joined the staff of the *Sunday Times* as a photojournalist, and remained there until June 2000.

Her work has been exhibited at the Jewish Museum in New York, the Photographers' Gallery, London, in 1987, and the National Portrait Gallery, London, in 1995. Her portraits remain on permanent exhibition in the National Collection in the UK, the Jewish Museum in New York, and may also be found in various collections worldwide.

She has had two books published: *Manpower*, in 1987, with an introduction by Harold Evans, and *Writers*, in 1995 with a preface by Norman Mailer. In the past she has worked as external examiner and lecturer at the London College of Printing and the Royal College of Art.

Soames is very certain why she became a portrait photographer. As she started to get a bit older, she realized that photojournalism was no good for her. "But I found I had a talent for photographing people, and I enjoyed it," she says. "I could see the onset of color and new technology in the distance, and I really just wanted to perfect my black and white photographs, take them how I wanted to take them."

"Color is a completely different cup of tea. First of all, you can rarely get away with using available light, I think. In order to get what people want, you have to use some kind of artificial lighting. I hate that. There is no way I could do that, I couldn't keep up with it, and I don't want to learn about color, it doesn't interest me."

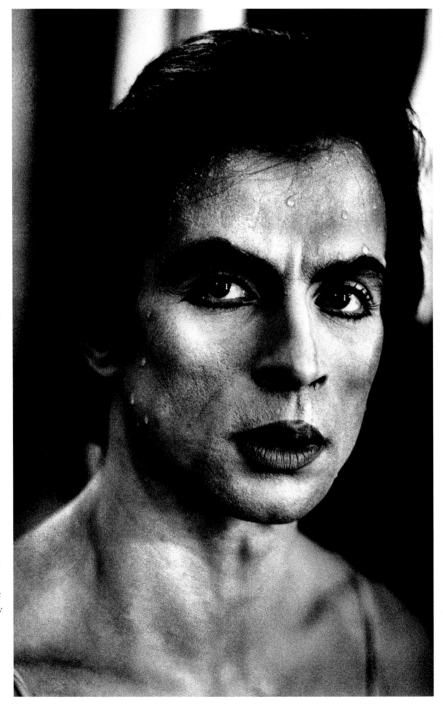

Rudolf Nureyev, ballet dancer
"This photograph was taken on Nureyev's 40th birthday. He was dancing with his company and directing the ballet, *The Sleeping Princess*. I had seen him dance many times in previous years, during his great days. It was a very moving moment when I went into his dressing room. I took a few photographs but I wasn't happy. He asked me if I would like to come with him to watch the beginning of the ballet from the wings. I went with him, and we watched the first act together. When he was satisfied that the ballet was going well, he invited me back to the dressing room. He was coated with sweat and I knew that I had the makings of a wonderful photograph. I knew I had something wonderful. He was the most beautiful and magnetic creature I have ever seen."

Ruth Rendell, writer.
"I went to her house in Regent's Park, London, and there was the most wonderful light on the staircase, absolutely fantastic. She just stood there. A lot of people have said to me, 'How can you? She doesn't look like that!' But I thought, she writes about thrillers and murders, she doesn't write books about cakes and cookery! So there we are, and the light is fabulous. Fantastic light."

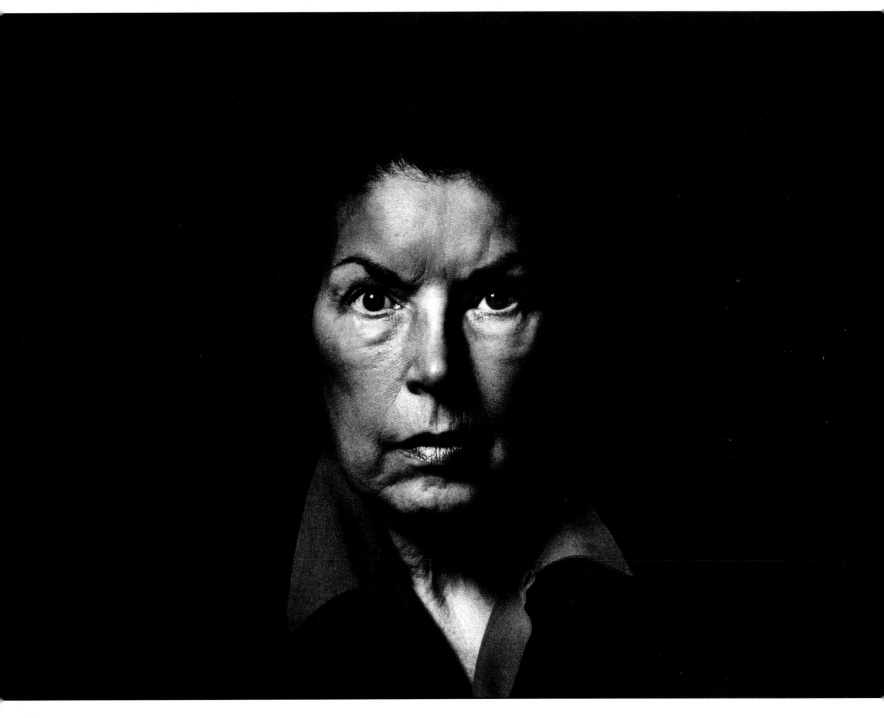

145 Sally Soames

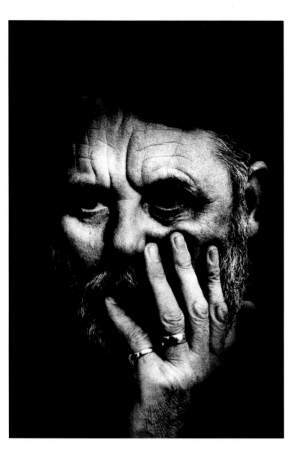

Terry Waite, humanitarian *(left)*
"I photographed him shortly after he had returned to England after his long imprisonment in Beirut. He was living and writing at Cambridge University. He was friendly but withdrawn after his experience in prison, so I didn't say much. There was a certain atmosphere about him, and I didn't want to spoil it, so I just asked him to sit quietly. I think I only took a few photographs, as I didn't want to intrude any more than I had to. He had obviously suffered a lot."

Robert Stevens, actor *(right)*
He was playing King Lear at Stratford-upon-Avon, and that whole environment to take photographs of people is horrific. There was nowhere I could get the kind of light, so I put a chair outside the men's toilet in a lobby area, and he sat down and I sat with him. I didn't think he was terribly well, and I was right, he wasn't. I said, 'Look, what I want is for you to run through King Lear, a very powerful moving speech from your part, in your head, and I want you to think it and say it but don't use your mouth. Just go through it in your mind and don't look at me.' That is what happened."

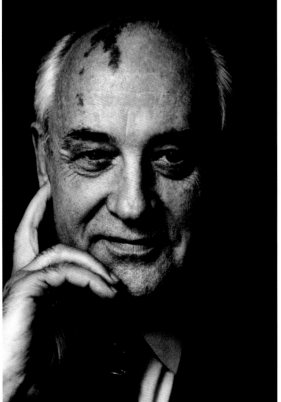

Mikhail Gorbachev *(left)*
"He was in London and I went to see him. I was very excited. When he arrived I told Mr. Gorbachev that my grandparents used to sing *Ochi Chernye* to me when I was a baby. *Ochi Chernye* in English means 'dark eyes,' and Gorbachev started to sing the song to me. I was moved. He had these wonderful, big hands, and was charming. Somebody suddenly interrupted us for a moment, he turned with undisguised impatience and anger, and his eyes had changed from kindness to a bleak darkness, which I found disturbing. But I saw the power of the man."

Soames is a colorful character with some compelling reasons to explain why she loves what she does. "First of all, I probably photograph the most interesting people in the world. It's virtually like history is being made, one way or another, whether somebody has written a wonderful book, or when I am meeting a hero of mine like Rudolf Nureyev or Norman Mailer, meeting those people whom I have worshiped is just extraordinary, and it's a healthy empowerment over them."

"I enjoy meeting people and I actually spend most of my time talking to them. I remember I had two-and-a-half minutes to photograph Sean Connery and I spent most of the time talking to him and took three shots. Somebody was there with a stopwatch. Seriously! The photograph was very good, actually." There are many aspects of her work that Soames enjoys, but the pinnacle is when she knows that she has taken the photograph

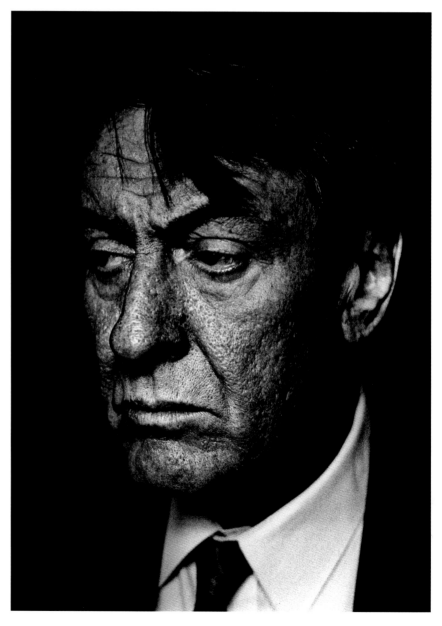

that she wanted. "I know that, unless the camera has screwed up inside or I get killed in a car crash on the way to the darkroom, I know that everything is perfect and that is my greatest happiness."

Soames considers the trademark look of her photographs. "I think that they are direct and strong. I have always wanted people to notice the photograph on the page; it's the photograph that attracts people to read the story. That is what I have always tried to do, to make the photo really important-looking so that it would catch people's eyes."

Of the photographers that she loves and who have been strong influences, Soames heralds Anthony Armstrong-Jones (Lord Snowdon) as her favorite. "If it hadn't been for Snowdon's early work I would never have been a photographer," she states.

Soames has never had formal training, but once she did join a camera club, where she learned how to enlarge photographs and began making huge prints of her photographs. "There was a competition in the *Evening Standard* every day, so I went to the *Evening Standard* with these two huge mounted prints of New Year's Eve, 1961, in Trafalgar Square. I was taking them to the picture editor and the clacking of all the typewriters (which is something that you never hear now), I found that incredibly interesting. The next day my photograph was there in the *Evening Standard*, huge, and they paid me five guineas. I won five guineas! I still have that picture and it's one of the best pictures I have ever taken."

Giorgio Armani, designer
"I went to meet him at his suite in a fancy hotel in London, and it was very cramped, with about 50 other people there. It was a hopeless photographic situation and I asked whether we could do it somewhere else. We went down in the lift together with various people, and he was carrying a raincoat on his arm, and I asked him whether he could put it over his shoulder. He said, 'You mean my Armani?' and I said, 'Yes, your Armani! Put it over your shoulder and stand right here.' We were in the fantastic lobby of the hotel, and the light was perfect. He has the brightest blue eyes you have ever seen in your life. It was just magic and it's a photograph that I am very pleased with."

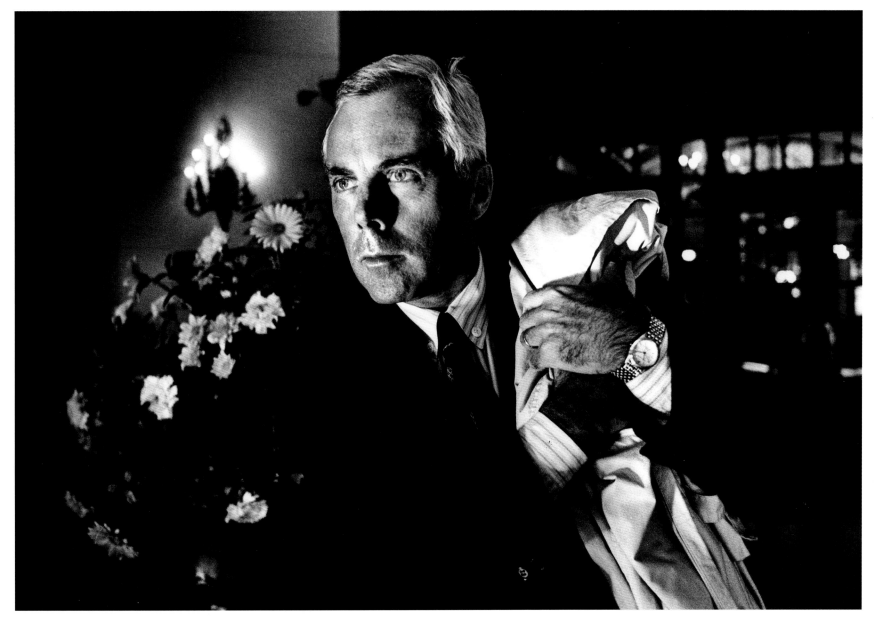

Sally Soames

Randee St. Nicholas

St. Nicholas became a portrait photographer completely by accident. "I was putting myself through art school as a model when some musician friends of mine needed pictures taken. I knew a lot of photographers in school, so I borrowed some equipment and shot some pictures. They turned out to become a huge act, The Knack, and I became a photographer.

"I never planned on being a photographer, I planned on being a painter. But when I became a photographer it was amazing therapy for me. It made me open up to people, which made me much looser as a person, much less contrived. You have to live in the moment when you are shooting people, so it's as if this profession has brought out qualities in me that I don't believe I would have developed had I stayed a painter. I would have been much more isolated."

Since the moment she started taking pictures, St. Nicholas has loved it. "I love people, and I am fascinated when I look at someone through the lens of a camera and I see something completely different than what I see without it. It's like looking for the good in everyone. Sometimes you have subjects that are fascinating to photograph, and some that are very difficult to photograph, in the sense that they are withdrawn, and I like the challenge to find out what lies beneath them."

St. Nicholas has a delightful sense of humor, which comes out when asked about her idea of perfect happiness as a photographer. "I would like nothing better than for someone to finance my travels around the world with a dozen or so amazing subjects, and just shoot whatever I want for a year. Doesn't that sound good?"

She has a special love and flair for celebrity portraiture. "There are so many restraints, so many different personalities and schedules, and so many things involved that it really forces you to put everything you've got in there to make it work. You feel like you have really accomplished something, which is great. I love when I am given the impossible task and actually pull it off. It makes me feel like I really did something."

Jakob Dylan, musician *(right)*
Double exposure: an intimate glimpse of a multi-dimensional artist.

Tyson, model

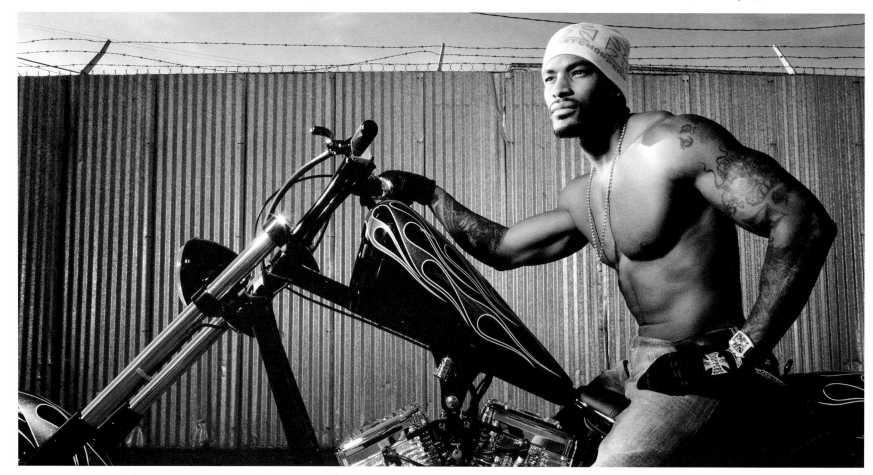

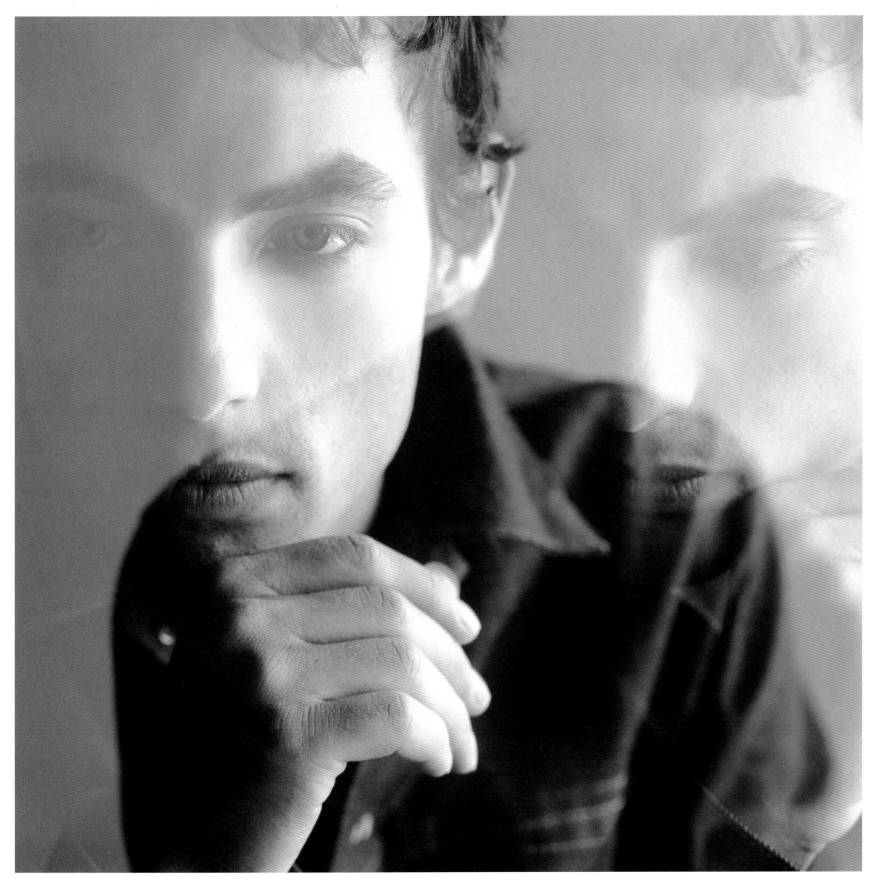

Randee St. Nicholas

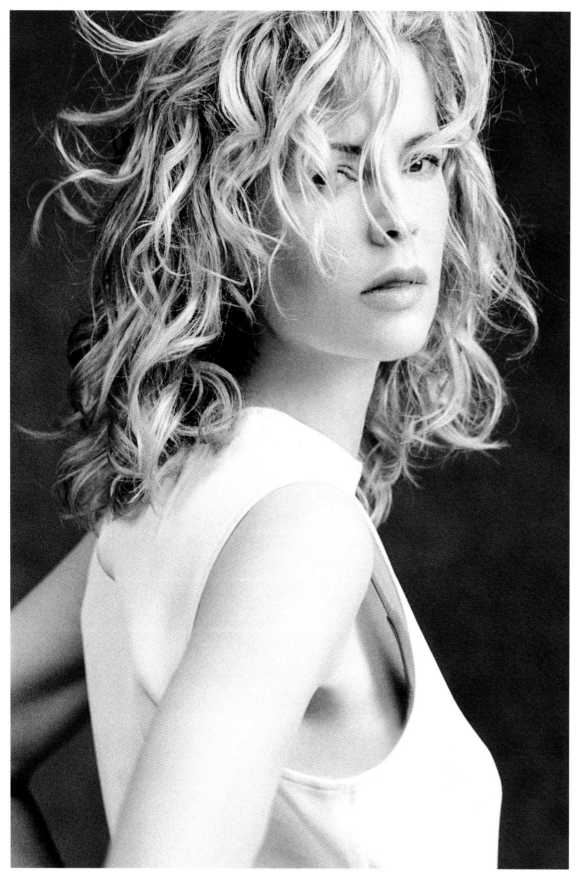

When asked about her strong points as a photographer, she says, "I tend not to think too much about what I am doing. I like to feel my way through. People say I make everyone look beautiful, and I am very relaxed when I work, and that makes people feel comfortable. It's obvious that I love my job, and I like to have a good time when I am shooting."

It's hard to imagine that a photographer of St. Nicholas' stature has any weaknesses, but she confesses that at times she can be too nice. "I am incredibly flexible, which I think can sometimes stand in the way of me accomplishing the vision I have. You have to hear all sides, and sometimes you water down what you are doing by trying to make everyone happy. That is why my ideal is to have no-one tell me what to do. No-one gives me orders, no-one gives me an idea, and I just go off and shoot the people I want to shoot. Someone else pays for it, of course!"

Being a photographer is to work in a funny business, she says. "In some ways it is to be ego-less. If you are capturing other people's images you want to go deeper and bring something else out in them. If you are shooting a celebrity who has been photographed by every great photographer that there is, then you really want to bring something else out in them.

"I want to make everyone look amazing, and sometimes I forfeit something else by having those restrictions. I am interested in finding a balance between my subject and me, and hopefully the chemistry between the two of us will bring out something that is fresh, that hasn't come out of me before, and hasn't come out of them. That's when it's really great."

There are so many photographers that inspire St. Nicholas. "First on my list is Helmut Newton. Then there are a lot of photographers from the 1960s and 1970s—Chris von Wangenheim, Pete Turner, and Robert Mapplethorpe. Of the newer photographers that I like there is a guy named Thierry Le Goues, whose work is dark and sexy, which I like very much. I love Man Ray's work, too. I have quite a collection of photography and art books."

Kim Basinger, actor

Kevon Babyface, Musician
Kevon doing push-ups in a
1950s silver cloud trailer.

St. Nicholas has truly had a charmed career, which is evidenced by the turn of events that led her to become one of the world's top portrait photographers. "My first photographs were of the rock band The Knack, my first video was for the musician Prince, and my first commercial was for Martha Stewart. When stuff like that happens to you, and you are paying attention, you say to yourself, 'Okay, I studied painting and maybe that's what I really want to do, but maybe there is a time for that later, and I should just go with this.' This is how I have approached my career and that is how I approach my subjects."

Her philosophy about capturing images is ages old. "The way we look like on the outside is definitely affected by what's going on in our inside. You wouldn't think that you would see the inside in photography, but you do. Somehow, something else comes through, it really does. I think there is a reason why some people were afraid to be photographed, like the American Indians, for example. They thought it was witchery, and were afraid that it captured your soul. I believe the lens does look beyond."

For a woman who has accomplished so many wonderful things in her life by going with the flow, St. Nicholas's humility is refreshing when she confides that she has yet to land her greatest achievement.

Randee St. Nicholas

Jordon Scott
"The Martini" a portrait with a
dual purpose.

D Carter

Rod Stewart, Musician
Rod is never mistaken for
anyone but Rod.

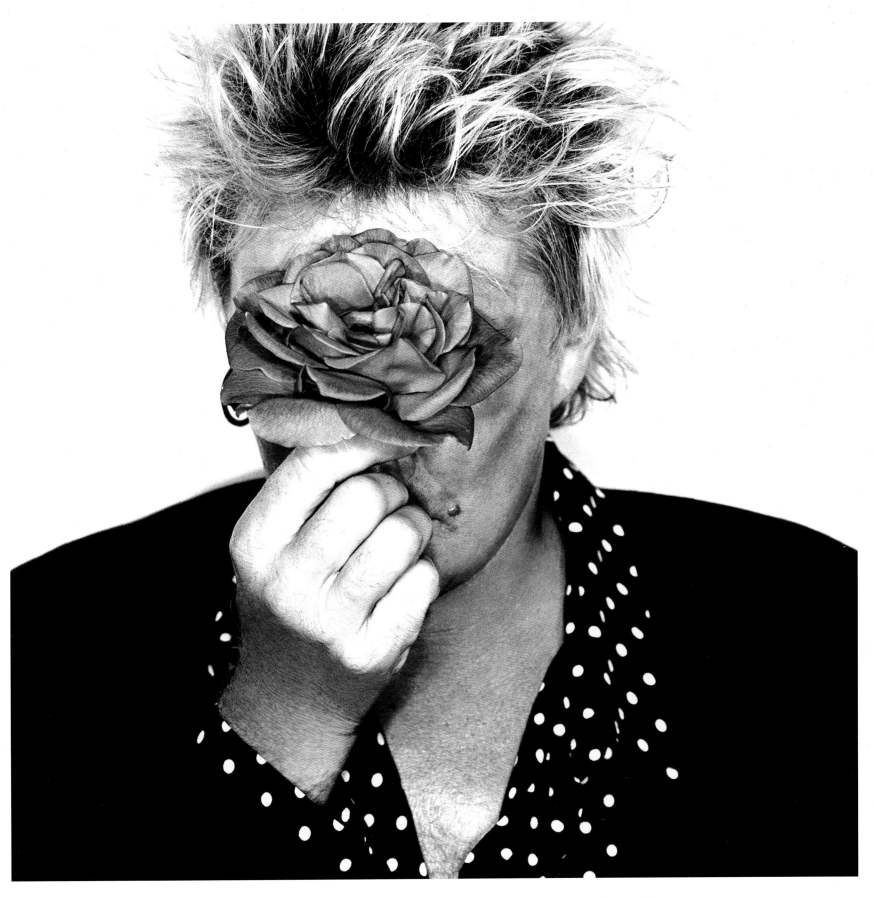

Randee St. Nicholas

John Stoddart

Stoddart's photography career began in Liverpool, England. "I was lucky, as in the early 1980s there was a pretty good rock 'n' roll scene happening in Liverpool, so I started shooting British bands, such as Frankie Goes To Hollywood and Echo and The Bunnymen, who were big at the time. I used to take pictures of pretty girls and rock stars as a hobby. It was sure better than stamp collecting!" He still considers his picture-taking as a hobby, but one that has gotten out of control.

"I love the glamor and the incredibly short working hours. Obviously, the money helps, but to be honest, the money isn't the motivation. I think it's a very glamorous occupation compared to what I could be doing. It still feels like a hobby for me, and it's fantastic." What he might be doing instead is a sobering thought for Stoddart. "At some point I realized that there was nothing else that I could do. I had been in the British Army for six years before, so I wasn't trained, I had no skills, and this was before the great computerization of the world. Being a photographer was the best thing I could have done so I did it. Otherwise, I suppose I would have wound up in Liverpool doing some kind of manual labor."

The first photograph that got Stoddart the notice he was due was a photo taken during the riots in Liverpool in the early 1980s. "I was shooting an obscure band there and I shot them in the backdrop of the riots. They were diving through flames and, well it all sounds so crazy, but the picture really got noticed. For me, that is the picture that mattered." Looking back, he misses the rock scene of that time, and would love to shoot more rock stars. "They are my favorite subjects—interesting, exciting."

Once the rock scene slowed down in Liverpool, he and his wife at the time realized that if he was going to do anything with a camera they would have to move away from the north of England. "I was naive really, in retrospect, but it was obviously the best thing I ever did. You've got to be in London where the action is. Even with the highs and the lows, I've never looked back."

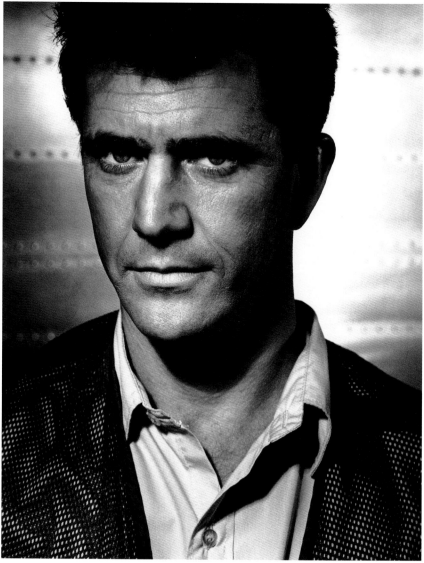

Arnold Schwarzeneggar, Actor
and politician

Mel Gibson, Actor
(facing opposite, right).

Elizabeth Hurley, Model
(facing opposite, left).

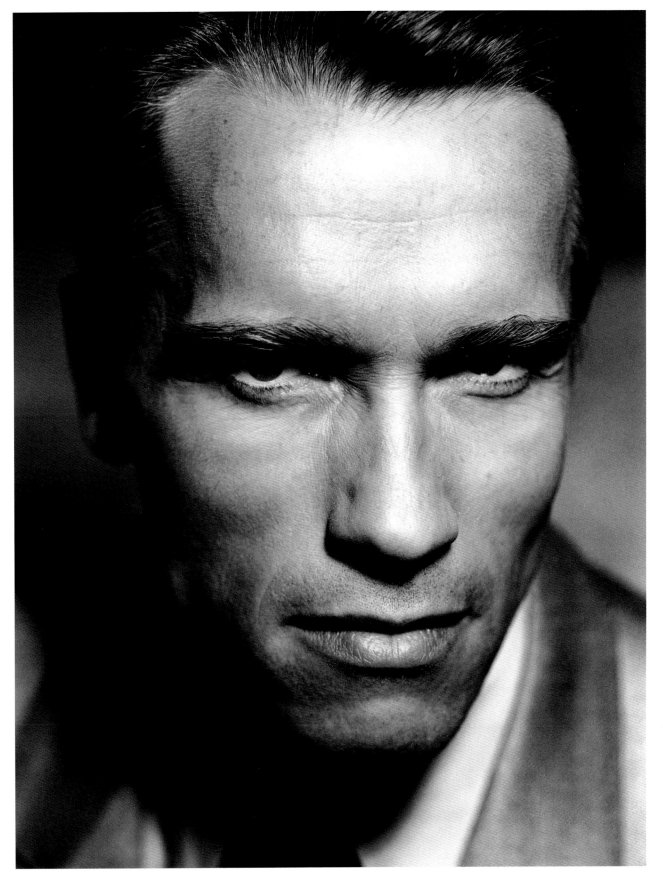

John Stoddart

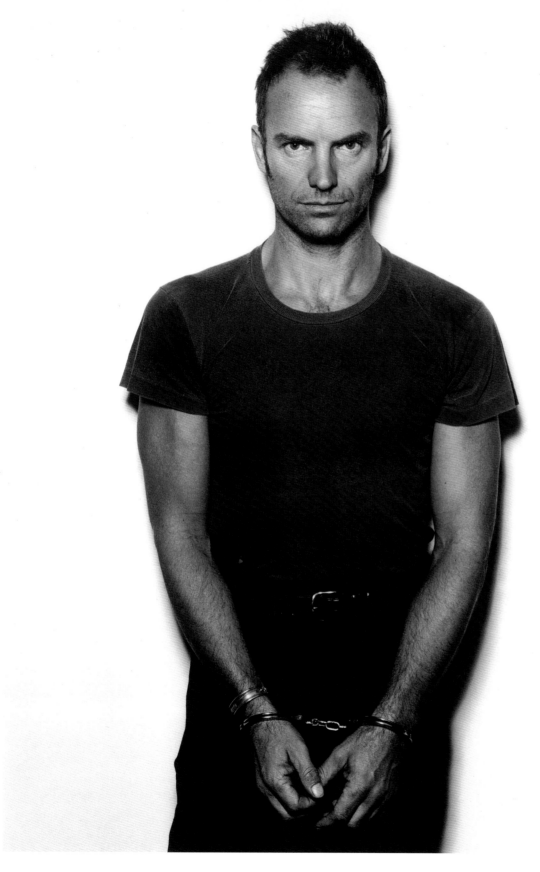

The Rolling Stones, Rock band

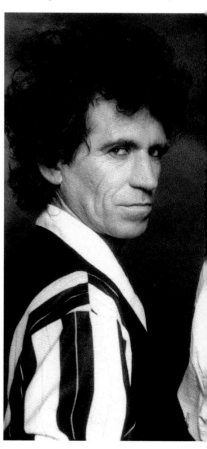

Since then, he has had dozens of exhibitions, worked for countless editorial and fashion clients, and had two books published—*It's Nothing Personal* in 1997, and *Peep World* in 2004, both of which are filled with his amazing images. He has had thousands of happy moments while compiling these books. "I love being in a five-star hotel with a semi-naked actress asking me if her ass looks big! I love knowing that there is a nice gin and tonic waiting for me downstairs, and that I am working for a good magazine."

His strength lies in communication and daring. "I don't consider myself an art photographer, I like to consider myself a continuation of tradition in photography. My main asset is that I am a good communicator, and I think that is the secret of portrait photography. I take in bits of what the subject says, and shoot when I know they will look fantastic." His photographs are glamorous, edgy, and not predictable. "I am not into that sort of 'perfect moment' style, where there is just a boring backdrop of gray and someone standing there. That's not what I want to do because it's been done a million times before."

If his strength is communication, he communicates his weaknesses very humorously. "Alcohol and loose women!" he laughs. "I lose all my money on women, and it drives me crazy. But really, my main weakness is a lack of confidence, believing that one day the phone won't ring anymore, the jobs will stop coming. I read somewhere that the average lifespan of a photographer is seven years." Despite this fear, the phone still keeps ringing, and Stoddart has thrived in his field. "I have classed myself as a photographer since I moved to London in 1984, so I've been in it for 20 years so far and I'm very proud of that."

Certainly, his continued success is due to the fact that he loves what he does, and continues to be excited and challenged by it. He is often asked why so many women take off their clothes for his photos. To this he responds, "I tell them it's not about vanity, nor morality. I do get private commissions, but I also approach people I know, like young models or sexy girls. They realize that it's not going to be a pretty portrait to take home to show Mummy and Daddy. They know that they are part of a bigger picture."

Stoddart is still thrilled with each new portraiture assignment, and is very glad that he is able to shoot people, not cars or food. "I think that's why advertising photographers must go crazy. If you're looking at a magazine and you see a full-page spread of a car, you'll look for a second, then turn the page. But if you see just a small Annie Leibovitz photo on the next page, you'll think about it for weeks. I like to take pictures that are thought-provoking. There are photographers whose work I don't particularly like, but I admire them because at least they make me think."

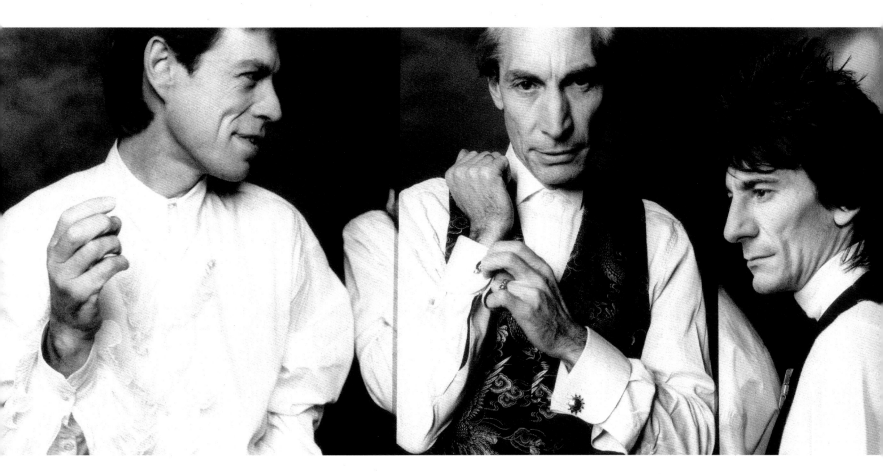

John Stoddart

Art Streiber

Art Streiber is a fifth-generation Californian who lives in Los Angeles. His wife, Glynis, is the West Coast Bureau Chief for *In Style* magazine. From 1989 through 1993, he and Glynis were the co-Bureau Chiefs of the Milan Bureau of Fairchild Publications, publishers of *Women's Wear Daily* and *W*.

Since the fall of 1993 Art Streiber has been a freelance photographer, specializing in photojournalism, travel, and entertainment-portrait photography. His vast and impressive client list includes magazines such as *Vanity Fair, W, Premiere, Wired, Town & Country, O*, and *Rolling Stone*, plus commercial clients such as HBO, NBC, CBS, Fox Television, Warner Bros, and Sony Music.

Streiber has explored many facets of photography during his career. "My work varies. I do reportage, interiors, lifestyle, travel and portrait photography. I pursued portraiture because I love the challenge of visually 'defining' my subjects." Clean, elegant, subtle and unpretentious are the words Streiber uses to describe his portraits. His work is often inspired by the photographers he most admires—Elliot Erwitt, James Nachtwey, Arnold Newman, Helmut Newton, and Annie Leibovitz.

Alan Ball and the cast of *Six Feet Under*

"When I photographed the cast the show had not yet premiered. I scouted their sets, and begged their line producer to let me shoot in the prep room, where the bodies are prepared for presentation. I liked the idea of lighting the room as 'naturally' as possible, so we hung five beauty dishes from the show's lighting grid, and then we lit the frosted windows from outside. When shooting large groups of people I shoot two cameras, side by side. I then either seamlessly composite the two frames together or to let the seam be raw and 'filmic.' In this case, I let the seam be natural, so we see that it is two different photographs, each one shot within a 10-minute window in the middle of a full production day for the cast and director."

Nicole Kidman, Actor

"I was told I would have only 20 minutes with the Oscar-winning actress. My crew and I got to the location four hours ahead of our start time in order to maximize our few minutes with Nicole, who was amazing in front of the camera. I think it's impossible to take a bad picture of her. After she slipped into a vintage, 1930s Madame Gres gown, we brought her into the hallway of the suite, metered the ambient light, and lit her very subtly with a daylight-balanced constant source to make sure that she didn't look lit at all."

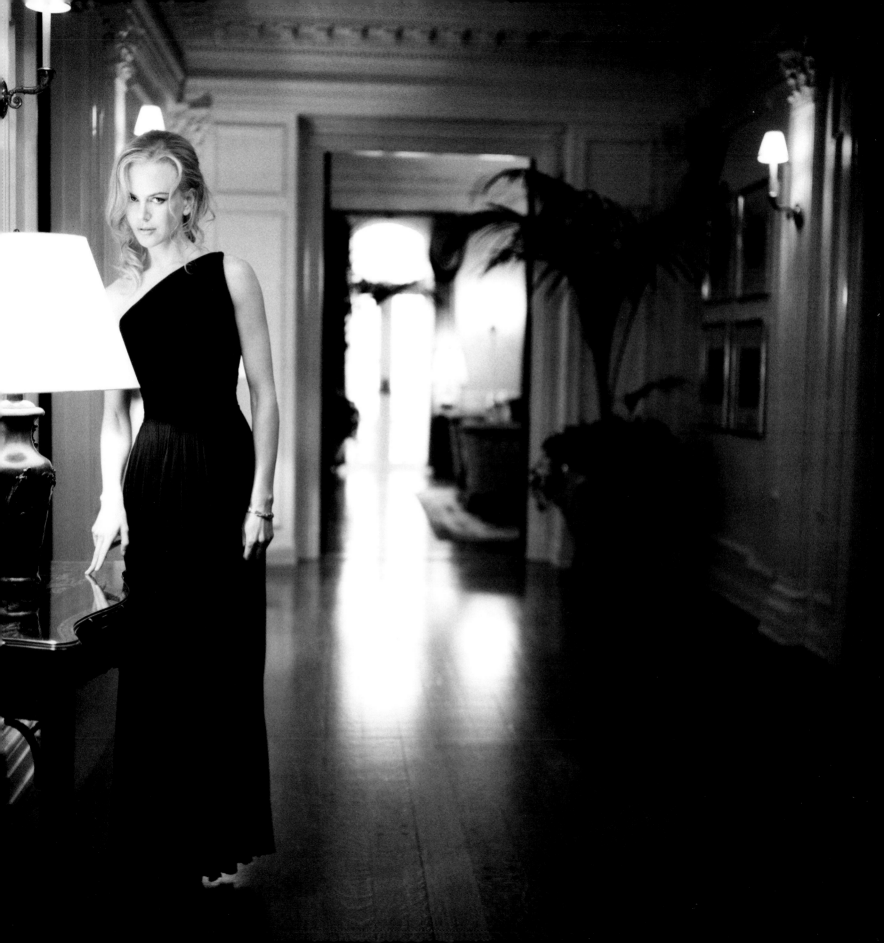

Well-known for his creative approach to portraiture, Streiber is the photographer who persuaded *Vanity Fair* to hire a crop sprayer so that he could recreate the famous scene from Hitchcock's *North by Northwest* to photograph its writer, Ernest Lehman. He also convinced newsman Sam Donaldson to roll in the grass with nine Labrador puppies when he shot him for *George* magazine, and actor Michael Keaton to be shot in the bath for *In Style* magazine.

"I am able, quite quickly, to size up a subject's environment, and compose a portrait with a few layers of meaning. I'm capable of putting my subjects at ease, and helping them understand that the process does not have to resemble dentistry!" Streiber kids around with his clients, immediately putting them at ease in his world of creativity and expression.

He loves all types of photography, but especially portraiture. "Portrait photography has taken me to incredible places, and has allowed me to meet and talk to fascinating people... from celebrities to surfers to sex addicts." In his work he strives to push his own boundaries: "I tend to 'box myself in' technically, and risk missing out on a great variation of the portrait I am working on.

Peter Jackson, Director
Four Seasons Hotel, Beverly
Hills, California.
"Following the overwhelming success of the *Lord of the Rings* trilogy, director Peter Jackson is about to take on another legend, remaking the classic *King Kong*. Jackson owns the original miniature, mechanical Kong from the 1933 film. He is fascinated by the one-of-kind collectible, and posed with the old Kong, duking it out with an Aragon action figure."

Severn Cullis-Suzuki
"It was raining in Vancouver when we asked environmental activist Severn Cullis-Suzuki to kneel in the mud in her grandfather's garden. My camera and I were shielded from the rain by a large golf umbrella, and we used two reflectors to fill in the shadows on Severn from the very overcast, gray sky. I shot tri-x pan film, and asked Severn to play up to the drizzly sky in order to fill her face with light."

"I love a subject who 'gives' something to the camera, who participates in the photo shoot," Streiber reveals, and for those who give that something during the shoot, the experience is delightful, fun, and memorable. Streiber has a terrific sense of humor, and reveals that he would, "love to work on a project of stand-up comedians, and perhaps turn it into a book."

He began taking pictures early in life, when he and his brother would shoot 110 and 126 cartridge film. "We would just goof off in the backyard shooting each other. I started shooting for my high school newspaper in the tenth grade." Ever since that time, Streiber has loved all aspects of portraiture, from designing the set-up, solving any technical problems that arise, and meeting the subjects. "I love the process itself," he says, and he can't imagine doing anything else with his life.

John Woo, Director
"John Woo was editing his film *Paycheck* when I photographed him for *Wired*. I was looking for a way to give the image an 'other worldly' quality. I came up with the idea of filling the space with helium balloons lit from the inside and anchored to the floor. The image was made on a 4x5 camera with a one-second exposure."

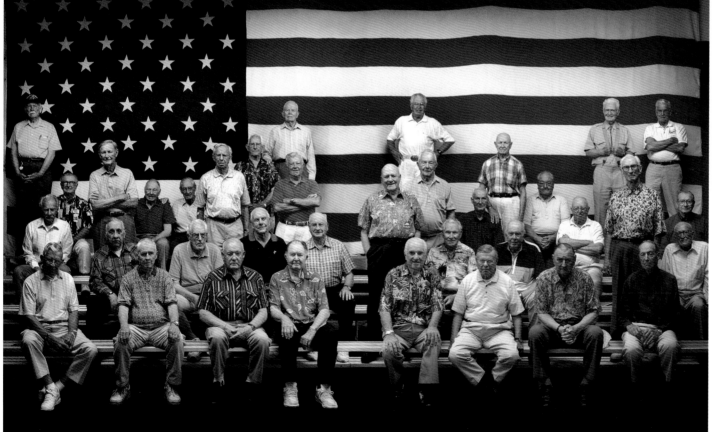

World War II Aces
"My assistant came up with this idea. My art director, Nick Tortorici, found the flag in LA. He then called around and tracked down some bleachers. We spent six hours hanging three large soft boxes and two large strip banks. Finally, getting these old military flyboys to sit and stand in a random way was no small task. It was a terrific honor to be in the presence of the remaining Aces."

Art Streiber

Ben Watts

All photographs taken during the Lulapalooza Festival, summer 2003.

Ben Watts was born in London in 1967, then moved to Wales, UK to live with his grandparents. He later returned to London to attend boarding school until his family moved to Sydney, Australia, in 1982. In 1985 he began his studies in Visual Communications at the Sydney College of Art, intending to become a graphic designer. It was here that Ben began to take photographs. "The first photo I ever took was for my course. It was of a 'Slinky,' and it was complete crap. I was just going through the motions." Fortunately, soon after this assignment, Watts became inspired to take pictures of the crowds at the nightclub where he worked.

"The adrenalin and vitality made me see how street culture influenced fashion," he says. "The more I shot, the more I realized that photography was the only medium in which I wanted to work." He started collecting images of his friends and any interesting people he encountered, and used them for his college projects.

When he realized that he wanted photography to be his career, Watts secured work as an assistant to one of Australia's top fashion photographers, and within a short period of time began shooting for the Australian editions of *Elle, Marie Claire*, and *Vogue*. His experience with shooting the "fashion of the streets" allowed him to create not only commercial images, but images that brought "real life" into the fashion fantasy, a winning combination that propelled him to the top of his field in a very short time.

The same year his star was rising in Sydney, he made his way to New York City, taking shots all over, from the Lower East Side to the Bronx, from Harlem to Coney Island, determined to capture its youth culture and nightlife. He shot kids, thugs, policemen, and street people. The result was a collection of images with a refreshing, candid, optimistic, joyous perspective on these groups that very few people had ever seen. He shed a new light on these people who had, by many, been considered at the least, intimidating.

Watts travels extensively all over the world, from New York to Los Angeles, the Caribbean, Asia, Brazil, and Europe, to capture the look of urban youth. Ever fascinated with American hip-hop culture, he continues his work documenting urban youth. He has become a regular at the Times Square boxing club and Carmine Street swimming pool, and always captures portraits as an insider rather than an observer.

In 1994 Nike hired him for his first commercial assignment to shoot some of their Olympic athletes in New York. They thought so highly of his work that they commissioned him to shoot their athletes in Brazil, China, Korea, and other Pacific Rim countries. He was also hired by *Vibe* to shoot a full range of editorial spreads, from fashion to the portraits of heavyweight fighters such as Lennox Lewis and Oscar De La Hoya. *Vibe* also ran an advertising campaign using the photographs he took at the Powerhouse Club in New York City in 1990.

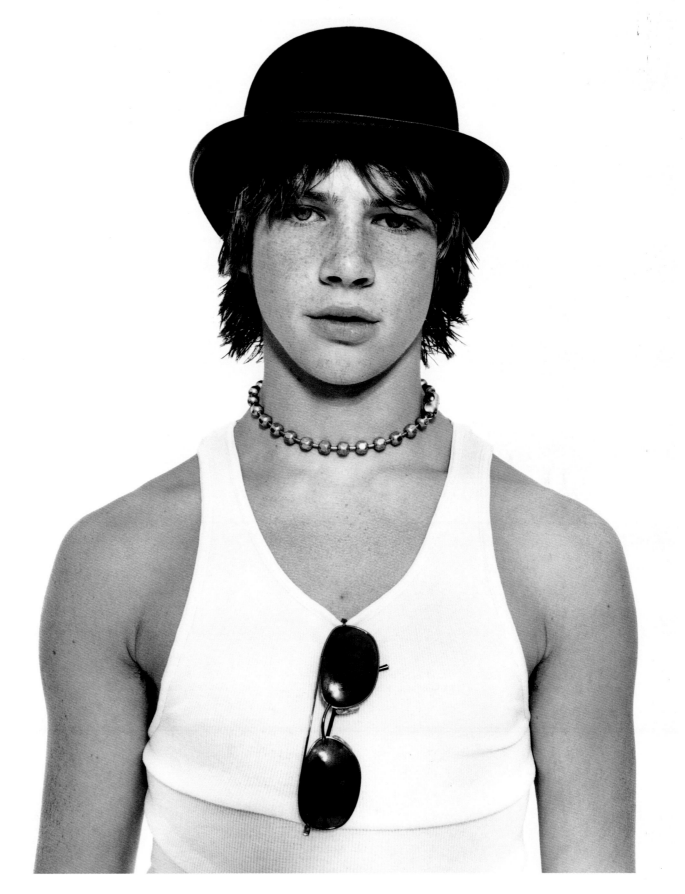

Ben Watts

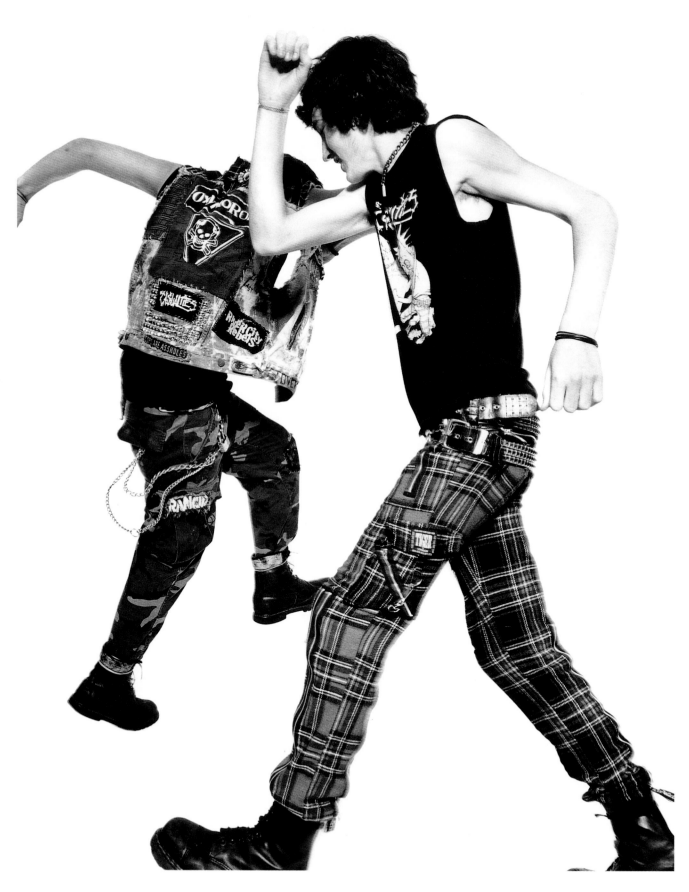

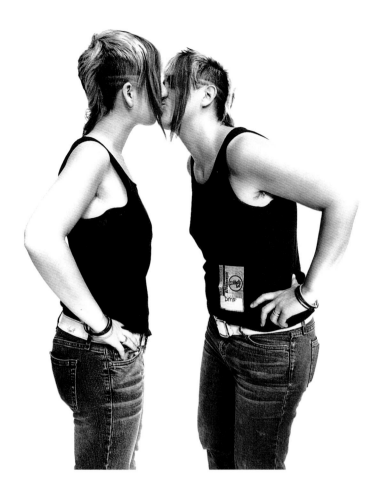

Watts continues to shoot fashion for some of the most prestigious magazines in the world, including *GQ*, *Interview*, *Harper's Bazaar*, *Rolling Stone*, and *Vanity Fair*. He has received many accolades from within the trade, including *Photo District News*, *Italian Photo*, *Photo Market*, and *Trace*. "Taking pictures that inspire me, making a living from what I enjoy, and receiving credit from my peers whose judgment I trust—this is what makes me happiest," Watts reveals.

He most appreciates humor in his subjects. Along with his playful appeal and skill in communicating with his subjects, he is able to draw out vibrant and insightful aspects from each of them. Watts says of his photographs and their style: "It's more in the preparation and the experience of the day. The subject's personality really defines my work." His images stay with the viewer long after they have been seen. This is a testament to the social value of his work, and the importance of his beautiful and energetic contribution to the arts and the world.

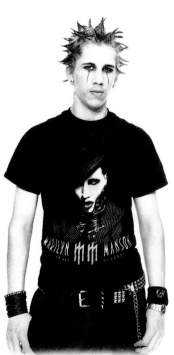

Ben Watts

Jim Wright

"I became a portrait photographer because I am a terrible painter!" So says Jim Wright who quickly changed his major at art school to fashion design. "My mom was a seamstress and made wedding dresses on the side. Being a tall teenager I used to have to wear the wedding dresses, and that's how I learned to cut patterns and sew." It was while studying fashion that he fell in love with photography—it was a requisite part of his course.

He also became an avid surfer, and eventually dropped out of school to design surf clothes full time. "A buddy of mine at the time was the East Coast champion in surfing and I used to travel with him. He had all this photography gear and I started taking pictures of him while he was competing. All the dudes at the beach told me I should go to school for photography. I hadn't known that I could go to school for it!" Inspired, Wright attended Drexel University for two years, then the Art Institute of Philadelphia. "I never really planned on being a photographer. It just kind of happened to me." Even while he was studying, it never occurred to him that he would actually become a shooter. "My goal was to become the world's greatest assistant." He left Philadelphia and moved to Los Angeles. "I told my friends I was going to LA to work for Herb Ritts, assisting, and they all said, 'Yeah, right.' But that's what I did. When I first got to Los Angeles I used to print Herb Ritts' work prints. I worked for him until I started working as Peggy Sirota's assistant, then worked for her for about five years. She was really a great mentor—really pushed me. And as much as she didn't want to see me go, she pushed me to get out there and do it. 'I don't know what you're waiting around for,' she said, 'you've got it, you've got the stuff, and you're good with people.' So, there you have it!"

Being a fan of all kinds of music is what drives Wright to keep shooting musicians. He himself played in rock 'n' roll bands while at college. "I am an absolute music nut, and it's great to work with people whose work I admire. There's long-running joke that I always tell my assistants: as soon as I shoot Bruce Springsteen, that's it, we're done, it's a wrap. Cameras go on the shelf and it's back to New Jersey to open the pizzeria!"

In the meantime, Wright remains wildly prolific. He has published three books under three different names, and has even put out a whole distinct portfolio under a pseudonym, too. "I am now investigating the gallery thing. I have this whole landscape thing that I do on the side—shooting landscapes, not landscaping! I am also working on a movie that is taking up a lot of my time. It's like my little baby right now.

Peter Yorn, Musician
"I work with Yorn a lot. I did a shoot with him and we became friends, and from that I ended up doing the promotional materials for his last album, *Day I Forgot*."

Dennis Quaid

"Dennis Quaid was great. He walked in the studio, no big entourage. Everyone knows him and he comes walking in. I had previously met him when I was shooting Tiger Woods at Tiger's practice space out in Las Vegas. Dennis Quaid happened to be there. I gave him the pictures I had taken of him and Tiger that day and he said, 'Oh my god! That's so great! What do you want to do today?' He was very cool. I told him I would put on some rock 'n' roll music and we would go for it. He is really into music, so we put on some Stones, and some Jerry Lee Lewis, and some Elvis, and he started going nuts. All I had to do was throw out the musical character and he would do it in front of the camera. He's doing Mick Jagger right there. It was so good and it was a case of there was no publicist on me—he was open."

ElenChrome Pro Photo Heads, dab of light on the background, Kodak 400 vis vis, rated at 250 pushed a half-stop.

Jim Wright

"I shot Johnny at the Sundance Film Festival a few years ago. He had a movie, directed by Julien Temple, called *The Filth and the Fury*, coming out about the Sex Pistols. Johnny Rotten is known for being difficult, and he thrives on it, I think. He was giving me shit and we were shooting in an alleyway and I was giving it back to him. He was ready to walk off and I called him an asshole. Steve Jones, his guitar player, said to him, 'Ha John! He can fucking tell you mate!' Then Rotten said to me, 'Finally, somebody finally got some fucking balls around this place. Come on mate, what do you want to do?' The reason he was really playing it up was because MTV was filming the shoot, so he was playing it up big, but the glare in this photo was for real. You couldn't fake that glare. After the MTV film crew dispersed, he turned around, smiled at me and gave me a thumbs up, like, 'Way to go!' It was perfect, I got what I wanted, and he got to keep his reputation of being difficult. I saw him later on that night and he said, 'I had seven shoots today and yours was the best one—all the other photographers just whimpered away in the corner.'"

That was the last time that I shot Pentax 67. Triax, open shade, a little over-exposed, nothing major. It's sepia. This is the digital file—the original print was done on Ilford Gallery Mat and then sepia tones. When I went digital I matched it in the computer.

Elisha Cuthbert, actress

"This was shot digitally for *Allure* magazine, on the roof of my studio, with a Hasselblad, right before I switched over, with a 120 lens I think. It was part of a beauty thing that we were doing that day for *Allure* right when *24*, her television show, was about to hit its stride. She is a sweet girl with beautiful skin. I like the softness of the picture and her hair looks just as soft as well. I like the whole color palette. Matthew Van Lewen was the makeup artist and David Gardner was doing hair that day; they are both awesome guys and they created this really great palette for a classic Hollywood kind of thing. Very natural, soft, and sweet, it reminds you of a big lump of vanilla ice cream. I have this picture hanging in my house."

"This other work I am doing is a complete 180 to shooting lifestyle and photojournalistic stuff. Frankly, I am trying to get away from that stuff. It doesn't float my boat any more. And to tell the God's honest truth, I am not that young any more and I can't move like that! I am enjoying the change, I need to do something different so that when I shoot the lifestyle it's fresh again."

Every day brings something different for Wright. "There is always a new set of rules for each shoot, a different experience or prerequisite that needs to be done. The easiest part is the actual shot. Once I get them in front of the camera, it's fine. The hardest part is the location, the hair, the make-up, the publicist, and la-ti-da—all the stuff that goes along with the celebrity stuff. It's one of the reasons I like to shoot musicians. Most of them are very strong-willed and have a definite vision of how they think they should be presented. I always try to make a connection with the artist prior to the shoot so we know what that vision is. All that kind of stuff changes and that's what keeps it fun and new."

"I am definitely opinionated as far as what I like to shoot, and I think my greatest strength is that I feel that I can do just about anything. I'm not just a fashion guy, a lifestyle guy, or a serious portrait guy. I feel strongly that I can shoot anything, and that is

Peter Yorn, musician (*left*)

Jim Wright

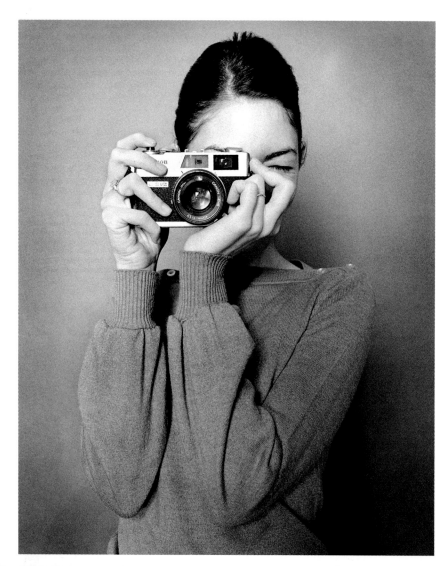

Sofia Coppola, Director

"This was shot at the Sundance Film Festival. It's kind of a funny picture because you don't really see her, but it kind of defines her, too. As much as she is in the press, she is really low-key. She is there, but she's not. Even when she was accepting the Academy Award this last time, she is kind of humble—that's how she is."

Hasselblad 50mm lens.

why I shoot a wide variety of stuff. My other strength is that I don't say one thing, then do another." Despite this, there are times that Wright feels that he doesn't speak up enough. He walks what he calls a "fine line", which is getting the image he wants without annoying people. "I'm a pretty laid-back guy and it takes a lot to ruffle my feathers on a shoot. It's so funny because the whole thing is always different and it's always a learning process. Once you think you've got it all down, that's when people's pictures become stagnant and all of a sudden you're old school."

Five for Fighting

"This is John Ondrasik, from the band Five for Fighting, and it was shot for his album package. We shot up on Mulholland Drive at an unfinished Frank Lloyd Wright house. It was supposed to be for his album theme—nature meeting technology and man. That is why in one part you see the blue skies and the grass, and then you have this rock structure with these metal rods sticking out. It looks manmade and abandoned."

Fuji 617 with a 90mm lens, f16 with a prophoto by 2 path outside, through silk. He is shaded by a 20x black devatine. The ground was brought back and digitally retouched so that you don't see any of the shadow from the shade.

The Cowboy

"This was shot out in New Mexico, and that kid is a professional cowhand. He goes to day school and he runs this huge ranch out in New Mexico. He was amazing to watch, rounding up these cattle, because he is just a little kid. That's a full-grown horse that's behind him. He was intense—it was like talking to man. He was 11 years old and he talked down to me. I thought he was a midget!"

Triax film rated 320 pushed a half-stop, with available light open shade, shot at 1/30th at f5/6.

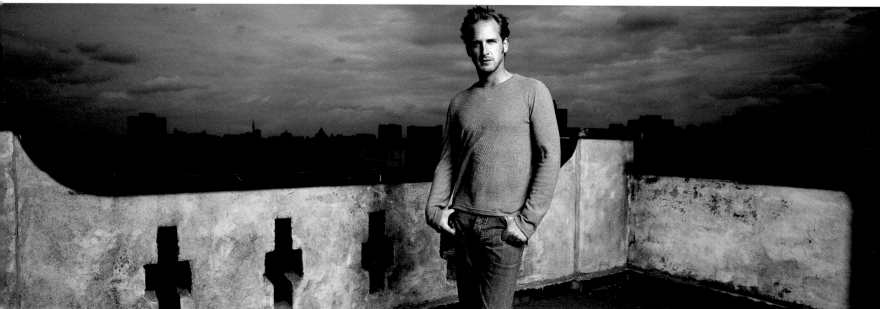

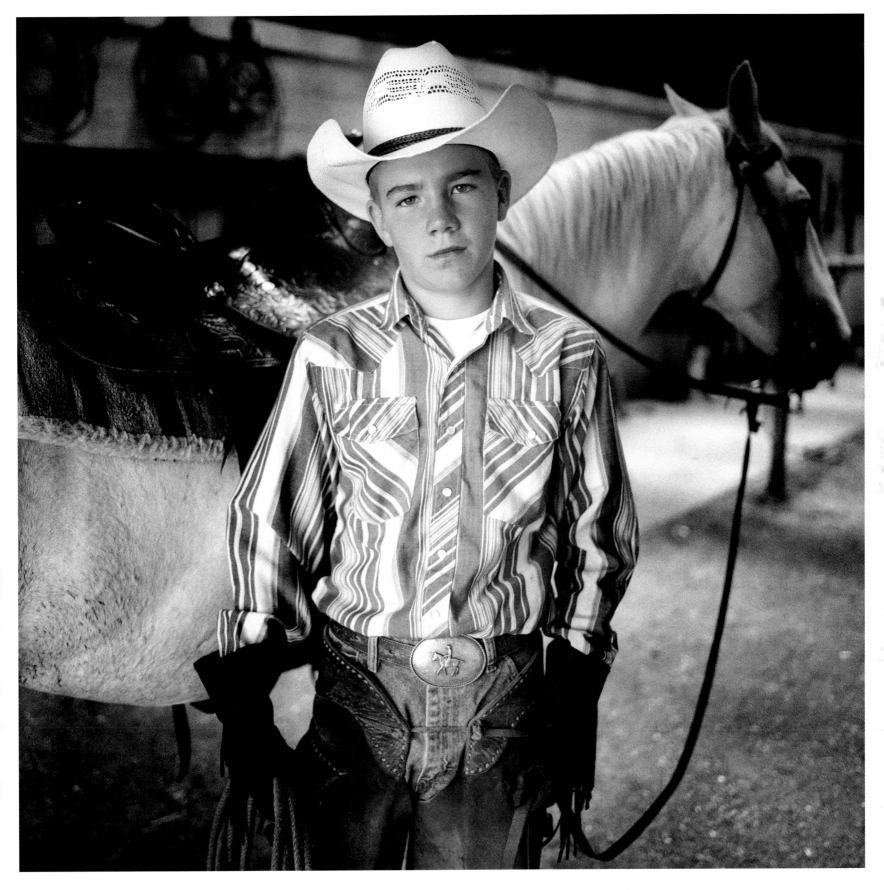

Jim Wright

Directory

Michael Birt

Web site: www.michael-birt.com

Jennifer Stanick (Rep)
CPI-New York
444 Park Avenue South,
Suite 502,
New York,
NY 10016
USA
Tel: 00 1 212 683 1455
Fax: 00 1 212 683 2796
Email: jennifer@cpi-reps.com
Web site: www.cpi-reps.com

Katz Pictures (Editorial sales)
109 Clifton Street
London
EC2A 4LD
UK
Tel: +44 (0) 207 749 6000
Email: K2@Katz Pictures

Zelda Cheatle Gallery
99 Mount Street
London
W1Y 5HF
UK
Email: galleryphoto@zcgall.demon.co.uk

Chris Buck

Web site: www.chrisbuck.com

Julian Richards (Rep)
381 Broadway,
#405, Manhattan,
NY 10013
USA
Tel: 00 1 212 219 1269
Email: julian@julianrichards.com
Web site: www.julianrichards.com

E. J. Camp

Web site: www.ejcamp.com

Dina Schefler (Rep)
In Focus Associates
305 East 46th Street,
15th Floor, New York,
NY 10017
USA
Tel: 00 1 212 593 5100
Fax: 001 212 593 8087
Email: info@infocusassociates.com
Web site: www.infocusassociates.com

John Clang

Web site: www.johnclang.com

Jae Choi (Rep)
Art & Commerce
755 Washington St.,
New York,
NY 10014
USA
Tel: 00 1 212 206 0737
Fax: 00 1 212 463 7267
Email: jchoi@artandcommerce.com
Web site: www.artandcommerce.com

William Claxton

Email: info@williamclaxton.com
Web site: www.williamclaxton.com

Thierry Demont (Rep)
Demont Photo Management
Tel: 00 1 212 214 0629
Fax: 00 1 212 202 5403
Email: thierry@demontphoto.com
Web site: www.demontphoto.com

Michael Hoppen
Michael Hoppen Gallery
Second Floor
3 Jubilee Place
London
SW3 3TD
UK
Tel: +44 (0)20 7352 4499
Fax: +44 (0)20 7352 3669
Email: info@michaelhoppengallery.com
Website: www.michaelhoppengallery.com

Fahey Klein Gallery
148 N. La Brea
Los Angeles
CA 90036
USA
Tel: 00 1 323 934 2250
Fax: 00 1 323 934 4243
Email: fahey.klein@pobox.com
Web site: www.faheykleingallery.com

Craig Cutler

15 East 32nd St.
4th Floor
New York
NY 10016
Tel: 00 1 212 779 9755
Fax: 00 1 212 779 9780
Email: studio@craigcutler.com
Web site: www.craigcutler.com

Art + Commerce (Rep)
755 Washington St.,
New York,
NY 10014
USA
Tel: 00 1 212 206 0737
Fax: 00 1 212 463 7267
Email: agents@artandcommerce.com
Web site: www.artandcommerce.com

A & C Anthology (Stock sales)
Tel: 00 1 212 206 0737
Fax: 00 1 212 645 8724
Email: anthology@artandcommerce.com
Web site: www.artandcommerce.com

Terence Donovan

Elizabeth Kerr (Syndication)
Camera Press
755 Washington Street,
New York,
NY 10014
US
Tel: +44 (0)20 7378 130
Fax: +44 (0)20 7278 5126
Web site: www.camerapress.com

Fahey Klein Gallery
148 N. La Brea
Los Angeles
CA 90036
USA
Tel: 00 1 323 934 2250
Web site: www.faheykleingallery.com

Meter Gallery
Web site: www.metergallery.com

Russell James

Palma Driscoll (Rep)
Bryan Bantry Agency NYC
Tel: 00 1 212 935 0200
Email: drawlight@aol.com

Russell James Studio
601 West 26th St.
Suite 1395
New York
NY 10001
USA
Tel: 00 1 212 243 0155
Fax: 00 1 212 243 7677
rj@russelljames.com
Web site: www.russelljames.com

Serlin Associates (Gallery)
126 Bd Bineau
92200 Neuilly Sur Seine
France
Tel: 33 1 41 43 24 24
Fax: 33 1 41 43 24 23

Nadav Kander

Web site: www.nadavkander.com

Bill Stockland (Rep NY)
Stockland Martel
5 Union Square West
6th Floor
New York
NY 10003
USA
Tel: 212 727 1400
Fax: 212 727 9459
Email: bill@stocklandmartel.com
Web site: www.stocklandmartel.com

Katy Niker (Rep London)
Burnham Niker
Unit 8 Canonbury Business Centre
190a-192a New North Rd.
London
N1 8BJ
UK
Tel: +44 (0)20 770 46565
Fax: +44 (0)20 7704 8383
Email: enquiries@burnham-niker.com
Web site: www.burnham-niker.com

Veronique Peres Domergue (Rep Paris)
Veronique Peres Domergue
Tel: 00 1 33 141 12 30 00
Email: veronique@vpd.com
Web site: www.vpd.com

Shine Gallery
Tel: +44 (0)20 7352 4499
Email: shine@shinegallery.co.uk

Yancey Richardson Gallery
212 343 1265
yrichardson@yrichardson.com
535 W. 22nd St.,
3rd Floor,
New York,
NY

Fahey Klein Gallery
148 N. La Brea
Los Angeles
CA 90036
USA
Tel: 00 1 323 934 2250
Web site: www.faheykleingallery.com

Yousuf Karsh

Elizabeth Kerr (Syndication)
Camera Press
21 Queen Elizabeth Street
London
SE1 2PD
UK
Tel: +44 (0)20 7378 130
Fax: +44 (0)20 7278 5126
Web site: www.camerapress.com

Richard Kern

PO Box 1267
New York
NY 10009
USA
Email: kern@richardkern.com
Web site: www.richardkern.com

Lord Lichfield
Contact: Penny Daly
Email: penny@lichfieldstudios.co.uk

Mark Liddell

Web site: www.markliddell.com

Raul Lamelas (Rep)
F11 Inc.
Tel: 00 1 323 882 8201
Email: f11@f11inc.com
Web site: www.f11inc.com

Vernon Jolly (Rep USA)
180 Varick St.
Suite 912
New York
NY 10014
Tel: 00 1 212 989 0800
Fax: 00 1 212 989 0002
Email: vjolly@vernonjolly.com
Web site: www.vernonjolly.com

Antoinette Kegel (Rep Europe)
Via Monte di Pieta,
19, Milan,
Italy
Tel: 00 39 02 8 90 06 99
Fax: 00 39 02 86 99 53 93
Email: info@antoinettekegel.com
Web site: www.antoinettekegel.com

Kimberly Ayl (Syndication)
Icon International
439 N. Larchmont Blvd.
Los Angeles
CA 90004 USA
323 468 4100
323 468 4101
Email: kimberlyayl@iconphoto.com
Web site: www.iconphoto.com

Sheryl Nields
Web site: www.sherylnieldsphotography.com

Terry O'Neill

Elizabeth Kerr (Syndication)
Camera Press
21 Queen Elizabeth Street
London
SE1 2PD
UK
Tel: +44 (0)20 7378 130
Fax: +44 (0)20 7278 5126
Web site: www.camerapress.com

Frank Ockenfels III

Carol LeFlufy (Rep)
iForward
Tel: 00 1 323 462 7950

Martin Parr

Web site: www.martinparr.com

Michael Shulman (Rep)
David Strettel (Prints)
Magnum Photos, Inc.
151 West 25th Street,
New York
MY 10001
USA
Tel: 00 1 212 929 6000
Fax: 00 1 212 929 9325
Email: michael@magnumphotos.com
Email: david@magnumphotos.com
Web site: www.magnumphotos.com

Nigel Parry

Web site: www.nigelparryphoto.com

Jennifer Stanick (Rep)
CPI-New York
444 Park Avenue South
Suite 502, New York
NY 10016 USA
Tel: 00 1 212 683 1455
Fax: 00 1 212 683 2796
Email: jennifer@cpi-reps.com
Web site: www.cpi-reps.com

Rankin

Web site: www.rankin.co.uk

ESP New York (Rep)
Tel: 00 1 212 431 8090
Email: info@esp-agency.com
Web site: www.esp-agency.com

ESP London (Rep)
Tel: +44 (0)207 209 1626

Steve Shaw

Steve Shaw Photography
550 N. Larchmont Blvd.,
#201,
Los Angeles,
CA 90004
Email: steve@steveshawphotography.com
Web site: www.steveshawphotography.com

D. Sharpe (Rep USA)
The Den
Tel: 00 1 323 993 0805
Fax: 001 323 993 0811
Email: dsharpe@thedenmgmt.com
Web site: www.thedenmgmt.com

T Photograpic (Rep UK)
1 Heathgate Place
78-83 Agincourt Rd.
London
NW3 2NU
Tel: +44 (0)20 7428 6070
Fax: +44 (0)20 7428 6079
Email: info@tphotographic.com
Web site: www.tphotographic.com

Lord Snowdon

Elizabeth Kerr (Syndication)
Camera Press
21 Queen Elizabeth Street
London
SE1 2PD
UK
Tel: +44 (0)20 7378 130
Fax: +44 (0)20 7278 5126
Web site: www.camerapress.com

Isabel Snyder

Web site: www.isabelsnyder.com

ARTmix The Agency (Rep LA)
2148 Federal Ave.
Suite B
Los Angeles
CA 90025
Tel: 00 1 310 473 0770
Fax: 00 1 310 473 0760
Email: giseller@artmixtheagency.com
Web site: www.artmixtheagency.com

ARTmix The Agency NY (Rep NY)
9 Desbrosses St.
Suite 513
New York
NY 10013
USA
Tel: 00 1 212 989 4990
Fax: 00 1 212 941 0776

Frank Roller (Rep Germany)
323 1/2 N. Ogden Drive,
Los Angeles,
CA 90036
Tel: 00 1 323 932 0500
Fax: 00 1 810 277 4306
Email: frank@glampr.com
Web site: www.glampr.com

Misato Sinohara (Rep Japan)
Tel: 00 310 399 34356
Fax: 00 310 396 1614
Email: misatos@earthlink.net

Lisa Diamond (Syndication)
Corbis Outline
Tel: 00 1 212 375 7600
Fax: 00 1 212 353 8316
Email: lisa.diamond@corbis.com
Web site: www.corbis.com

Randee St. Nicholas

Web site: www.randeestnicholas.com

Lamprecht & Bennett, Inc. (Rep)
601 West 26th St.
Suite 1227
New York
NY 10001
Tel: 00 1 212 533 3900
Fax: 00 1 212 533 4191
Email: info@lamprechtbennett.com
Web site: www.lamprechtbennett.com

Ulrik Neumann (Manager)
1287 N. Crescent Heights Blvd.
West Hollywood
CA 90046
USA
Tel: 00 1 323 936 0090
Fax: 00 1 323 936 8090
Email: ulrik@ulrikneumann.com
Web site: www.ulrikneumann.com

John Stoddart

Web site: www.peepworld.co.uk

Art Streiber

Web site: www.artstreiber.com

Kim Gillis (Rep) and Vonetta Baldwin
Montage
Tel: 00 1 323 769 0600
Email: kim@montagephoto.net
Email: vonetta@montagephoto.net
www.montagephoto.net

Kimberly Ayl (Syndication)
Icon International
439 N. Larchmont Blvd.
Los Angeles
CA 90004
USA
Tel: 00 1 323 468 4100
Fax: 00 1 323 468 4101
Email: kimberlyayl@iconphoto.com
Web site: www.iconphoto.com

Wright Jim

Web site: www.jimwirghtphotography.com

Kim Gillis (Rep)
Montage
Tel: 00 1 323 769 0600
Email: kim@montagephoto.net
Web site: www.montagephoto.net

Acknowledgments

There are many that have been generous with their support and help in putting this book together, to whom I owe a huge debt of gratitude and thanks.

Firstly, my grateful thanks to all those photographers who have given their time and images, without whose help this book could not have been produced.

There are many who have given so much time, energy, and enthusiasm—you all know who you are. However, I must bring particular attention and thanks to the following:

Lindsay Stewart, for all her exceptional writing abilities, patience, and perseverance, without whom this project would never have seen the light of day. Her management of the project has been faultless.

Kimberley Ayl, and everybody at Icon International, LA, for their generosity, professionalism, and judgment. It is always a delight to communicate and deal with them.

Also Josette Lata at BBH for selflessly sharing advice and knowledge, and for the supporting book.

I would also like to thank Christopher Dougherty, Scarlet Lacey, Frank Parvis, Nan Richards, Yupa Randle, Rafael Guerero, David and Sheila Greer, Sandy Williams, Billy Mernit, Heather McGlone, Lisa Wright, Robert Violette, Carol Brandwein, Geoffrey Matthews, Charlotte Blofeld, Carlo Banfi, Kee and Sheona Levi, Florence Chase, Michael Hoppen, Terence Pepper, Julian Treger, Mike Sherry at Sky Photographic, and Vincent McCartney.

And of course, my continuing thanks to Katya and Ludmilla Greer, who have, as always, supported me throughout the entire project.

Fergus Greer studied at St Martins School of Art, London, and The Royal Military Academy, Sandhurst, Surrey, in the mid 1980s before becoming a photographer in the early 1990s.

Since 1996 he has been based in Los Angeles, California. He has photographed for editorial, advertising, and book assignments, and his clients include: *Vanity Fair, The New Yorker, The New York Times Magazine, The London Sunday Times Magazine, Marie Claire, GQ, Premier, Fortune, TV Guide, Maxim, Town and Country,* and *New York Magazine.* His campaigns include IBM, Charles Schwab, Peoplesoft, Washington Post, Cigna, CNN, Autel, Exxon, and Mobil. He also exhibits in museums throughout the world.